D1060235

AMERICAN
THEATRE WING

An Oral History

Edited by Patrick Pacheco

100 Years, 100 Voices, 100 Million Miracles

"If we are ever needed again in a call which supersedes everything else, we are here and ready—and if it comes after we ourselves are gone, we shall leave it in the annals of the theater that the trained imagination of the theater can be used for serving humanity in more ways than entertainment."

–Rachel Crothers, playwright, co-founder of the American Theatre Wing

American Theatre Wing, An Oral History: 100 Years, 100 Voices, 100 Million Miracles
Edited by Patrick Pacheco

GRAPHIC ARTS
BOOKS™

Design, Jennifer Markson, The Euclid Shop
Photo Editing, Julie Tesser, Ian Weiss, and Joanna Sheehan Bell
Production, Karen Matsu Greenberg, Hourglass Press

Library of Congress Cataloging-in-Publication Data
Available upon request

ISBN: 978-1-513-26146-1

Pre-Press in China, by Mission Productions, Ltd.
Printed in China, by Chang Jiang Printing Media Co., Ltd.

TABLE OF CONTENTS

FOREWORD

Their Finest Hour BY ANGELA LANSBURY .. ix

PREFACE

Sanctuary in a Velvet Seat BY ROSIE O'DONNELL ... xii

CHAPTER I

History and Origins: Answering the Call BY DALE CENDALI .. 15

Voices of World War I .. 25

Voices of World War II ... 36

The Stage Door Canteen and Other War Efforts .. 40

Women of the American Theatre Wing BY PATRICK PACHECO ... 70

CHAPTER II

Education: Opening Doors BY ALLISON CONSIDINE .. 83

The Voices of Education ... 89

SpringboardNYC and Other Educational Programs .. 99

Exellence in Theatre Education Honors ... 106

The Andrew Lloyd Webber Initiative: Schooling the Next Generation BY PATRICK PACHECO 110

CHAPTER III

Community: When Your Story Becomes Our Story BY DAVID HENRY HWANG ... 129

The Voices of Community .. 136

Harvey Fierstein, the Tony, and Not Just for Gays BY PATRICK PACHECO .. 160

CHAPTER IV

Excellence: A Place in the Sun BY KENNY LEON .. 167

The Voices of Excellence ... 174

A Question of Excellence BY PATTI LUPONE ... 192

The History of the Tony Award ... 196

The Tonys and "It's a Wonderful Life" BY PATRICK PACHECO ... 204

The Obie Award: The American Theatre Wing Embraces the "Wild Child" ... 212

Pasek and Paul and the Ghost of Jonathan Larson ... 228

CHAPTER V

The Past Is Prologue: The American Theatre Wing's Next Century BY HEATHER A. HITCHENS 233

The Voices of a Call to Action ... 237

Ars Nova, Jonathan Larson, and Two Comets Streaking Across the Sky BY PATRICK PACHECO 260

AMERICAN THEATRE WING

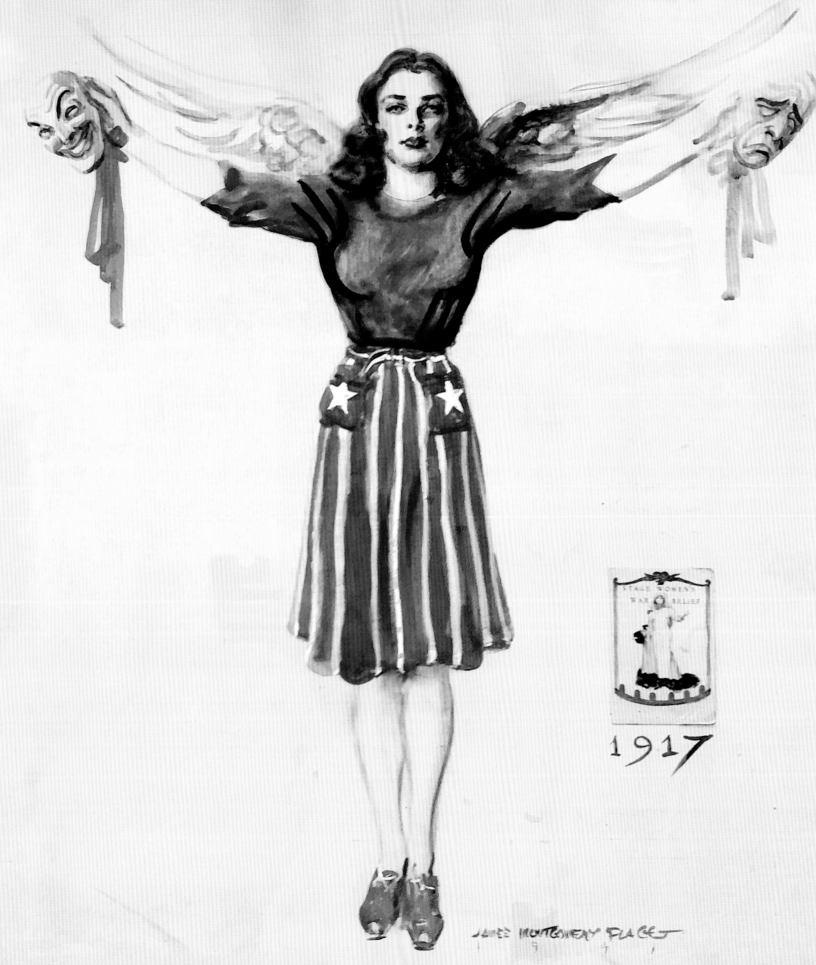

1917

Their Finest Hour

By Angela Lansbury

Much to my surprise, a friend recently told me that I had once been considered for the role of Miss Casswell in *All About Eve,* one that rightly went to Marilyn Monroe. There's that amusing party scene in the movie when Addison DeWitt dryly introduces the buxom Miss Casswell as an actress who attended "The Copacabana School of Dramatic Art."

Well, I never went there, sad to say. But in 1939, I did attend the much more sober Feagin School of Dramatic Art in New York City thanks to a scholarship given to me by the American Theatre Wing. How I ended up there at the age of fourteen is the story of war, the generosity of strangers toward refugees, and a group of strong, intuitive and empathetic women who founded and nurtured an organization that would mean "home" to both soldiers and artists.

This remarkable saga starts with my mother, Moyna Macgill who was an actress, and who used her formidable resources and connections to save her children from the ravages of World War II. We were living in London at the time and the American Theatre Wing, in tandem with its British counterpart, was not only raising funds to support the war effort but also taking into their homes the children of English actors.

That was how my twin brothers, Bruce and Edgar, and I arrived in Canada on the Duchess of Atholl with no money to speak of, and then made our way to New York and into the home of a kind American family.

Later on, life would not be easy for my mother. But these war years were Moyna Macgill's finest hour. She managed not only to save her children from the London Blitz but several others as well. She put me into the Feagin School and my brothers into Choate in Connecticut. All this at a time when we were virtually penniless, mind you. And she raised funds for the British Stage Women's War Relief by touring throughout Canada in Noel Coward's *Tonight at 8:30.* My mother was ferocious in the face of this crisis. And in that regard she was a sister-in-arms to the staunch and independent women

> **"The story of the American Theatre Wing is the story of war, generosity toward refugees, and a group of strong and empathetic women."**

who in 1917 had founded the American Theatre Wing in the darkness of World War I.

The playwright Rachel Crothers and

six others—call them the Magnificent Seven—were of the theater. At a time when women didn't have the right to vote and actresses were considered a notch above you know what, Crothers and her group got down to business. They held bond rallies, put on patriotic shows, and filled workrooms with volunteers knitting and sewing clothing to be shipped overseas to the men in the trenches. The numbers prove the depth of their passion and commitment. In the course of the war, they raised $7 million for the allied efforts, took in 284 families, and sent 1,863,645 articles of food and clothing to the European war zones.

When the war to end all wars proved illusory and the threat of Wilhelm II blistered into the threat of Hitler, the women—and now men—of the American Theatre Wing mobilized to once again support the allied troops. Their finest hour occurred in March 1942, when they opened the Stage Door Canteen™ in the basement of a theater on West 44th Street and offered a place where soldiers from all over the world could get a sandwich, be entertained by stars, and dance with—or bend the sympathetic ear of—volunteer hostesses. I was one of them and I can tell you, we had a ball. What was on tap, in addition to milk, was "soul

OPPOSITE PAGE: *In 1939, artist James Montgomery Flagg, best known for the iconic "Uncle Sam Wants You" World War I poster, captured the American Theatre Wing as a woman poised to be borne aloft with the emblems of comedy and tragedy in hand.*

service" which is how one of my fellow volunteers so perfectly framed it.

That "soul service" knew no bounds. Six years before Truman integrated the armed forces and Jackie Robinson integrated professional baseball, the women of the Stage Door Canteen instituted an interracial policy where black soldiers and white soldiers mixed together for the first time. And when a black soldier asked a white hostess to dance with him, we were instructed to do so. For their pains, the women of the American Theatre Wing were denounced from the well of the United States Senate for the "mongrelization of the races" that was going on at the Stage Door Canteen. It was threatened with closure. The reply was curt: "Go suck on an egg." These American democratic ideals were what the Allied soldiers of all races were fighting and dying for. The least we could do was provide a respite from the horrors they were sure to face.

In the succeeding decades, the American Theatre Wing has held true to those values. Since then the seeds planted by brave women and cultivated by brilliant leaders, have blossomed into something quite glorious and magical. I don't think it's a stretch to say that the American Theatre Wing has earned the right to be called the "soul of the theater." At least, I believe it to be so.

The subtitle of this oral history—*100 Years, 100 Voices, 100 Million Miracles*—is not an idle one. Anybody who has labored as long as I have on our stages knows that it's always a bit miraculous when, despite the nerves and jitters, the play goes sufficiently well. As you will hear in the voices that resound throughout this book, the American Theatre Wing has helped artists navigate the minefields of the creative act. Just as those women in 1917 knitted jumpers and socks to protect our

soldiers, the American Theatre Wing puts it together stitch by stitch wherever it is needed, whether through its national grants, outreach, networking, or the celebration of excellence through the Tony Award.

There have been so many fine hours for the American Theatre Wing in its history. And it has been my honor and privilege to have been included in several of them, from the Feagin School of Dramatic Art to being honored with the Tony.

As the country and the world again enters such perilous and uncertain times, that legacy will be tested again and again. And the answer will be as it always has been: light the darkness with art.

"Art isn't easy," my friend Steve Sondheim wrote. But the American Theatre Wing has always nurtured the contexts in which it is most likely to occur. As grateful as I am for all that the American Theatre Wing has achieved for the past century—most of which I've been around for—I truly believe its finest hours are yet to come.

Happy birthday,
American Theatre Wing!

OPPOSITE PAGE: *Angela Lansbury credits her mother, the actress Moyna Macgill, with saving a number of children from the London bombings during World War II.*

Sanctuary in a Velvet Seat

By Rosie O'Donnell

Sanctuary. You hear that word a lot these days. A safe place. A nurturing place. A holy place.

That's what theater has always been to me. A sanctuary. And it's what I have tried to offer to others, born with lots of strikes against them, through Rosie's Theater Kids. It's the least I could do for all that theater has given to me.

When I took the first group to see *Aida* on Broadway at the Palace Theatre, my ten-year-old pal, Zion, looked inside a theater for the first time in his life and asked, "Rosie, where we gonna sit?" Pointing out rows for about two hundred kids, I replied, "How about those empty seats right there, kiddo?" His eyes brightened. He said, "You mean in the velvet?"

In 2014, I was thrilled when I received a special Tony Award named for Isabelle Stevenson, the late chairwoman of the American Theatre Wing. If the first fifty years of the Wing were about the selfless sacrifices epitomized by the Stage Door Canteen, the second half of the century has been about excellence and acknowledgement that the theater can and should be a lifeline for the marginalized and most vulnerable in our society. I felt the honor given to me was an endorsement of our efforts to put kids "in the velvet." Further proof of the Wing's commitment is the support it gives to exceptional teachers, schools, and students through the Andrew Lloyd Webber Initiative and its other programs.

It's the oldest story in the book: a poor young man is heading to a life of incarceration. Somebody believes in him, places a trumpet in his hands, and suddenly a legend is born. I'm not a legend and I don't play trumpet but that kind of happened to me. That "somebody" was Pat Maravel, a seventh-grade teacher who rescued

> **"Had I not just experienced *Hamilton*, I'm not sure that I would have survived the onslaught that followed."**

this lost puppy of a girl and never stopped believing in her. My mother died when I was ten and my father had "issues." All anybody wants in life is to be *seen*. I felt invisible. Then Pat saw me—and placed me inside her family. Stephen Sondheim says that the word "teacher" always brings tears to his eyes. I know how he feels. Pat Maravel taught me about freedom and family, about tolerance and activism, about compassion and how to live, love and give back.

The theater amplified those lessons. I was lucky I lived in Long Island. Just a train ride away was Broadway, which introduced me to a magic and beauty that made me dream of a life better than the one I was living. I would second-act a lot of shows, going in after the intermission and finding a seat wherever I could. The musicals that I saw, like *Les Misérables* and

The Elephant Man, shaped my moral center, made me want to be better than I was, made me want to be more compassionate, more giving. The way that some people feel when they enter a church is how I feel when I come to the theater. The lights are lowered, the music begins, and everybody settles in for something to be held in communion.

A couple of years ago, I felt that way during one of the most trying periods of my life. I was coming out of the Richard Rodgers Theatre on the opening night of *Hamilton* when I suddenly found myself the center of explosive publicity. That night my name had been brought up during a Republican presidential debate. Had I not just experienced Lin-Manuel Miranda's moving testament to the Founding Fathers, I'm not sure that I would have survived the onslaught that followed. It was a terrible time—compounded by a family trauma—and I returned often to immerse myself in the beauty and idealism of *Hamilton*. It became a joke with the ushers. "You again?" But its message of patriotism, love and forgiveness shamed everything else that was going on outside the walls of the theater.

It saved me.

When my therapist asked me, "Where are the tears?" I told her, "They're at the Richard Rodgers."

What did the whole experience teach me? That we make art out of pain. That our common bonds help to mend our broken hearts. That's what lies at the crux of shows like *Les Misérables,*

Hamilton, and *Fun Home.* It's what Pat Maravel taught me, and it is her name that graces our new Maravel Arts Center. And it's what the American Theatre Wing has long been nurturing through its recognition of artists who strive for inclusiveness and healing. That includes the innovative reaches of Off and Off-Off-Broadway since the Wing now oversees the Obie Awards. Excellence wherever they find it. A recent honoree of the Jonathan Larson Grant is Ty Defoe, an incredibly talented transgender Native American with a beautiful heart who is telling wonderful stories that have yet to be heard in the velvet seats.

People ask me if I'd like to win a Tony Award. Sure, who wouldn't? But I'll tell you what would be even better. I'd love for one of Rosie's Kids to win one and to get up there and say, "I'd like to thank the American Theatre Wing, Rosie O'Donnell and the Theater Kids." It's my dream and I think it's gonna happen. It's the reason why we do the things we do. We seed and cultivate the dreams that take shape in the velvet seats. Watching that happen has been one of the greatest privileges of my life.

When I accepted the Isabelle Stevenson Award I said that "Broadway is better than Prozac." I wasn't kidding.

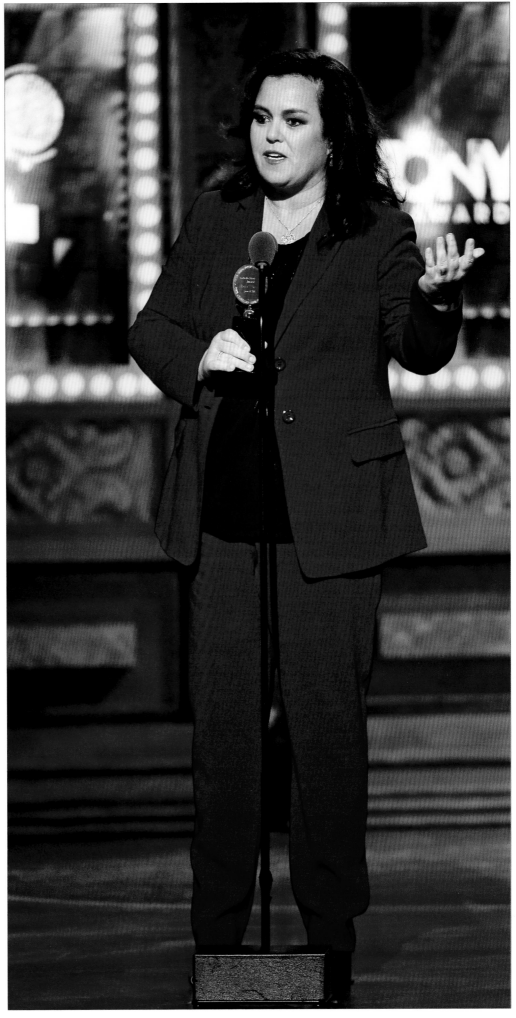

RIGHT: *Rosie O'Donnell received the 2014 Isabelle Stevenson Award for her tireless efforts on behalf of disenfranchised young people through Rosie's Theater Kids.*

HISTORY AND ORIGINS
ANSWERING THE CALL

By Dale Cendali

Creativity. Commitment. Community. Compassion. Patriotism. One hundred years of the American Theatre Wing. A hundred years that reflect not just the history of an organization, but the inclusive power of the theater community with regard to both women and minorities, as well as the theater community's effort to achieve mainstream respect and promote the arts.

The American Theatre Wing was founded and run by women. Just two days after the United States declared war on Germany on April 6, 1917, playwright Rachel Crothers issued an appeal published in eight major New York newspapers to "every woman who has ever been and is now connected to the theatrical profession" to attend a mass meeting to start a war relief organization. The first assembly of the Stage Women's War Relief was on April 13 at the Hudson Theatre—the only theater then owned by a woman, Renée Harris.

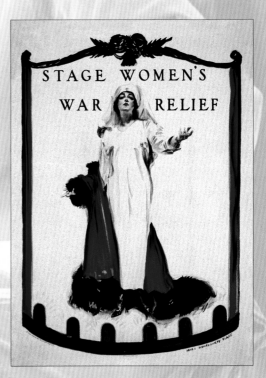

RIGHT: *In 1917, artist James Montgomery Flagg, best known for the iconic Uncle Sam "I Want You" poster, captured the sacrificial essence of the Stage Women's War Relief with a woman doffing an elegant wrap to reveal a nurse's outfit. The choice of outfit was not idle. Actors were just emerging from a "low" reputation.*
BACKGROUND: *"The Magnificent Seven": In 1917, Rachel Crothers, Louise Closser Hale, Dorothy Donnelly, Josephine Hull, Minnie Dupree, Bessie Tyree and Louise Drew establish the Stage Women's War Relief, later dubbed the American Theatre Wing.*

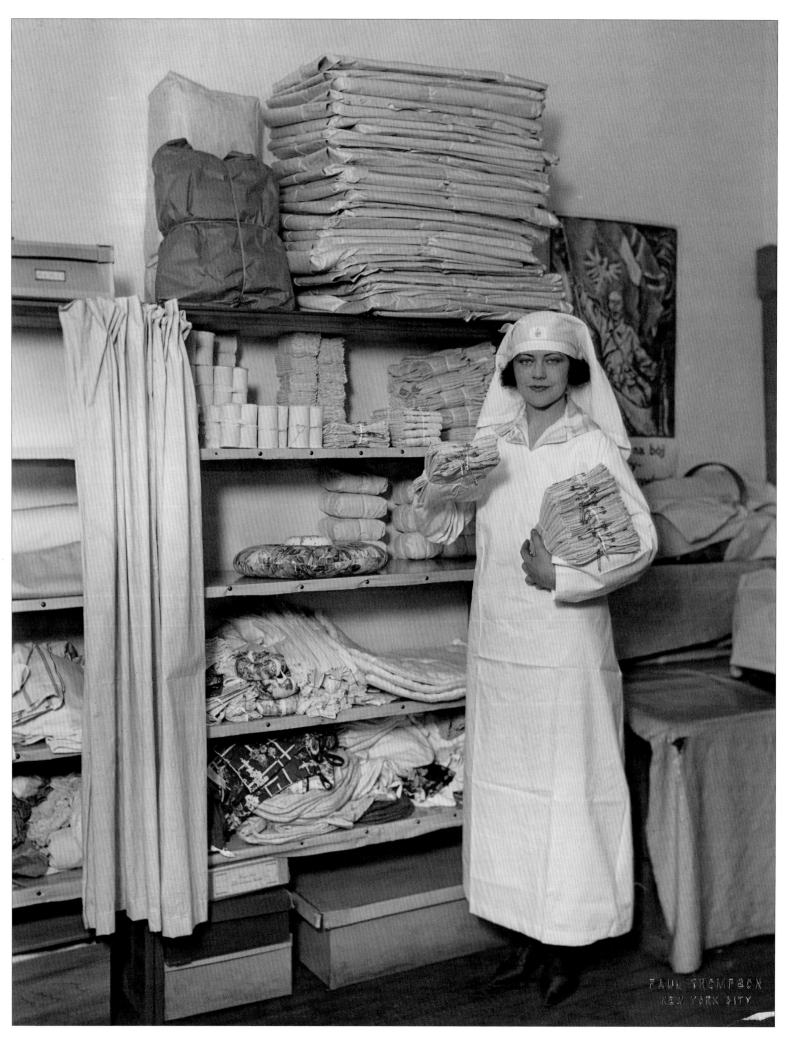

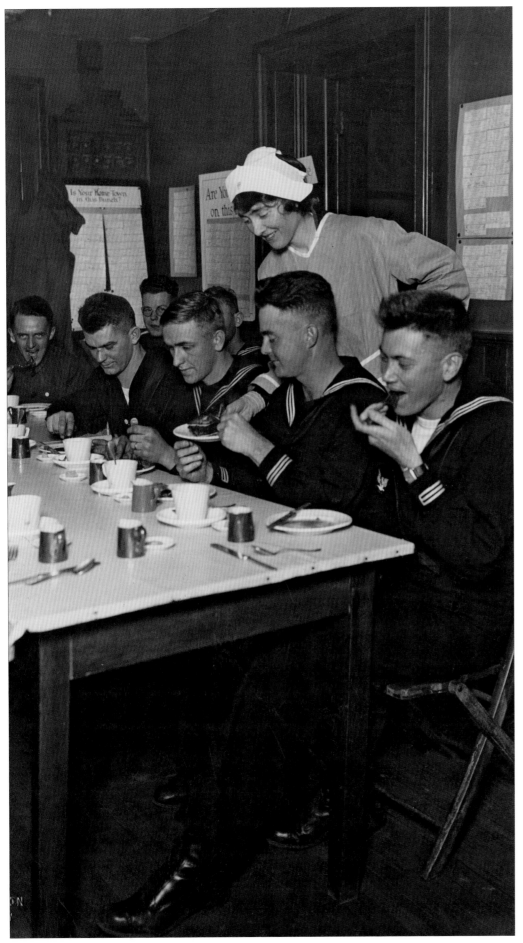

Crothers was more than a playwright; she was a socialite and a suffragette. Her writing was mindful of the lack of respect at that time for women generally and women in theater in particular. The Stage Women's War Relief was intended to both help the war effort and show women in the theater (and the theater generally) in a new, respectable light. Famous artist James Montgomery Flagg painted a heroic portrait of a Stage Women's War Relief volunteer that captured the type of conservative, nun/nurse-like attire worn by the volunteers of that period.

And volunteer they did. The Stage Women's War Relief workroom made an average of 2,500 dresses, 630 supply kits, 900 baby garments and 50 vests to be sent abroad *each week*. Actresses grew food and taught first aid. A service house was established to provide cheap, safe lodging. The Stage Women's War Relief also used its unique talents to entertain the troops as a precursor to the U.S.O.—sending 1,430 shows to camps, battleships, and hospital wards, in addition to participating in countless

> "**AN AVERAGE OF 2,500 DRESSES, 630 SUPPLY KITS, 900 BABY GARMENTS AND 50 VESTS WERE SENT ABROAD *EACH WEEK*. ACTRESSES GREW FOOD AND TAUGHT FIRST AID.**"

ABOVE: *To aid returning vets, the Stage Women's War Relief established a service house where soldiers could get a hot meal and a bed.*

OPPOSITE PAGE: *Actress Peggy O'Neil, in her nun-like garb, works in one of the many supply rooms commandeered by the Stage Women's War Relief.*

domestic events to raise money and to promote the sale of war bonds. They even started a soldier and sailor hospitality "canteen" on Broadway and 47th Street.

Moreover, at a time when many war relief organizations were being investigated for manipulation, the Stage Women's War Relief stood out for being entirely self-funded and only spending 12 percent on administrative costs. Crothers's dual mission would not have it any other way.

Crothers, aided by a new group of dynamic, hard-working theater professionals, was there again when World War II loomed. On June 4, 1940—a year and a half before Pearl Harbor—Crothers wrote to other women in the theater to resume war relief work. The United States theater community had a history of close ties to its London counterpart, and it was natural for Crothers to want to assist again when Britain was imperiled. As the U.S. itself was not yet in the war, the revised name of the organization was The American Theatre Wing of the British War Relief Society. While "wing" originally meant "branch" of the British society, after Pearl Harbor, the name was legally changed to drop the reference to the British organization. "Wing" became a double-edged play on "wing" as a tactical unit of the new U.S. Army Air Forces and as a behind-the-scenes work space of the theater.

After setting the stage, Crothers handed the baton of running the Wing to Antoinette Perry, best known for directing the hit play *Harvey,* who became chairwoman of the board. But this time around, the Wing was open to men too—both on the board and as volunteers—as everyone wanted to pitch in and there was much to do.

The signature effort of the Wing

was the Stage Door Canteen, which was located in the donated basement of Lee Shubert's 44th Street Theatre. It launched on March 2, 1942 after a massive and speedy renovation made possible by free labor donated by the stage unions. The Canteen was a place where servicemen would be served sandwiches, cake, and coffee by people in the theater while enjoying Broadway-style entertainment.

In a typical week, the Canteen gave out 14,000 sandwiches, 21,000 slices of cake, 22,000 cups of coffee,

"What's remarkable to me about the American Theatre Wing is that it was founded by women, tough women, and yet the organization is this combination of grit and heart. Maybe because we give birth, we have the capacity to share our lives, to share our souls, to care for something other than ourselves. To sacrifice, if need be."

—CHITA RIVERA, ACTOR

and 42 crates of citrus fruit. The food was largely donated, with neighboring restaurant Sardi's carrying a big load. (Young Vincent Sardi, Jr., after spending time in the Canteen teaching Alfred Lunt how to efficiently wash dishes, shipped out with the Marines). Both established stars and young junior hostesses danced with the troops, and the mood was intentionally upbeat—no "I'll Be Seeing You" there. Thus, Ethel Merman, Al Jolson, Bette Davis, Ethel Waters, Howard Keel, Alfred Lunt, Rosetta LeNoire, and a multitude of others would drop by to perform and mingle—Shirley Booth came by almost every night to jitterbug with a

sailor nicknamed "Killer Joe" Piro. The choruses of *Oklahoma!, By Jupiter,* and *Star and Garter* were regular visitors. Non-Broadway celebrities—ranging from the Brooklyn Dodgers to Yehudi Menuhin—would sometimes also stop by. And the ambiance was decidedly and purposefully wholesome. No alcohol was served. And there were strict, well-publicized rules preventing fraternization outside the club between the hostesses and the servicemen.

When Hollywood made an extremely popular movie based on the Canteen that helped fund the Wing's operations (i.e., *Stage Door Canteen* with its hit song, "I Left My Heart at the Stage Door Canteen"), this innocent quality was emphasized. When a serviceman in the film asked senior hostess Helen Hayes, "How far can you go with these girls?" She replied, "Just as far as the door." This wholesome emphasis was not accidental, but consistent with the idea of transforming how the public viewed women of the theater.

The Canteen was also transformative in its inclusive nature—so reflective of the theater community. At a time when the military was strictly segregated, the Canteen was open to all servicemen, regardless of creed or color. The Canteen went to great lengths to recruit African-American junior hostesses to better reflect the population. But to be clear, if an African-American soldier asked a white hostess to dance, her answer was a friendly yes—in sharp contrast with the social norms in other venues throughout the country. Despite naysayers predicting calamity due to the Canteen's open-door policy, no serious incident ensued. They had a plan if needed—the band would simply start playing "The Star Spangled Banner," thus forcing the troops to stand at attention—but it was only needed

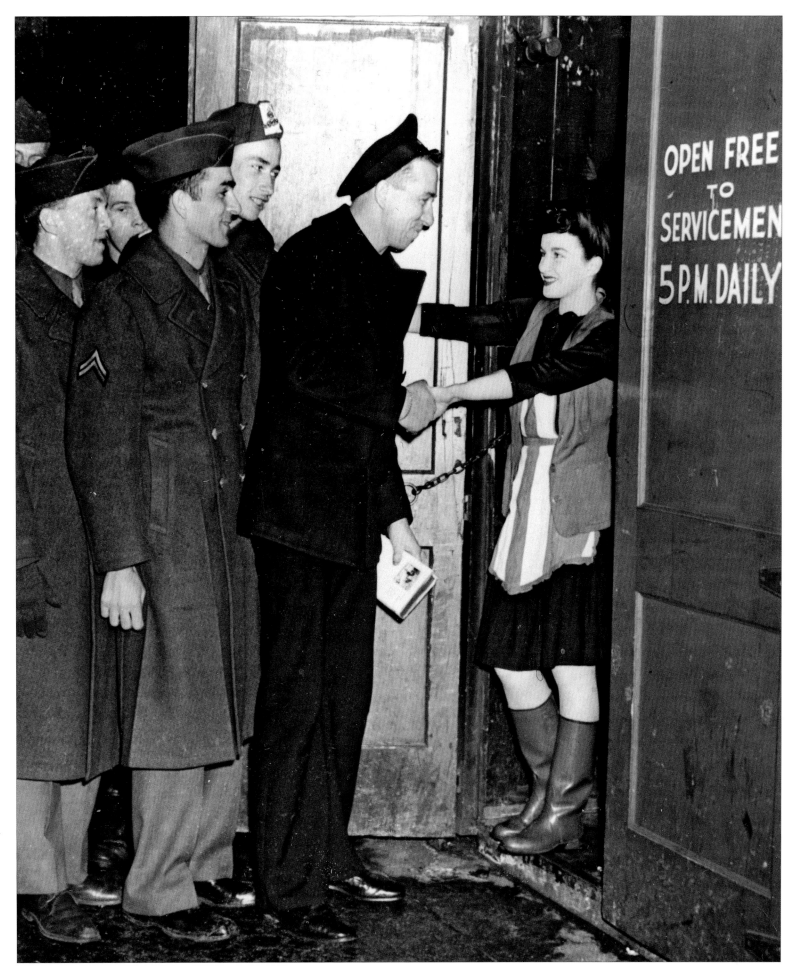

ABOVE: *A hostess greets soldiers at the door of the Stage Door Canteen™. Lee Shubert offered the American Theatre Wing the unoccupied basement of the 44th Street Theatre building in which to establish a club which opened there in March of 1942 and entertained three million soldiers over the course of the war.*

19

once when there was a dispute over a missing—and later found—wristwatch.

Moreover, while many clubs were

"It's not surprising to me that women were the backbone of the American Theatre Wing when it started because I think that women are extraordinary leaders. Women see the future and they're fearless about putting their hearts, souls and ideas into the future."

—MOLLY SMITH, ARTISTIC DIRECTOR,
ARENA STAGE, WASHINGTON, D.C.

limited to "officers only," the Canteen welcomed all, as befitting theater's own egalitarian roots.

Eleanor Roosevelt famously declared the Stage Door Canteen "the finest of all contributions toward war morale." The Canteen was a smash hit, spawning branches across the country. The Hollywood Canteen greeted 10,000 men a night who were entertained by the likes of Humphrey Bogart, Roy Rogers, and Hedy Lamarr. The Hollywood Canteen became the locale of the second Canteen film.

But the American Theatre Wing did far more in World War II than just run the Canteens. Among other things, it ran a Speakers Bureau to promote morale, filling 4,035 engagements by the end of the war. The Wing similarly started the Victory Players to create and perform plays about such things as the dangers of the black market and the need to conserve resources.

Moreover, while the Wing discovered fewer people knew how to sew during WWII compared to WWI, it nonetheless taught eager volunteers the

basics and, by the war's end, the Wing's workroom had donated 36,000 sewn items and 50,000 pieces of new and used clothing to aid the impoverished.

And at a time when the U.S.O. only sent light entertainment to the troops, thinking anything too highbrow would be ill-received, the Wing worked with the army to send overseas a full production of *The Barretts of Wimpole Street*, starring the acclaimed Katharine Cornell and Brian Aherne. The story involved the romance between Robert Browning and Elizabeth Barrett. The troupe made a seven-month wartime tour of Italy and France playing to

"ELEANOR ROOSEVELT DECLARED THE STAGE DOOR CANTEEN, 'THE FINEST OF ALL CONTRIBUTIONS TOWARD WAR MORALE.'"

packed stadiums.

When the war ended, the Wing continued its mission—now providing entertainment to veterans at hospitals and running a school to train returning servicemen to work in the theater. The Wing estimated that over 25,000 individual volunteers contributed to the Wing's efforts throughout the war.

Sadly, Antoinette Perry died unexpectedly in June 1946 of an illness she had concealed. Her compatriots felt she "gave" her life for the Wing and

were devastated by her loss. To honor her, the Antoinette Perry Award was initiated and bestowed annually by the Wing for excellence in the theater. Those "Tony" awards—and the Wing's broadly inclusive activities in promoting the theater and in training young professionals—help link the Wing of today to the Wing of a hundred years ago—and counting. In fact the Wing has had a long line of great volunteers and leaders, including the late Isabelle Stevenson. And the Wing's president is still a woman, Heather Hitchens.

On the spot where the Stage Door Canteen was, the New York Times erected a plaque with this dedication: "During All the Combat Days of the War Between the United Nations and the Axis powers, The American Theatre Wing Stage Door Canteen Occupied This Site. This Tablet is Dedicated to Men and Women of the Entertainment World Who Brought Cheer and Comfort to The Soldiers, Sailors, and Marines of America and Her Allies."

I noticed this plaque on one of my trips to the theater as an undergraduate at Yale, majoring in history and serving as the president of the Yale Dramatic Association. After numerous trips to the Wing's archives at Lincoln Center and after being privileged to interview many of the amazing volunteers who helped make the Wing a success, I wrote my senior thesis about the Wing, as I was so struck by its untold history, dynamic passion to help, and its ahead-of-its-time thinking.

It is thus both ironic and deeply rewarding that my path has taken me now to being an ATW trustee. As the song goes, "I Left My Heart at the Stage Door Canteen."

OPPOSITE PAGE: *Private Ed Maron and Dorothy McGuire, actress and hostess, listen as singer Hazel Scott brings her electrifying style to the Stage Door Canteen in 1942.*

By the Numbers
The Stage Women's War Relief Efforts

6 Branches of New York's Stage Women's War Relief: Boston, Chicago, Philadelphia, Detroit, San Francisco and Los Angeles

4,700,000 Number of Americans who served in World War I

117,000 Soldiers killed

202,000 Soldiers wounded

17,000 Men who received bed and breakfast at the Stage Women's War Relief's Service House in New York City

60 Disabled veterans who lived at the Stage Women's War Relief's Service House

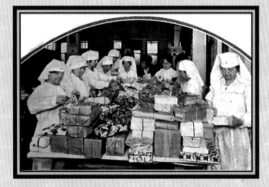

ABOVE: *Volunteers packed and sent almost two million articles "over there" to aid soldiers and refugees in war-torn Europe.*

13 Silent films made to fund the Stage Women's War Relief purchase of hometown newspapers for wounded soldiers

284 Number of actors' families supported by the Stage Women's War Relief

3 Number of J.M. Barrie plays— *The Twelve Pound Look, The Old Lady Shows Her Medals, The New World*— the proceeds from which benefitted the Stage Women's War Relief

14,000 Pounds of jam sent by Stage Women's War Relief to convalescing soldiers in Europe

$7,000,000 *Raised by the Stage Women's War Relief for the allied efforts in World War I*

$70,000 *Raised in forty minutes by Theda Bara for Stage Women's War Relief at the Liberty Theatre*

$5,000 *Raised in one night, April 21st, for the Stage Women's War Relief in collections taken up at theaters in Manhattan and Brooklyn*

$100,000 *Raised per week by the Stage Women's War Relief's Travelling Theatre featuring stage and screen stars*

$1,000 *Purchase price of a Liberty Bond that came with a free portrait session by James Montgomery Flagg, illustrator of the Stage Women's War Relief poster*

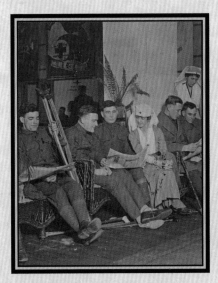

ABOVE: *One of the consolations given to wounded soldiers at Debarkation Hospital No.5 were copies of their hometown newspapers provided by the Stage Women's War Relief.*

1,863,645 *Articles of clothing and food sent by the Stage Women's War Relief to Europe during World War I*

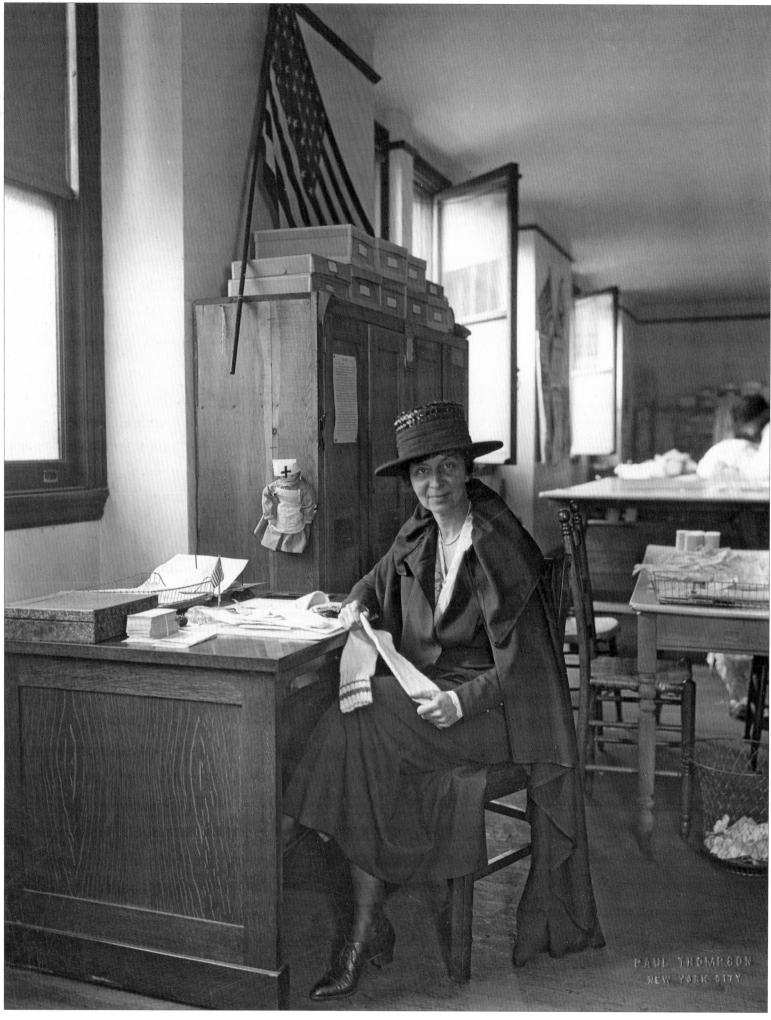

PAUL THOMPSON
NEW YORK CITY

THE VOICES OF WORLD WAR I

"The Hudson Theatre was opened for the meeting and the women of the stage poured in. It was the greatest coming together of women of the theater that was ever known for the greatest cause. During that meeting a wave of consecration passed over them, and they determined to make the stage mean more than art and play a noble part in world drama. In two weeks time, the workroom was in perfect running order, stocked with materials from which surgical dressings, hospital garments, baby clothes, and soldiers' knitted things could be made. These gigantic jobs had been undertaken... with the fearlessness of trained imaginations and the force and directness of women who are breadwinners. Several out of town branches were organized in Philadelphia, Los Angeles, San Francisco, and Detroit."

–DAISY HUMPHREYS, STAGE WOMEN'S WAR RELIEF PUBLICITY DEPARTMENT

"The restless depression which had to come to so many of us because of the war then as now gradually was making life— which had been interesting and stimulating—dull and selfish and narrow. It was intolerable to go on with daily routine. It was Dorothy Donnelly's idea that we must have a workroom of our own, where only women of the theater worked, and where enthusiasm and success would grow out of comradeship and our understanding of each other and sharing of a common responsibility."

–RACHEL CROTHERS, PLAYWRIGHT, CO-FOUNDER OF THE STAGE WOMEN'S WAR RELIEF, 1917

"There is something of pathos in the emblem which these women of the stage chose for their work in war relief. It is a Crusader's Cross—and, truly, when they slipped from their stage finery into their white working garb, they were faring forth upon something of the great adventuring of the early seekers after a hidden Hallowed Thing. What the stage found was a usefulness that lay not far from home, and one of their most important contributions to our army has been the amassing of talent and the continued sending out of programmes to the hospitals."

–LOUISE CLOSSER HALE, ACTRESS

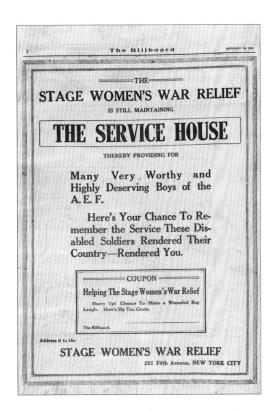

RIGHT: The Stage Women's War Relief established the publicly-supported Service House where returning wounded soldiers could recuperate and find a warm meal and bed.

OPPOSITE PAGE: Playwright Rachel Crothers was a dynamic force in the early years of the organization, setting up workrooms, mobilizing volunteers, and corralling donors.

"**EVERYONE SAID THE WOMEN OF THE THEATER WERE TOO FLIGHTY TO PUT THEIR HANDS TO ANYTHING USEFUL.**"

–Rachel Crothers, playwright, co-founder of the Stage Women's War Relief, 1917

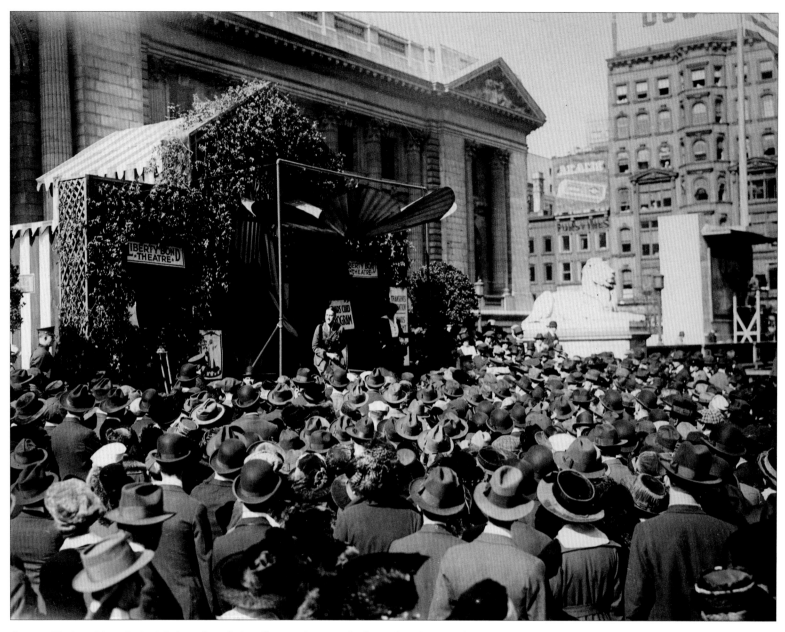

ABOVE: *The Stage Women's War Relief raised nearly $7 million at Liberty Bond rallies such as this one in front of the New York Public Library. Silent film vamp Theda Bara raised $70,000 in forty minutes by touching men's wallets as much as their hearts.*

"Theda Bara, the movie vampire, for whom men have fought and bled and died (in the movies), extracted the last measure of their devotion yesterday when she turned their pockets inside out for the Liberty Loan at the Liberty Theatre in front of the Public Library. Begging, pleading, scolding had brought forth reasonable sales all day long at the theater, but vamping as demonstrated by Miss Bara brought the bills and pledges showering into the money boxes of the Stage Women's War Relief, and it was amply proved that the woman who can touch men's hearts can touch their pocketbooks with equal success."

–THE TRIBUNE, OCTOBER 12, 1917

"One of the first duties was to care for the families of the theater that suffered privation because their men were fighting. Clothes and shoes were needed for destitute families in Europe. A jam department was also created by Louise Closser Hale to supply the convalescent soldiers with the sweets their system needed for perfect recovery."

–DAISY HUMPHREYS

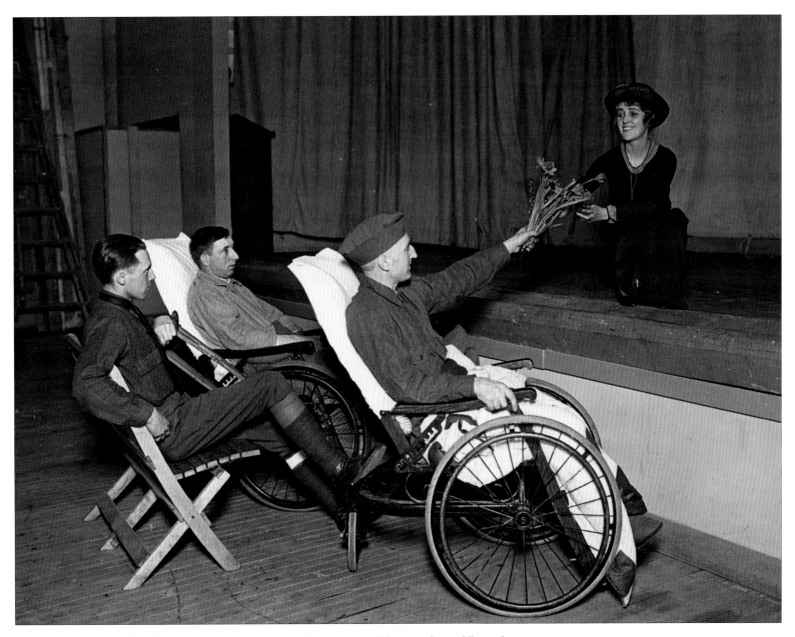

ABOVE: *Popular actress Violet Heming, a volunteer with the Stage Women's War Relief, receives flowers following her performance at the Debarkation Hospital No. 5 in New York.*

"Then the finest quality was called into action—self-abnegation. The more we realized what our men were enduring over there and what those stricken countries were experiencing, the less we thought about individual selves. All things that we had hitherto known seemed trivial. The smaller sacrifices that confronted us were accepted with gladness. To be part of, to help to give, and to feel this thing, were the emotions that awakened the spirit of kinship towards all suffering humanity."

–ELSIE FERGUSON, ACTRESS

"We gave 1,430 shows and entertained in more than 1,000 wards in hospitals. We played in 61 different hospitals, 58 camps and training stations, 67 clubs and service houses, and on 14 battleships. We cooperated with YMCA and every organization—the Red Cross, Knights of Columbus, Jewish Welfare, Warm Camp Community, and Salvation Army—and with individuals."

–EULA S. GARRISON, MANAGER OF CAMP ENTERTAINMENTS

"WHEN A FELLER NEEDS A FRIEND"

A Play in Three Acts

BY

HARVEY O'HIGGINS

AND

HARRIET FORD

———

*Written for the benefit of the
War Orphans of the Allies*

Title from "Briggs" of the New York *Tribune*
Song, "Marching to Berlin"—Words by Oliver Herford.
Music by R. Hugo.
Produced under the direction of
George Henry Trader

———

COPYRIGHT, 1918, BY HARVEY O'HIGGINS AND
HARRIET FORD

COPYRIGHT, 1920, BY HARVEY O'HIGGINS AND
HARRIET FORD

"Then came the armistice, and the actress realized that her work had just begun. To put a hopeful gleam in those sad young eyes, to help them in their difficult task of reconstructing their shattered lives and to stand staunchly by them in that effort, this was what the stage women felt to be their duty now. The first tip in that direction was the Service House. They developed the idea of maintaining a home for the care and education of the permanently disabled boys, until they were able to stay on their own feet."

–DAISY HUMPHREYS

"We broke the laws and traditions by collecting in all the New York and Brooklyn theaters every Saturday night. Girls would pass around the audience with red, white and blue dippers. The organization received the entire net proceeds of three Barrie plays. *The Twelve Pound Look, The Old Lady Shows Her Medals,* and *The New World.* Ethel Barrymore acted in one without salary."

–JANE COWL, ACTRESS

"Groups of players can reach the [military training] camps and give them entertainment which will keep them in touch with home and the things they've given up and will tell them more forcibly than anything else that this is a mission of brotherly love and a tribute of our appreciation. It will help carry them over the hard hours of boredom and homesickness and the ghastly temptations which loneliness brings and above all it will prove that the theater holds something more than art and commercialism and can carry a message of love and healing on its wings."

–RACHEL CROTHERS, THE NEW YORK TIMES, MAY 27, 1917

ABOVE, LEFT: *The Stage Women's War Relief raised an astonishing $7 million for the war effort in part by hosting fundraisers like the presentation of the play,* When a Feller Needs a Friend.
OPPOSITE PAGE: *A wounded soldier helps Chrystal Herne pin up the Stage Women's War Relief poster designed by James Montgomery Flagg. The illustration came to define the theater community's response to World War I.*

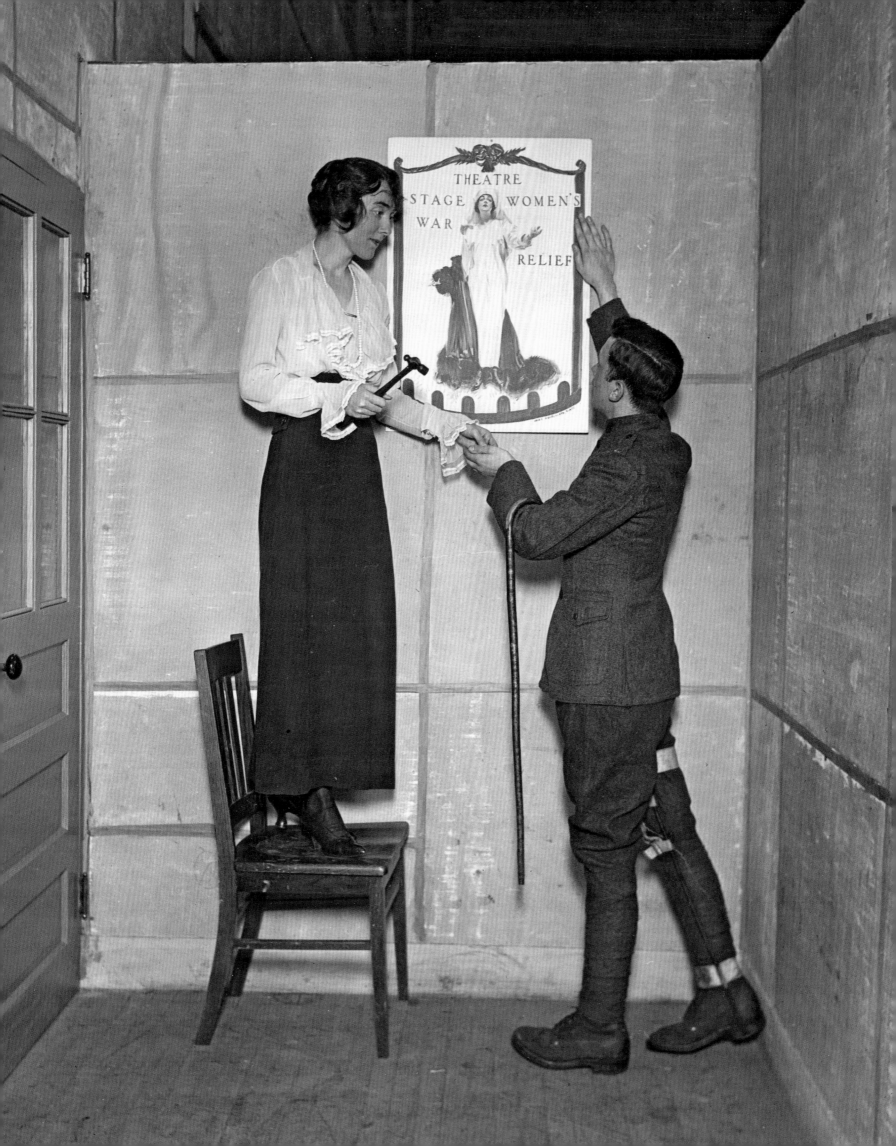

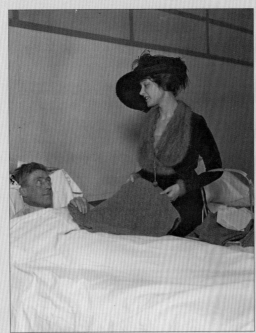

"Some wonderful boys and myself were being photographed at the Debarkation Hospital at the Grand Central Palace in New York. One of the boys kept trying to back his chair out of the picture. When the photographer protested, the boy said, 'I am ashamed to show the leg,' pointing to a stump from which the lower leg had been taken. I said, 'If I had a leg like that, gained as yours was, I'd be so proud of it I wouldn't speak to anyone.' The boy sensed the genuineness of my remark and was cheered. Their suffering seems more than balanced by their sense of having served their country."

—FLORENCE NASH, ACTRESS

"Can you see all right?" I asked one with a foot wound, longing to bring him a chair but wanting him to realize that he was as much a cavalier as ever.

"Can see fine. Won't you rest yoah coat, lady?"

"Ah, from the South?"

"Carolina, yes ma'am."

One could not ask him which Carolina. There was only one to him.

"This heah's the first troupe I've seen in seven months. They do shine!"

—LOUISE CLOSSER HALE AT THE STAGE WOMEN'S WAR RELIEF THEATER AT THE DEBARKATION HOSPITAL NO.5, NEW YORK

"As one of the many boys who have enjoyed the efforts of the Stage Women's War Relief, may the undersigned call your attention to the war work rendered by Miss Grace George. Rain or shine, summer or winter, she has been on her job and she is the idol of the lonesome soldier, who has found no place to go for his weekend."

—A LETTER TO THE EDITOR OF THE TRIBUNE SIGNED "A SOLDIER"

ABOVE: *Elsie Ferguson was among the many volunteer actresses who tended to wounded veterans at the Debarkation Hospital No.5.*
LEFT: *The Stage Women's War Relief provided entertainment, visits and outings for the war wounded.*

"**IN ALL OUR HISTORY, WE HAVE YET TO HEAR AS A RESPONSE TO OUR APPEAL THE EXCUSE, 'WE ARE TIRED.'**"

–*Daisy Humphreys*

ABOVE: *Famous actresses such as Jane Cowl accompanied the war wounded on excursions to the countryside.*

"**Private motor cars were arranged to convey the seriously wounded boys from the hospital to an estate within easy motoring distance from New York. Their chairs were taken out by the Motor Corps and placed on the lawn beneath the trees. The boys look forward eagerly to these outings and it is astonishing to see what a difference even one day in the open makes in their outlook on life. One boy, who'd been operated upon sixteen times, and with the seventeenth to follow after the picnic said, 'Well, I had one good day anyway.'**"

–DAISY HUMPHREYS

"When Mrs. Patricia Henshaw and Dorothy Donnelly [of the Stage Women's War Relief] found that I was a dispatch rider and exposed constantly to all kinds of weather they gave me one of the windproof vests which had been given to them to distribute. The day they gave it to me was one of the raw, damp kind that is so common in France. The next day, on my 306-mile ride, I wore the vest and it was the first time that I have to ride so far that I had been in any way comfortable."

–CORPORAL JAMES F. ARBUCKLE,
12TH SERVICE SIGNAL CORPS,
AMERICAN ARMY IN FRANCE

"The villagers, exiled by war, were returning to rebuild their homes in the little village of Arcy [France] when the Stage Women's War Relief played Santa Claus. The pitiful lack of all that goes with the season went to the heart of Dorothy Donnelly, The Stage Women's War Relief representative in Paris. As a result Christmas came to Arcy with a Christmas tree place in a manger of an old stone barn. Every child received a toy, a scrapbook and at least one warm garment. Each mother was given a dress length of woolen material and a bowl of sugar."

–Mrs. Raymond Brown,
president of the New
York State Women's
Suffrage Association

"Dear Mrs. Crothers,
Please find my check for $2,000,
one-third of the first royalty
statement from M.Witmark
& Sons for my song, 'When
You Come Back'...to be used
for the entertainment of
the returning soldiers."

–George M. Cohan, actor,
playwright and composer

ABOVE: *George M. Cohan was the "Head Abbott" of the Friars Club when the club offered this 1919 fundraiser for the Stage Women's War Relief. Even though armistice had been declared, the work continued on behalf of the many wounded soldiers and suffering civilian population both "here" and "over there."*

33

By the Numbers
The Wing's World War II Efforts

$25,000

Estimated cost of turning Justine Johnson's dilapidated Little Club on West 44th Street into the Stage Door Canteen

$300

Actual cost of the renovation due to free union labor

3,000,000

G.I.s who visited the Canteen

2 Number hours that a G.I. could stay at the Canteen

7% Percentage of blacks to whites at Stage Door Canteen

1 Number of racial incidents at the Canteen

10 Number of hostesses out of 14,500 who declined to dance with African-American soldiers

16,100,000
Americans who served in World War II

405,000
American soldiers killed in World War II

672,000
American soldiers wounded in World War II

ABOVE: *P.F.C. Howie Bruno sends a postcard from the Washington, D.C. Stage Door Canteen.*

3,000-4,000

G.I. visitors on first day of the Stage Door Canteen , (500 were expected)

17-20¢ Cost of feeding each soldier per week because of food donations

6,000
Volunteer junior hostesses at the Canteen

4,500,000
Miles danced by junior hostesses with G.I.s

438,000
Annual number of half-pints of milk drunk at the Canteen along with **720,000** sandwiches, **1,000** pounds of fruit, **5,000** pounds of candy and **55,000** cakes and pies

ABOVE: *A Food Check issued on 6/30/1944 gave the soldier a sandwich, milk, dessert, coffee and some motherly loving care from the kitchen staff. They were cautioned to eat everything they took—which was not a problem.*

21 *Rules governing hostesses' behavior with* G.I.s *(i.e. "Do not eat any of the food")*

29,050
Service women, who were not allowed in the Canteen, who enjoyed Sunday tea dances at the Roosevelt Hotel

$4,500,000
Box-office gross of the 1942 film hit, Stage Door Canteen

$2,277,857.23
Film royalties to the Canteen

6,000
Number of volunteers dispatched to entertain wounded vets at twenty-five hospitals and army bases in the year after World War II

9,000,000
Theater tickets donated to servicemen

241
Number of actors who appeared in 2,016 performances of the Victory Players

494 Number of Community Players performances in 166 plays

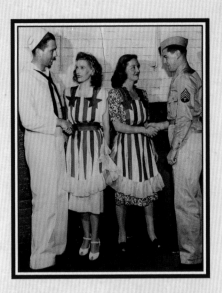

ABOVE: *Bette Davis and Helen Menken, who would later lead the American Theatre Wing, were among the celebrity hostesses at the Canteen.*

2,000
Speeches given by **300** voulnteers with the Speakers Bureau at war rallies

306 Number of returning G.I.s who started classes at the Wing's Professional Training School in 1946

1,120
Number of G.I.s in the second session in 1947 with Oscar Hammerstein teaching musical writing, Agnes DeMille instructing dance, and Robert Anderson, playwriting. Among the alumni were George Burns, Bob Fosse, Charlton Heston, William Warfield and Jason Robards, Jr.

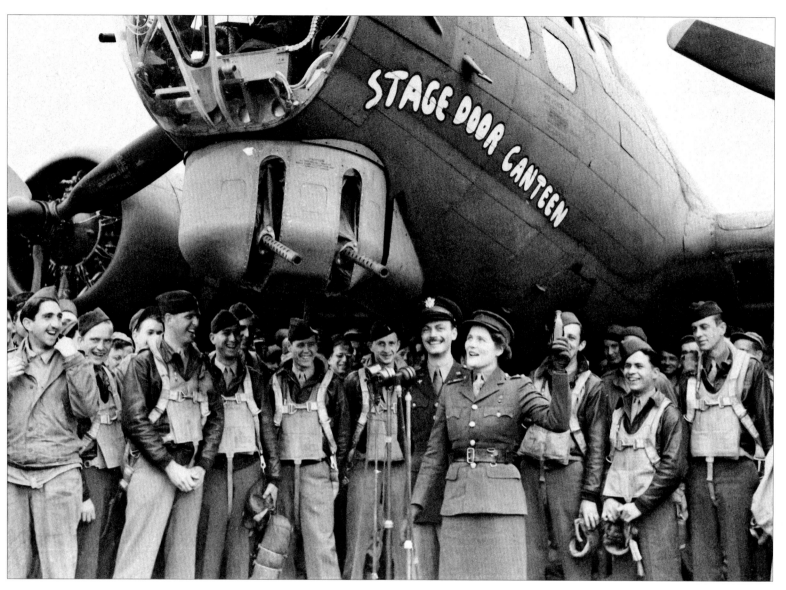

ABOVE: *In April of 1944, Lt. Mary Churchill, Winston Churchill's youngest daughter, christened this B-17 "Stage Door Canteen," indicative of just how far and wide the club's fame had spread.*
OPPOSITE PAGE: *Katharine Cornell and Guthrie McClintic arrive in Europe with the Wing's Victory Players to present* The Barretts of Wimpole Street *to soldiers fighting in the field.*

"Gents. I give you woman! Let us propose [a toast] in honor of the good ladies of the American Theatre Wing. Since January, 1940, they have been working away at war relief on a war basis, sewing and knitting garments, collecting money and second-hand clothes impartially and dispatching everything to England. Last Autumn a men's committee was organized under Gilbert Miller's chairmanship.

It made deep masculine sounds for about two months before getting down to work. But the impractical and glamorous ladies of the stage, who are commonly suspected of being helpless, inefficient and vain, have been carrying on for more than a year without benefit of champagne or orchids."

—BROOKS ATKINSON, THE NEW YORK TIMES

"I am commanded by Queen Mary to tell the members of the American Theatre Wing how deeply her majesty appreciates the splendid work they are doing to help Great Britain in her desperate struggle to save the liberty of the world."

—CONSTANCE MILNES GASKELL, BUCKINGHAM PALACE

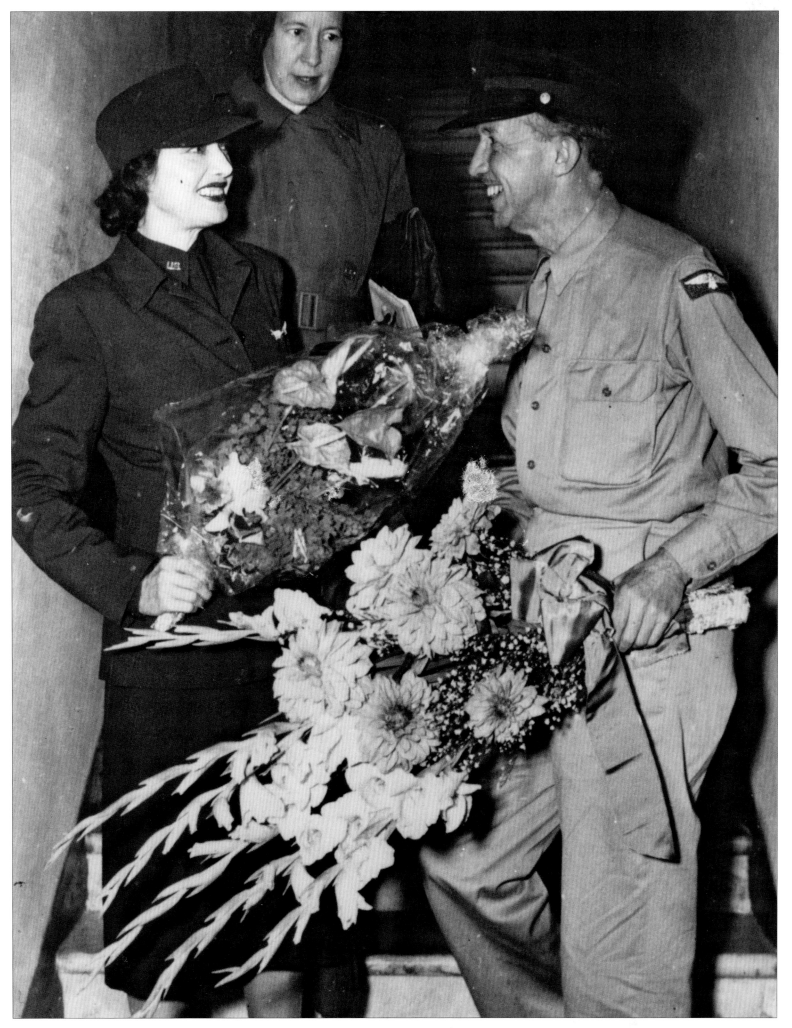

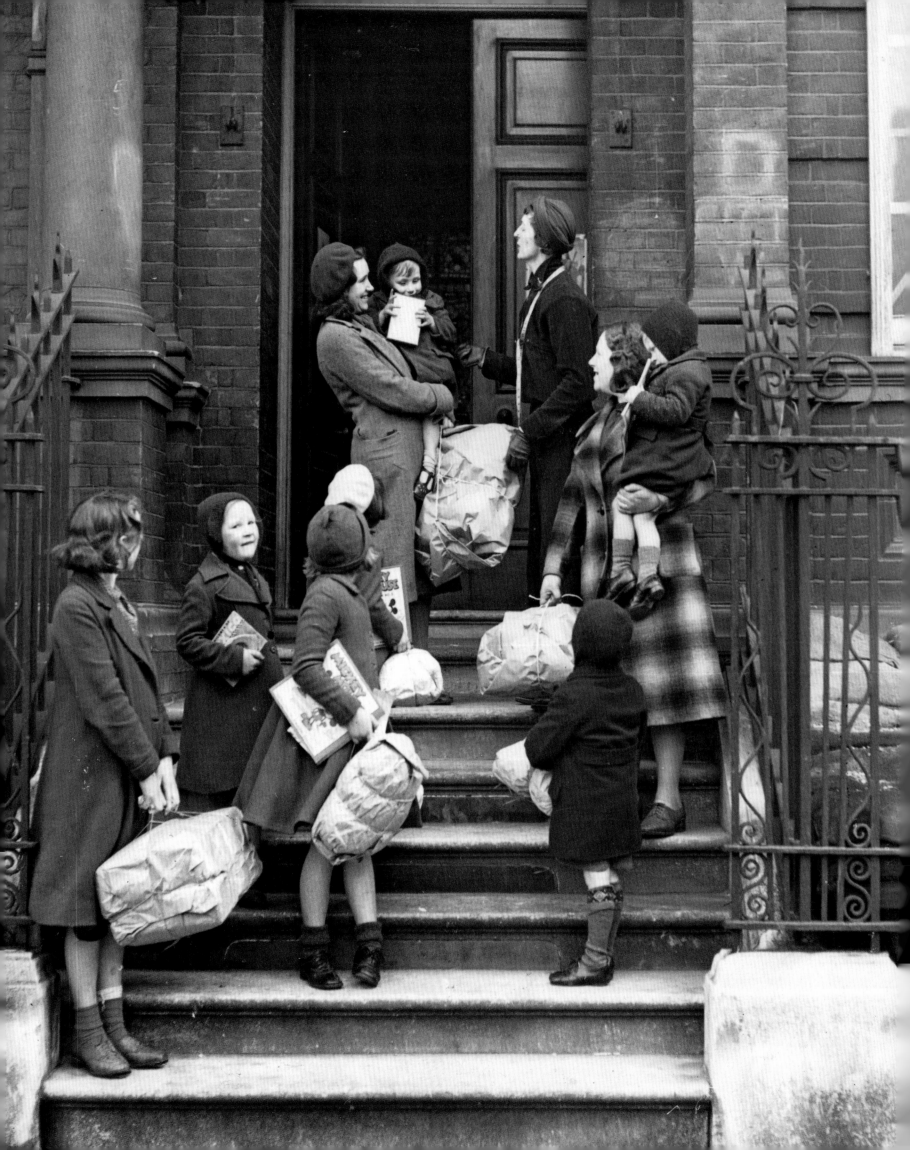

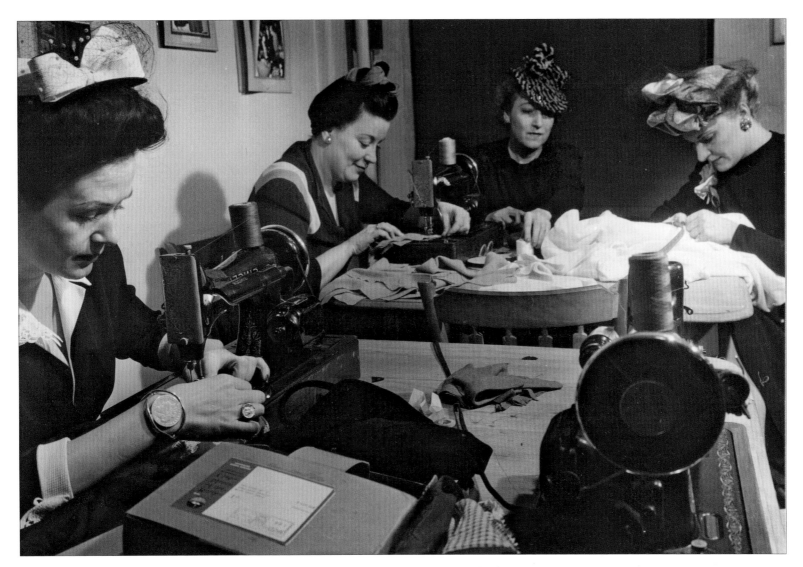

ABOVE: *Even before Pearl Harbor and the U.S. entrance into World War II, the American Theatre Wing had mobilized to provide support for allied troops and refugees. Women worked sewing machines to aid the effort.*
OPPOSITE PAGE: *The American Theatre Wing responded to the growing crisis in Europe and the existential threat to Great Britain by sending packages to those devastated by the war. They also raised funds and took in refugees, especially the children of actors. Mary, the Queen Mother of England, praised the care packages provided by the American Theatre Wing to Blitz-bombed London.*

"This is again war with the old enemy—an enemy twenty years stronger, twenty years more inhuman, twenty years more skillful in the art of killing. We are determined to use the power of the theater to its full strength to help save England and thereby America."

–RACHEL CROTHERS,
PLAYWRIGHT, CO-FOUNDER
OF THE AMERICAN THEATRE
WING, JANUARY 1940

"Your quite magnificent case of clothing has just been unpacked by us. I can assure you many an exclamation of delight came from the unpackers as useful and excellent garment after garment was taken out. The tax on our resources is tremendous…so very many victims of air raids, dependents of our fighting men without clothes. Will you please thank those who are responsible for this noble gift?"

–LETTER FROM HONORABLE
SECRETARY NORA E. SHAW OF
THE SOLDIERS', SAILORS' AND
AIRMENS' ASSOCIATION

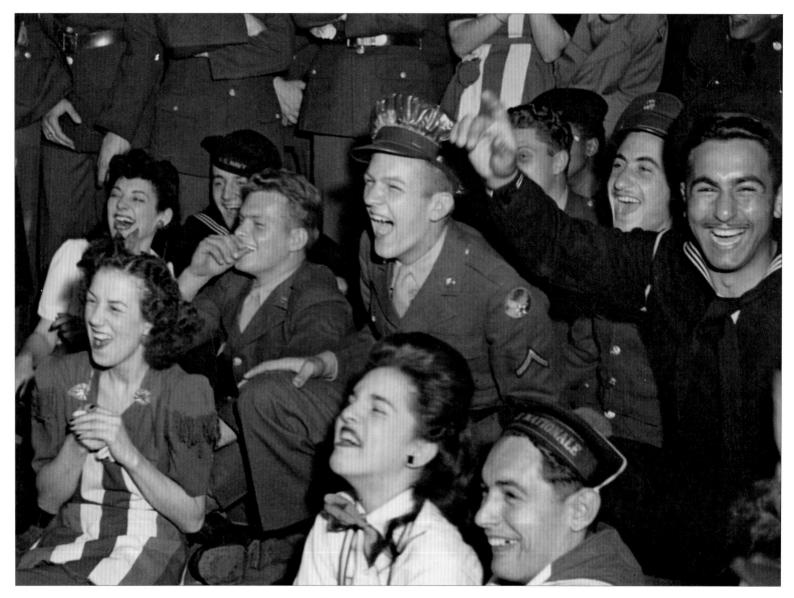

ABOVE : *Soldiers, who gathered at the Stage Door Canteen, were there for the laughs and the girls, and let it be known patriotic songs and tributes to their sacrifices bored them.*

OPPOSITE PAGE: *Marlene Dietrich plays hostess at The American Theatre Wing's Stage Door Canteen in Paris, one of eight satellites of the club which was first established in Times Square in 1942. The canteens gave allied soldiers a respite from the cruelties of wars and became, in the words, of Eleanor Roosevelt, "...the finest of all contributions toward war morale."*

"We call it a canteen but it's really going to be a nightclub. There will be something doing from five to midnight every night. Everything will be free to any man in a service uniform. Everything is being freely given, the place, the decorations, furnishings, work, food, drinks. We're having only two paid workers, a dishwasher and a cleaner. On busy nights, you'll probably find us back in the kitchen helping with the dishes or making sandwiches. Our crews are signed up for weeks ahead. 1500 girls from stage, screen and radio are signed up. Three shifts, ninety in all, will be there each night. When the spotlight goes on for a star on the stage, it will be a surprise appearance."

–SELENA ROYLE, ACTRESS

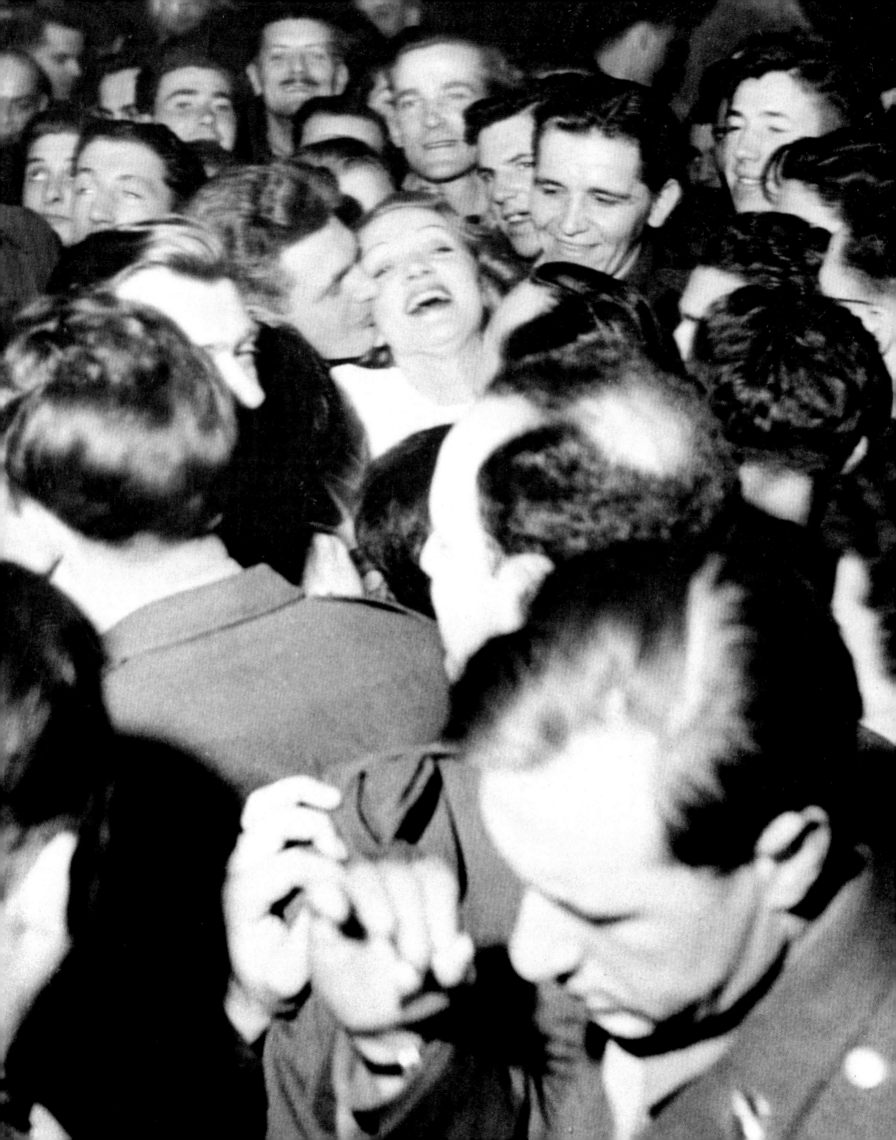

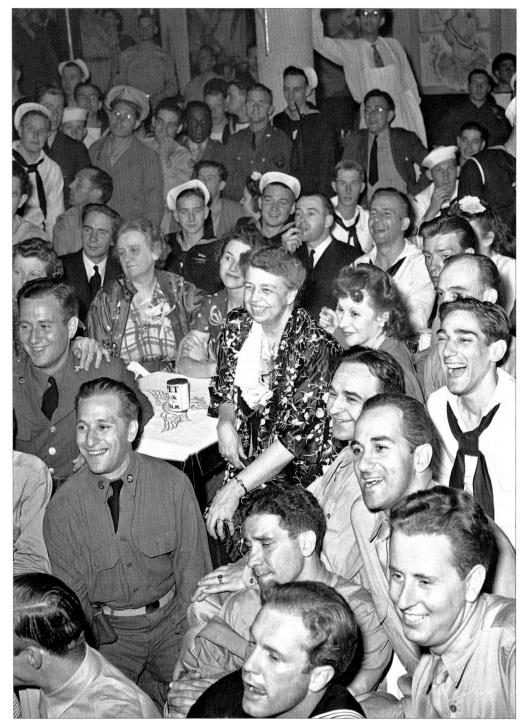

ABOVE: *First Lady Eleanor Roosevelt was a frequent guest at the Stage Door Canteen, here pictured with popular actress Greer Garson.*

ABOVE : *Popular actress Helen Menken, who would later serve as president of the American Theatre Wing, enlists a soldier and man's best friend to raise funds for the Stage Door Canteen.*

"It was like spontaneous combustion. Many bright minds all working together. You know how theater people are. We'll put this [Stage Door Canteen] over. If the crowd becomes too big, we'll open another."

–JANE COWL, ACTRESS

"NO LIQUOR, BUT DAMNED GOOD ANYWAY."

–A sailor waving signal flags to another ship regarding the Stage Door Canteen

"These people are not going to applaud and go haywire with delight simply because you're coming to see them. They're the toughest kind of audience; they know exactly what truth and falsehood are. They will applaud only that which is sincere and given with the whole heart. Then their applause is the most wonderful to behold, for a performer, of any audience you can name."

–HELEN MENKEN, ACTRESS

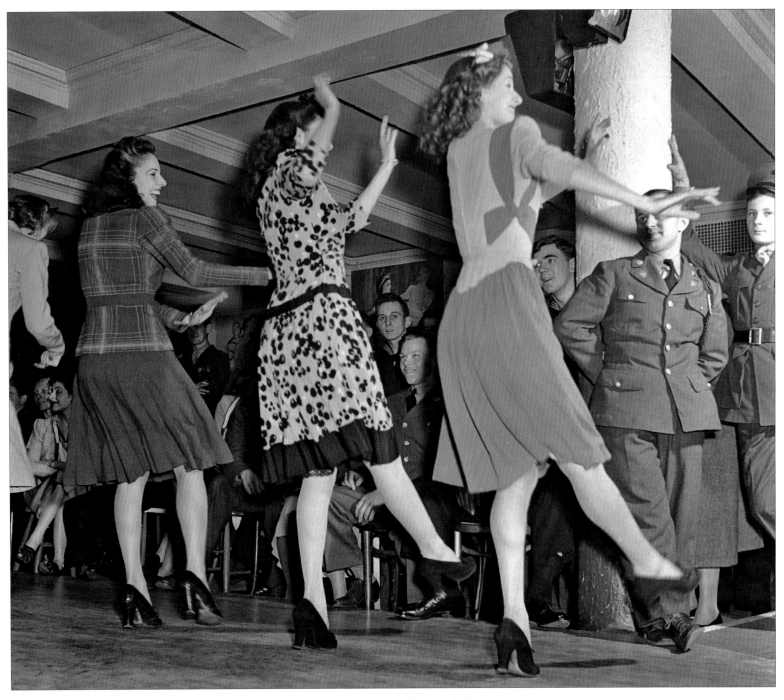

ABOVE: *The soldiers who crowded into the Stage Door Canteen came for a snack, music, celebrities and, of course, beautiful girls. Here they perform a number from the Olsen and Johnson revue,* Sons of Fun.

"I wish someone would send us a cow—a whole cow. Wouldn't it be lovely if some nice, generous man would do that? We're going to need an awful lot of milk at that bar. Our biggest surprise was finding out what a great number of milk drinkers are among our fighting forces... Almost unanimously they said they preferred milk when we asked about drinks. It seems that tastes have changed since the other world war."

–JANE COWL, ACTRESS

" 'Girls and Music': That's our slogan. And, believe me, that's what the boys on leave are after."

–BROCK PEMBERTON, PRODUCER, CO-FOUNDER OF THE AMERICAN THEATRE WING

ABOVE: *Bette Davis was on hand to boost the morale of the troops at the Stage Door Canteen.*
OPPOSITE PAGE: *Ingrid Bergman's star was on the rise when she served the boys at the Stage Door Canteen.*

"[Antoinette Perry] greets everyone as if he [or she] were the one on whom the whole organization depended. She gives the impression of a woman in the presence of a miracle— about to burst into tears at the sheer splendor of it."

– GORDON MERRICK, JOURNALIST

"I became familiar with the American Theatre Wing early on because I remember my mother [Ingrid Bergman] talking about going to the Stage Door Canteen. The people there were young and my mother was Swedish and probably hadn't been accustomed to American views. She always said it was great fun. The men were pleased to be dancing with famous actors, though some were not so well known. My mother was just beginning so it wasn't as though she was a movie star yet. Later, in 1947, she starred in her first Broadway play, *Joan of Lorraine*, by Maxwell Anderson and she won a Tony at the very first awards ceremony. It was a compact in those days. I still have it. Joan of Arc was someone who had fascinated my mother for years. I'm not quite sure why but it has something do with a young girl who gets an inspiration to go on and do something magnificent and heroic."

–PIA LINDSTRÖM, AMERICAN THEATRE WING TRUSTEE

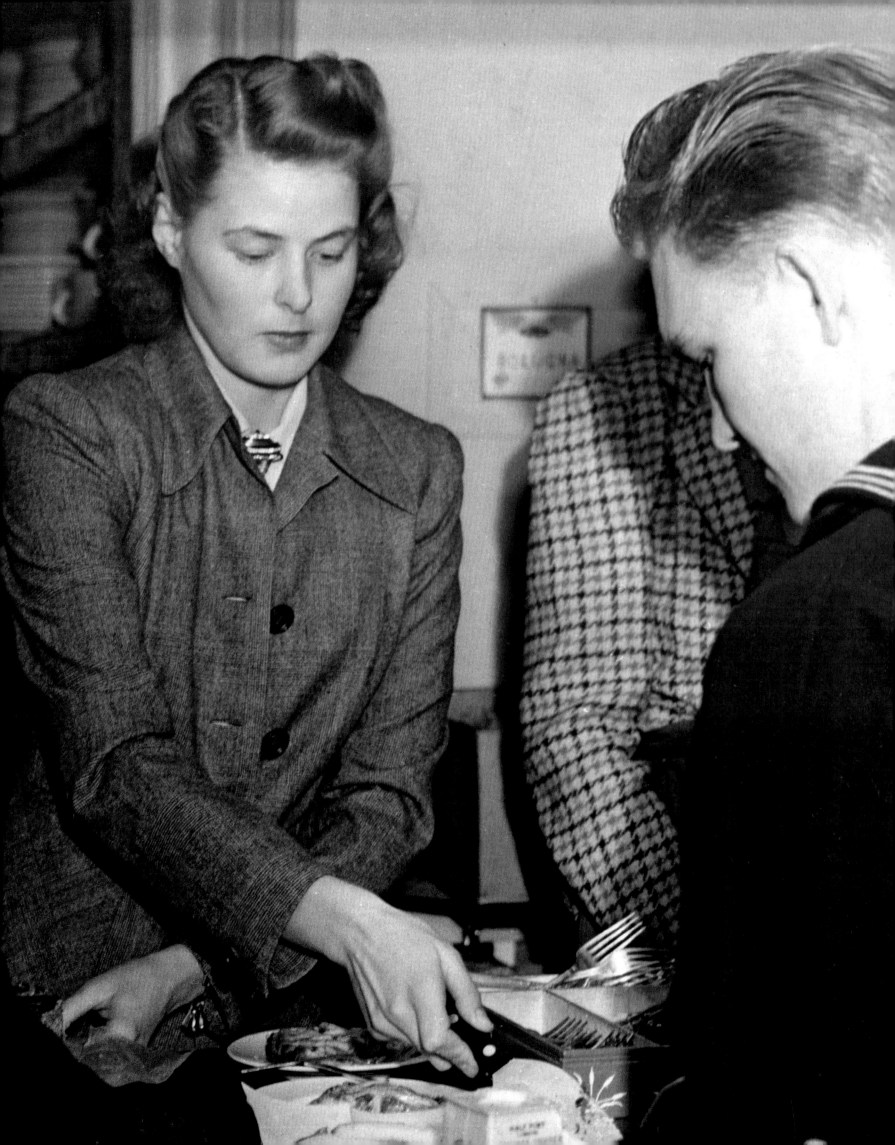

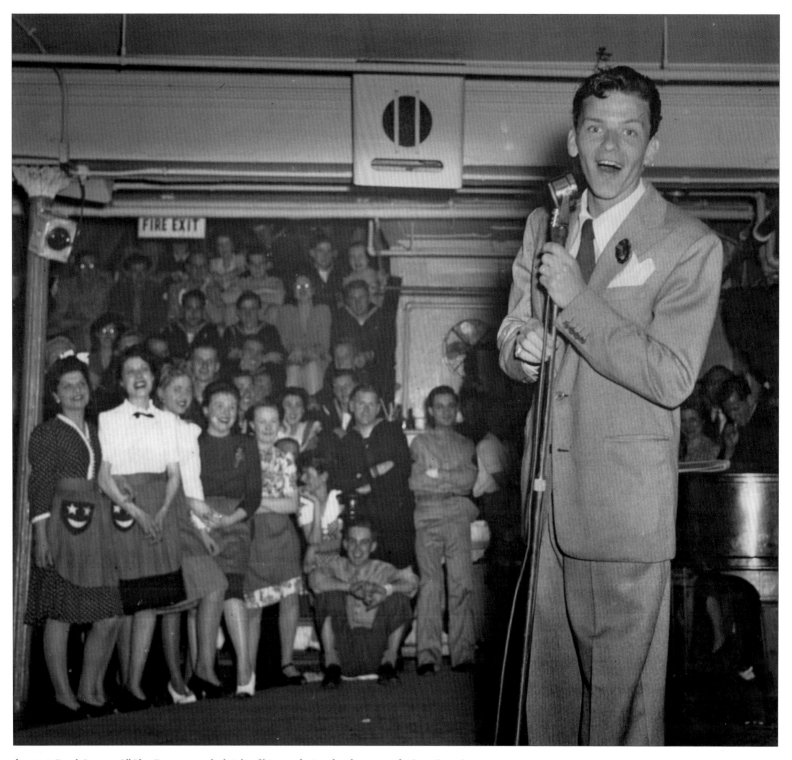

ABOVE: *Frank Sinatra, Ol' Blue Eyes, was at the height of his popularity when he sang at the Stage Door Canteen.*
OPPOSITE PAGE: *John Carradine, who gave rise to an acting dynasty, appeared at the Stage Door Canteen and a young Lauren Bacall looks captivated.*

"Almost every night many of us were in tears. We all knew many of the guys we were dancing with were not going to make it back alive."

—EDYTHE FREEMAN,
JUNIOR HOSTESS

"Private Alfred Cohen had entered the canteen on crutches, and left without them, thanks to a therapeutic dance with junior hostess Marjorie Greenstein."

—"DANCE CURES WOUNDED G.I."
THE NEW YORK SUN, JUNE 6, 1945

"Many of the [servicemen] had girls at home, were homesick, and would transfer their attentions to one of us out of loneliness and need."

—LAUREN BACALL,
JUNIOR HOSTESS.

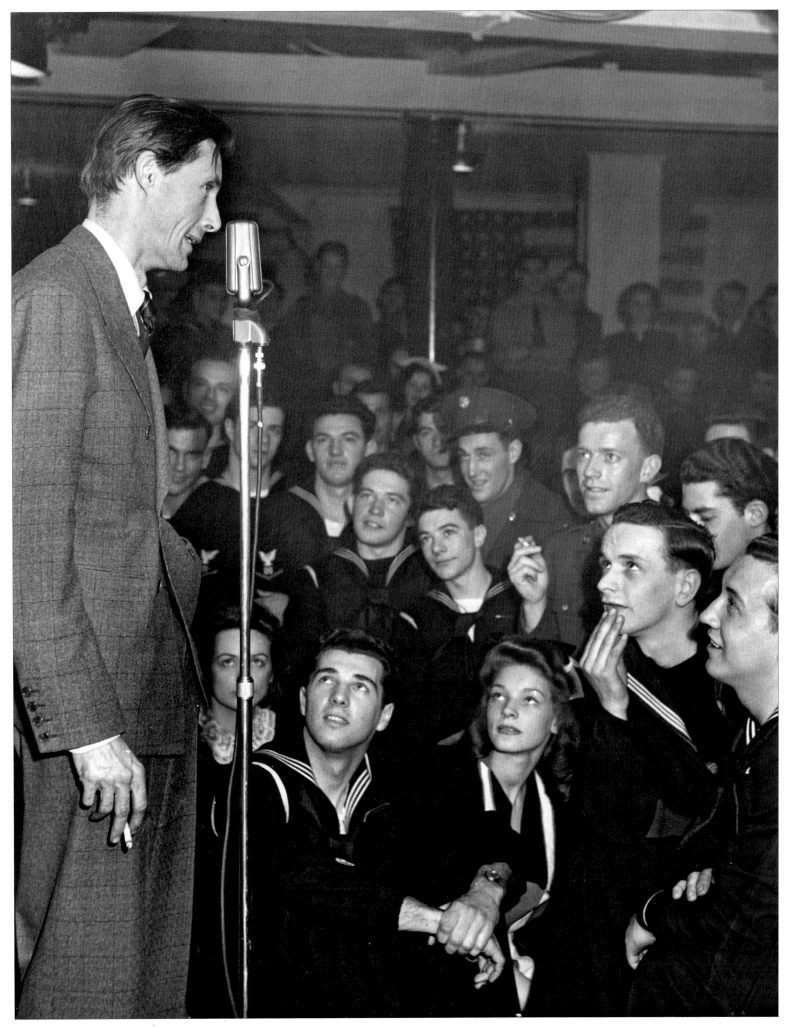

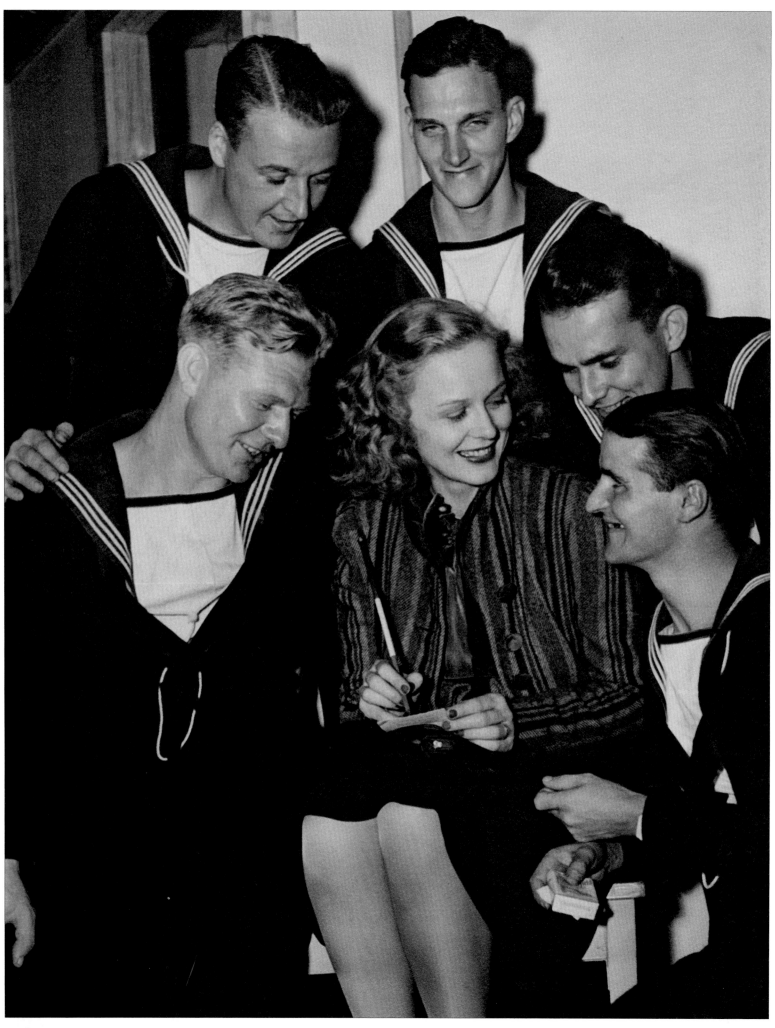

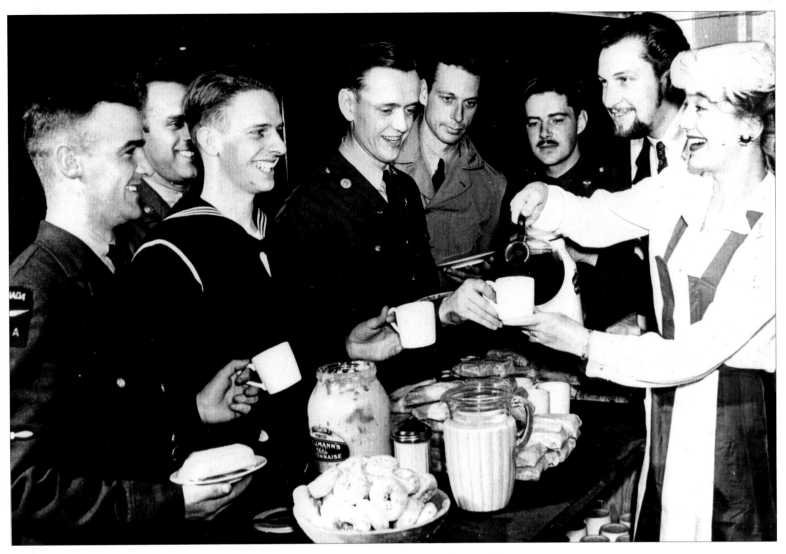

ABOVE: *Gertrude Lawrence, one of the most frequent celebrity hostesses, pours coffee for the boys at the New York Stage Door Canteen.*

BELOW: *In March of 1943, the legendary photographer Weegee caught this couple dancing, labeling it simply, "The Boy from the Richielieu meets girl at Stage Door Canteen."*

OPPOSITE PAGE: *Gloria Stewart signs autographs for an adoring group at the Stage Door Canteen. Decades later, at 87, the actress was nominated for an Oscar for her stunning turn in* Titanic.

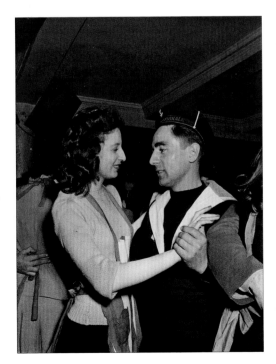

"Most of the servicemen who visited were leaving for the front any day and they wouldn't be coming back. That's what the intensity was, most of the time. Every time you went you had a lump in your throat, or I did, anyway."

—GLORIA STROOCK, JUNIOR HOSTESS

"We should be proud of the chance to prove ourselves worthy of the cause others give their lives for. For us to praise ourselves because we have given one extra performance and so made a youth laugh once more before he went aloft to die for us is not a 'sacrifice' on our part. It is an entertainer's proud privilege!"

—GERTRUDE LAWRENCE, ACTRESS, TONY AWARD WINNER, *THE KING AND I*

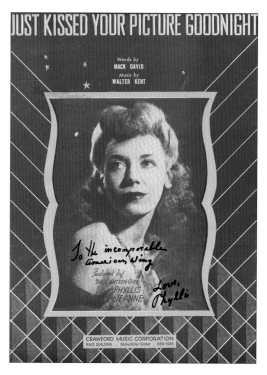

"There is something psychological in a cigarette to a soldier. Nothing else takes it place."

—CAPTAIN MORRISON
AT A BENEFIT FOR THE
ATW'S TOBACCO FUND

ABOVE: *Matchbook covers promoted everything from war relief for Britain to Philadelphia's Stage Door Canteen.*
BELOW: *Helen Hayes, who served as the Wing's president in the 1950s, was featured on some of the postcards given to soldiers.*
RIGHT: *Phyllis Jeanne Creore, a Stage Door Canteen hostess, also had a radio show which featured the signature song, "I Just Kissed Your Picture Goodnight."*

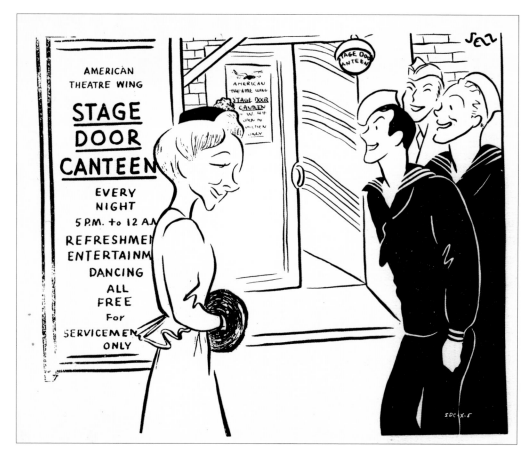

"I was living at the Rehearsal Club and you signed up once or twice a week for the Stage Door Canteen when you could get away from an audition or a rehearsal. The [soldiers] were only seventeen, some of them, and they were scared and homesick. But there was good food, stars cooking hamburgers and hot dogs."

—PHYLLIS JEANNE CREORE,
JUNIOR HOSTESS

"Young Chinese flyers, be-turbaned bearded Hindus in R.A.F. uniforms, and Negro sailors mingle with American-Japanese soldiers from Hawaii, Polish aviators, blond Dutch seamen and American boys from Texas, Missouri and your hometown."

—FRANCES PAELIAN, PORTRAIT ARTIST AT THE STAGE DOOR CANTEEN

"When I told them I was Jewish, they were stunned. One asked me to stand so he could get a look at me and they studied me from head to toe. Finally, one said, 'You're not bad for a Jewish girl.' I wasn't offended. They were expecting to see horns on me and when they didn't, it was a new experience, an insight."

—MILDRED CLINTON, JUNIOR HOSTESS

"Canteen officials were dealing with very volatile stuff. Not only young people but people involved in war and loss and hurt. Also, nationally the whole image of ourselves. And hormones. And music. And heat. It was a very potentially explosive kind of environment."

—JANE WHITE, JUNIOR HOSTESS, ACTRESS AND DAUGHTER OF WALTER WHITE, EXECUTIVE SECRETARY OF THE NAACP

"I hereby pledge to uphold and further all principles of the American Theatre Wing Stage Door Canteen in my capacity as a Canteen worker. I will not pass on any military information and I will not practice nor permit any discrimination as to race, color or creed."

—PLEDGE CARD SIGNED BY JUNIOR HOSTESSES

"I can remember dancing with a black man for the first time in my life, and nobody did or said anything about it."

—PHYLLIS JEANNE CREORE

"At thirty-one, thirty-two, you are regarded by a canteen clientele which is mostly ten years your junior as too old to be interesting, but not quite withered enough to pinch for Dear Old Mom."

—MARGARET HALSEY, CAPTAIN OF THE JUNIOR HOSTESSES

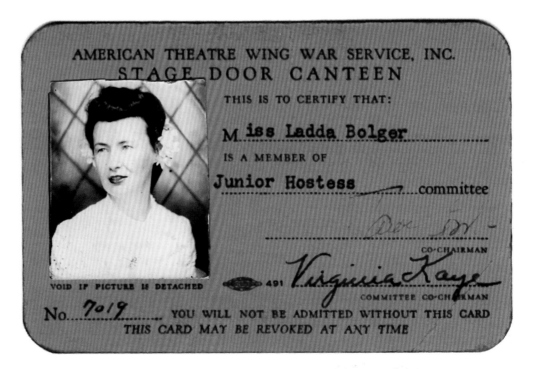

ABOVE: *Miss Ladda Bolger was one of the 1500 young women of the theater who signed up to be a volunteer hostess. She and her peers were strictly counseled to follow the many rules, including not dating soldiers outside the club and dancing with black soldiers if asked.*

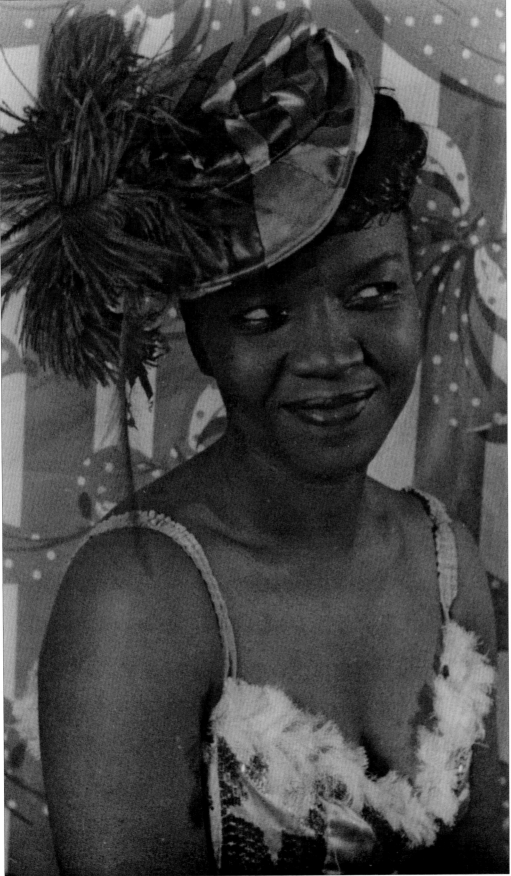

"A lady on the kitchen committee knew I was a singer. There were a lot of white singers at the Canteen but very few black singers. Most played clubs in Harlem. I came in and sang songs from a show I was in and it went over very well. I stayed to dance with the soldiers and soon I was called to be a hostess. They didn't try to have integration—they did it."

–ROSETTA LENOIRE, SINGER

"THE PURPOSE OF THE STAGE DOOR CANTEEN WAS TO PROVIDE 'SOUL SERVICE.'"

–Natalie J. Biro, Canteen News, March 8, 1945

ABOVE: Rosetta LeNoire, here in a Carl Van Vechten portrait, was invited to sing at the Stage Door Canteen as one of the few African-American performers and stayed on as a hostess.
OPPOSITE PAGE: Osceola Archer, the captain of the African-American hostesses at the Stage Door Canteen, greeted both black and white soldiers, many of whom were mixing together for the first time in their lives.

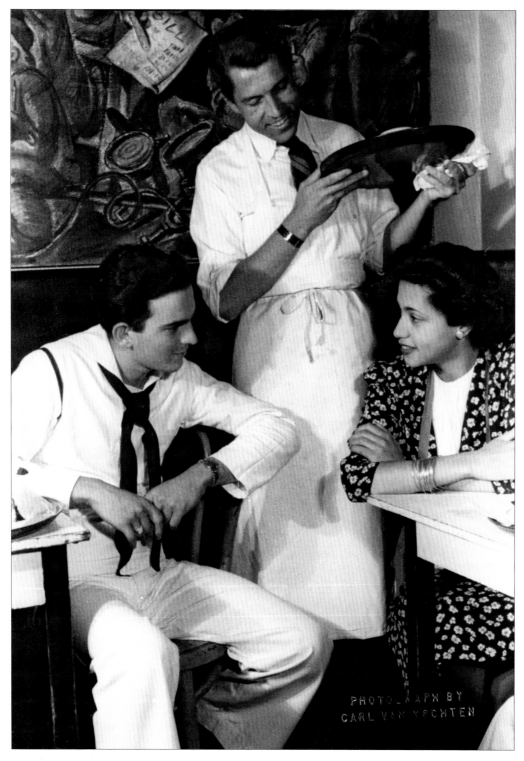

ABOVE: *Jane White, whose father Walter White was the executive secretary of the NAACP, was a hostess at the Stage Door Canteen which instituted an interracial policy six years before the armed forces were integrated.*

"When a group of white American South soldiers saw a white hostess fraternizing with a black soldier, one of them let it be known that 'it only costs thirty-five dollars to kill the bastards.' The [hostess] captain used her head. With the speed of light, she rounded up every white hostess she could lay her hands on, and then she and the other white girls descended on the Negroes' table like rooks coming home at twilight. The Negro soldiers virtually disappeared from view in a cloud of white girls...."

–MARGARET HALSEY, CAPTAIN OF THE JUNIOR HOSTESSES

"The Canteen helped black servicemen, frustrated and furious from the experiences in the Southern army camps to visualize democracy. Many of them were experiencing it for the first time in their lives at the Stage Door Canteen. So were many white servicemen."

–OSCEOLA ARCHER, CAPTAIN OF AFRICAN AMERICAN HOSTESSES

"The Canteen was a strong example of integration because it violated an obvious, widely-recognized taboo of black men dancing with white women, not because black women danced with white men."

–CARL VAN VECHTEN, LETTER TO LANGSTON HUGHES

"Action which could only be designed to promote the mongrelization of this country has been demanded of the junior hostesses at the Stage Door Canteen. Margaret Halsey, captain of the junior hostesses, ordered the white girls serving as hostesses to dance with Negro soldiers and to accept them as their social equals."

–Theodore G. Bilbo,
United States Senator

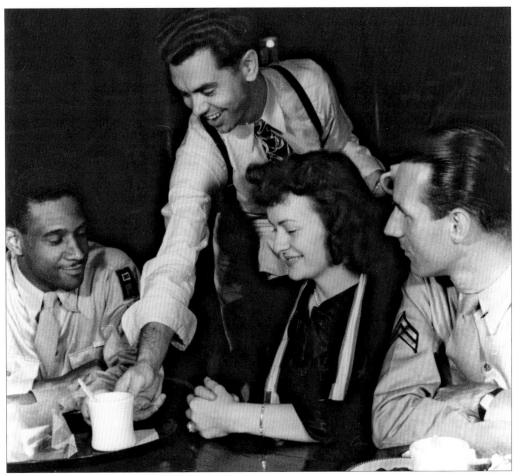

"The Stage Door Canteen fame has traveled into many lands and been heard about upon more battlefronts than you were ever to imagine. It has done much to warm the hearts of these men who—if, as, and when they die—give their lives for the Klan, the Gerald L.K. Smiths, the Rankins, the Bilbos and the rest of the intolerant, blind, Fascist, undemocratic America, as well as for the finer element. We can take it. But we are so glad to know that at home there are a few brave souls that want to put into practice those four freedoms of the Atlantic Charter which are [being written] down with our life's blood."

–African American corporal
to Margaret Halsey

Top: *Senator Theodore Bilbo of Mississippi objected strenuously to the interracial policy at the Stage Door Canteen, denouncing from the well of the Senate the "mongrelization" that was going on there.*
Bottom: *At the Stage Door Canteen, racial equality was the norm six years before President Truman integrated the armed forces. Moreover if an African-American soldier asked a white woman to dance, she was instructed to do so without reservation.*

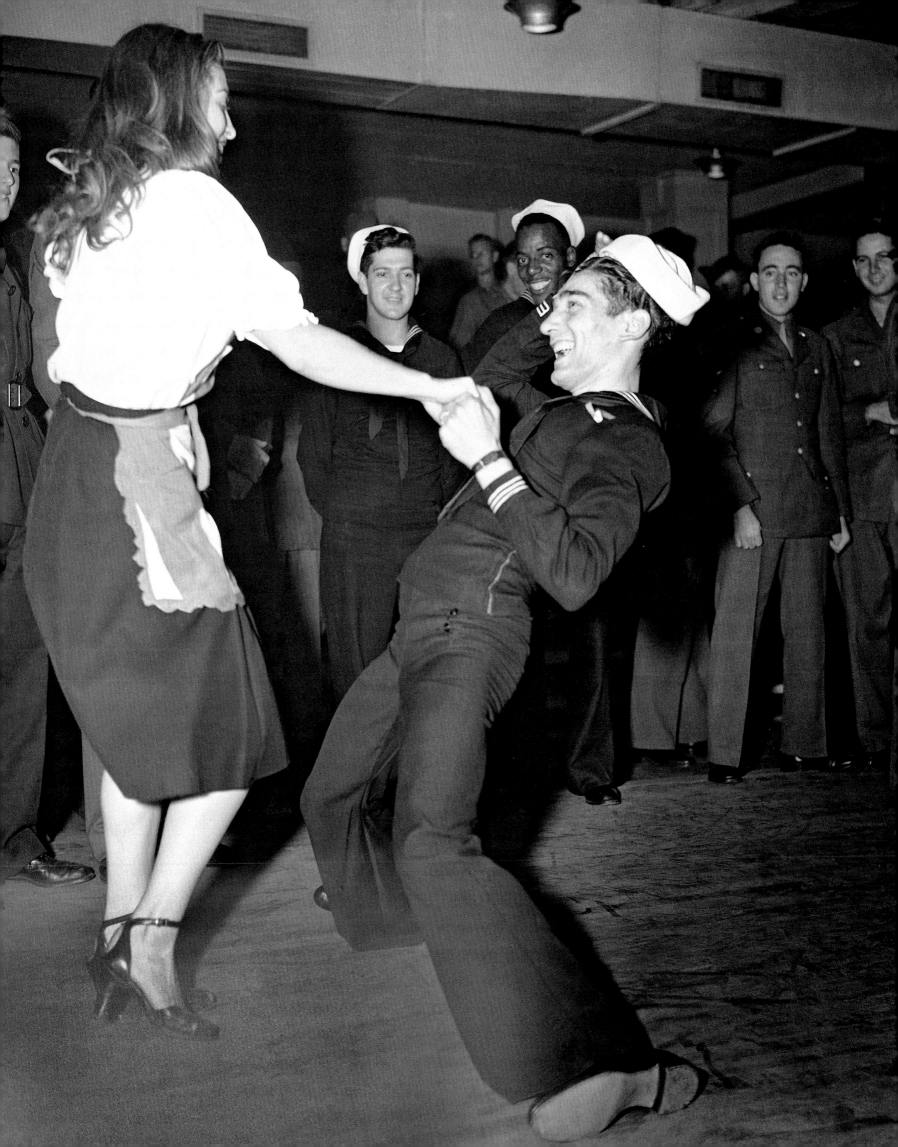

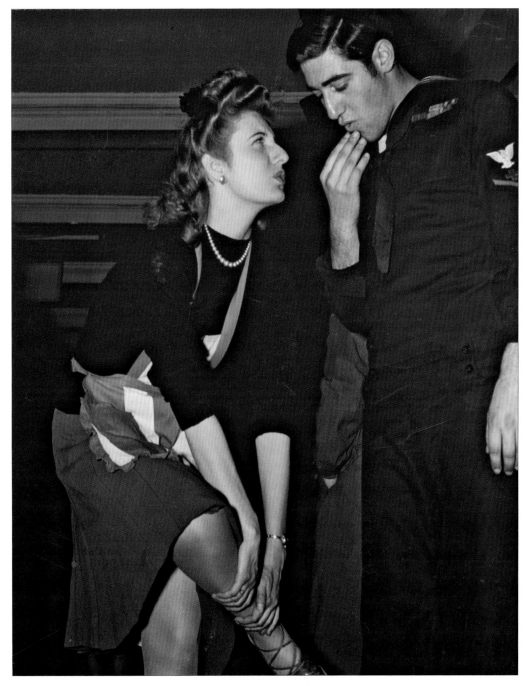

"The morale could not be better. They are tough but not subdued. Even the wounded are gay and humorous. The best Jitterbugs will often be wearing Purple Hearts or even Presidential Citations. Best of all, they make the Canteen the first stop on their return."

–Isadora Bennett,
Dance Publicist

Above: *"I'm getting corns for my country," was a rallying cry for the hostesses who cumulatively danced 4.5 million miles in the course of the war at the Stage Door Canteen*
Opposite Page: *A hostess jitterbugs with a sailor affectionately known as "Killer Joe," Piro a frequent guest at the Stage Door Canteen.*

"During All the Combat Days of the War Between the United Nations and the Axis Powers, The American Theatre Wing Stage Door Canteen Occupied This Site. This Tablet is Dedicated to Men and Women of the Entertainment World Who Brought Cheer and Comfort to Soldiers, Sailors and Marines of America and Her Allies."

–Plaque placed on March 29, 1979 at This Site of the Stage Door Canteen by the New York Times

"I was no longer alone. I was with people. I became me again—I became me!—Thank you. Stage Door Canteen, thank you so much—I was lonely."

–Letter from soldier Herbert Chessen, March 19, 1944

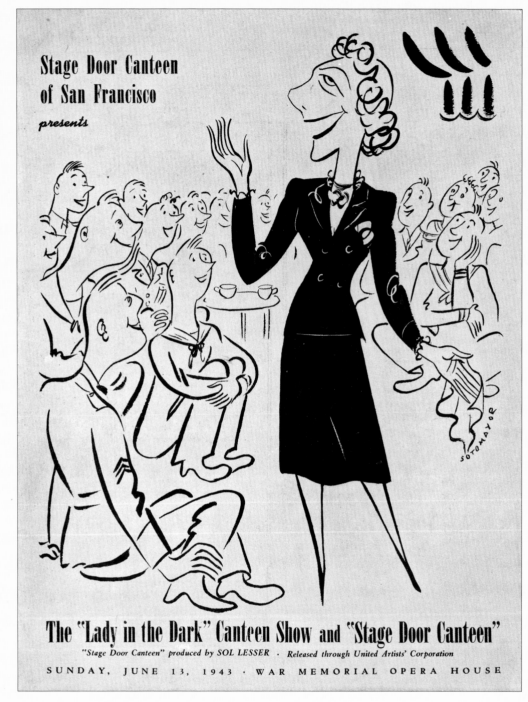

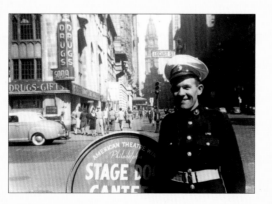

ABOVE: *Gertrude Lawrence was still riding high from her 1941 Broadway hit,* Lady in the Dark, *even though Ginger Rogers starred in the 1944 movie version. The Stage Door Canteen San Francisco presented an evening of the Canteen movie and a pre-show of songs from* Lady in the Dark.

TOP RIGHT: *Postcards were a popular perk among the visitors to the Stage Door Canteen as well as hobnobbing with the stars who came to entertain the G.I.s. The boys wrote on the cards and staff saw that they were stamped and mailed.*

CENTER RIGHT: *Eddie Cantor entertains at the Hollywood Canteen, one of a several satellites across the country and around the world of the New York flagship.*

BOTTOM RIGHT: *Philadelphia, the City of Brotherly Love, was also among the eight cities hosting a Stage Door Canteen.*

OPPOSITE PAGE: *Program cover of the London Stage Door Canteen*

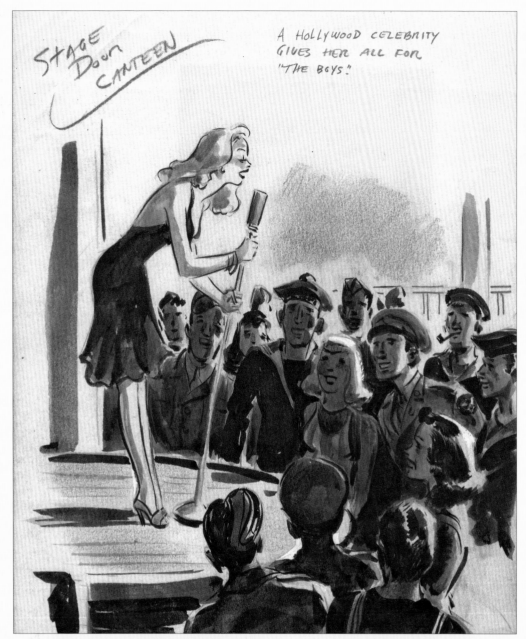

STAGE DOOR CANTEEN

A HOLLYWOOD CELEBRITY GIVES HER ALL FOR "THE BOYS"

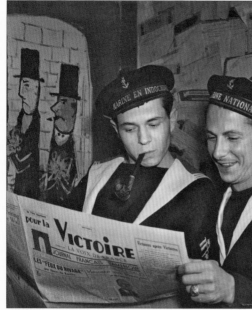

ABOVE: *Allied soldiers were quick to catch up on the news at the Stage Door Canteen no matter where they were in the world. .*

TOP LEFT: *"A Hollywood Celebrity gives her all for the boys" was the caption for this cartoon.*

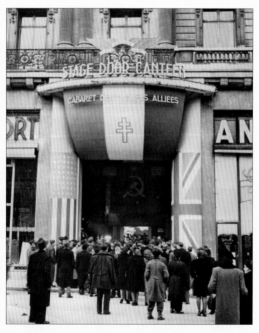

ABOVE: *The Stage Door Canteen in Paris offered not only food but also helped allied soldiers catch up on the war's progress. The canteens, abroad and stateside, opened their doors to all allied servicemen.*

BOTTOM LEFT: *During World War II, men were a driving force at the Canteen and no one was more dedicated than producer-director Brock Pemberton, here with First Lady Eleanor Roosevelt and Tallulah Bankhead in Washington, D.C.*

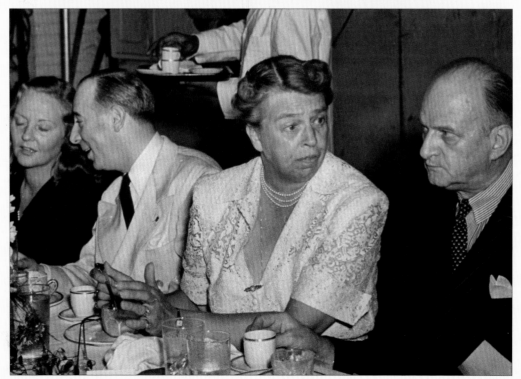

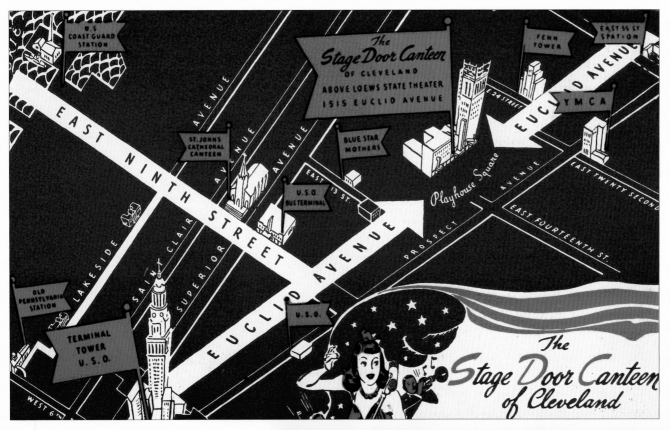

ABOVE: *The Stage Door Canteen of Cleveland was one of the eight clubs eventually established across the country. Later Paris and London would have their own places for soldiers to get some badly needed R&R.*

RIGHT: *German-born Marlene Dietrich dances with a handsome soldier at the Stage Door Canteen in Paris. Rebuffing Hitler's overtures to return to her homeland, the actress and singer worked tirelessly on behalf of the allies.*

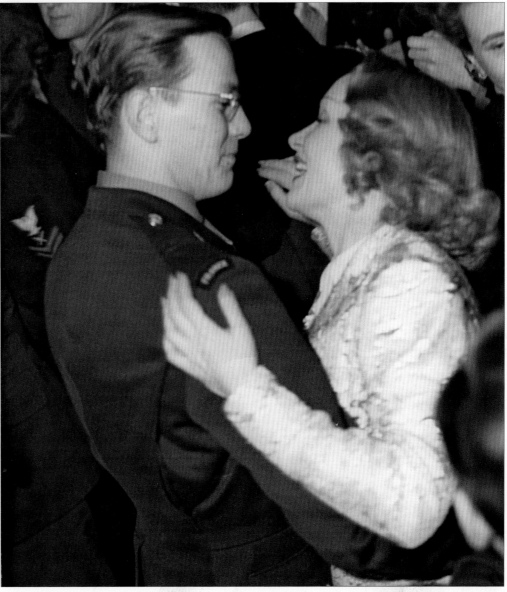

STAGE DOOR CANTEEN, THE MOVIE

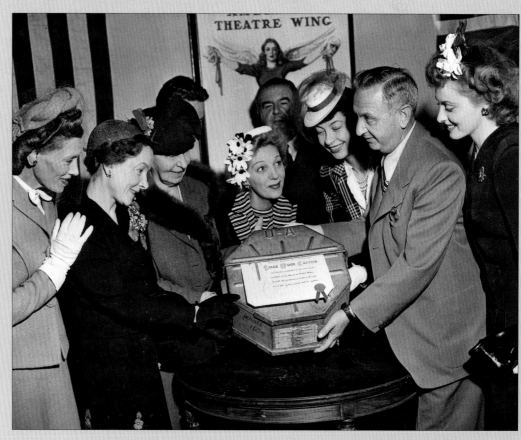

"A taste of the fun and entertainment which service men share each night at the famous Stage Door Canteen—in fact, a full banquet of it—is now to be had by the public in a bulging and generally heart-warming film entitled (so that no one can possibly mistake it) simply *Stage Door Canteen.* This is the film which Sol Lesser produced here and on the West Coast, the film for which virtually every actor and entertainer in the business did a stunt and the one from which all of the profits—or some 90 per cent of them—are to go to the support and advancement of the American Theatre Wing. So money put down at the wicket of the Capitol (where it is showing) is money well spent. You'll not get so much entertainment in a good cause if you shop the whole town. For show folks are temperamentally generous when it comes to giving of themselves to a service in which the hearts are bound up. And devotion freely flows at the Canteen. In this film, the locale is wholly—except for a few connecting scenes—

the service men's recreation center which is down one flight just west of Broadway. And in it you will see such rare divertissement as only a uniform can really buy. You will see Katharine Cornell distributing oranges and speaking lines from *Romeo and Juliet,* you will see Alfred Lunt washing dishes and Producer Brock Pemberton emptying ash trays. But you will also get in this picture a rather obvious but very touching romance between a soldier boy and a hostess, which is the thread that holds it all

together. And that is the thing which gives it, as a picture, a plain and moving gallantry. For this, after all, is a true glimpse of that little corner of New York where the people of the theatre and the show world are making lonesome youngsters happy for a spell. No matter how you look at it, there is poignancy and bravery in the scene."

–BOSLEY CROWTHER, FILM CRITIC, NEW YORK TIMES, JUNE 25, 1943

ABOVE: *Film producer Sol Lesser presents a canister containing the reels of his* Stage Door Canteen *to Gertrude Lawrence (center) and (from left) Helen Menken and Helen Hayes.*

OPPOSITE PAGE: *A program for the all-star movie* Stage Door Canteen *which was one of the most popular attractions of 1943. Royalties from the film brought over $2 million into the coffers of the American Theatre Wing.*

STAGE DOOR CANTEEN

Produced and presented by
SOL LESSER
in association with
AMERICAN THEATRE WING

25c

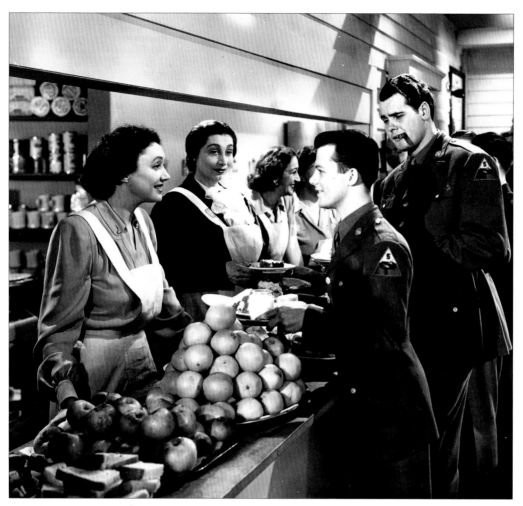

ABOVE: *Katharine Cornell's scene with Lon McCallister in the film* Stage Door Canteen *was captured in this charming caricature by Irma "Selz."*

TOP LEFT: Stage Door Canteen *boasts the only feature film appearance of stage great Katharine Cornell. In this memorable scene, she briefly recites the balcony scene opposite Lon McCallister's Romeo as he moves through the chow line at the club.*

BELOW: *Screen beauty Merle Oberon plays matchmaker to Eileen (Cheryl Walker) and Dakota (William Terry) in the film* Stage Door Canteen. *The still shows a roominess that was virtually absent in a place that was packed like sardines nightly.*

ABOVE: *Katharine Hepburn gives a heart-stirring speech to a hostess grieving for her departed beau in the film,* Stage Door Canteen, *which was one of 1943's biggest hits.*
BELOW: *Ethel Merman picks up the pace in the film,* Stage Door Canteen, *with the song. "We'll Be Singing Hallelujah (Marching through Berlin)."*

"Yes, that's right. We're in a war and we've got to win. And we're going to win. And that's why the boy you love is going overseas. And isn't that maybe why you're going to go back in there and get on your job? Look, you're a good kid, I don't wonder he loves you. He knows what he's fighting for. He's fighting for the kind of world in which you and he can live together in happiness, in peace, in love. Don't ever think about quitting. Don't ever stop for a minute working, fighting, praying until we've got that kind of world, for you, for him, for your children, for the whole human race. Days without end. Amen."

—KATHARINE HEPBURN TO A HEARTBROKEN HOSTESS IN THE FILM *STAGE DOOR CANTEEN*

THE SPEAKERS BUREAU

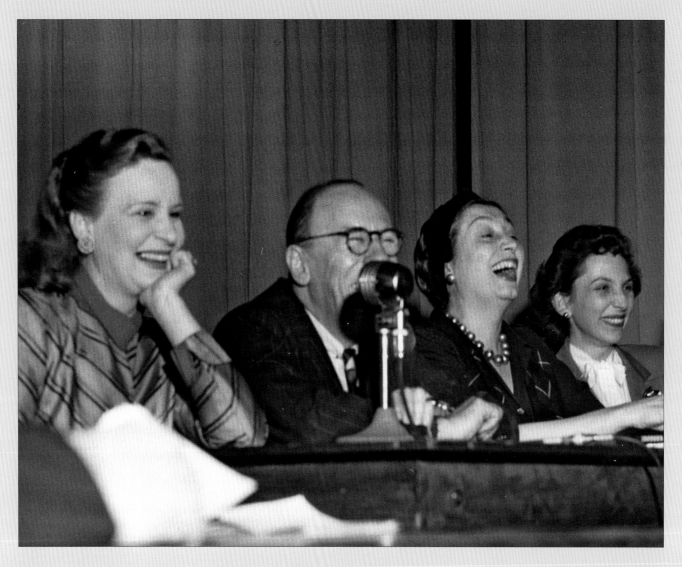

"The entire civilian population must learn to adapt itself to new conditions and must understand clearly the reasons for doing so. This will necessitate a tremendous job of public education in which the Speakers Bureau of the American Theatre Wing hopes to help materially. Its members have the trained voices and disciplined bodies necessary for good public speaking."

–VERA ALLEN, DANCER
AND ACTRESS

"Some people think they can get the Virgin Mary for 150 people from the Speakers Bureau. 'Can the Bureau put me in touch with an acrobat who can do an act on the Fire Department ladder 80-ft high? It can be either a straight act or a comedy act.'"

–MEMO RE THE
SPEAKER'S BUREAU

"We were afraid that they might overdramatize instead of being simple and accurate. We had forgotten that the actors work off all their exhibitionism behind the footlights. They sold the subject, not themselves."

–VERA ALLEN

RIGHT: *Shirley Temple jokes with emcee Bert Lytell and comic Johnny Morgan in this 1944 broadcast of the Stage Door Canteen's weekly radio hour.*

BELOW RIGHT: *The American Theatre Wing's Lunchtime Follies was a popular series of performances at factories and shipyards to boost war morale. David Burns, as Hitler, is paraded through a Brooklyn shipyard in a sketch.*

BELOW LEFT: *Concurrent with the Stage Door Canteen, the American Theatre Wing sent out performers in Lunchtime Follies.*

"Plays, personalities, players and all other familiar conversational things are gone. The theater has lost its old gossipy, haphazard laziness. It has a purpose that is beyond selfish ambition and personality. Dynamic, certain, lucid, and as relevant as relevant."

–JAY CARMODY, THE WASHINGTON STAR

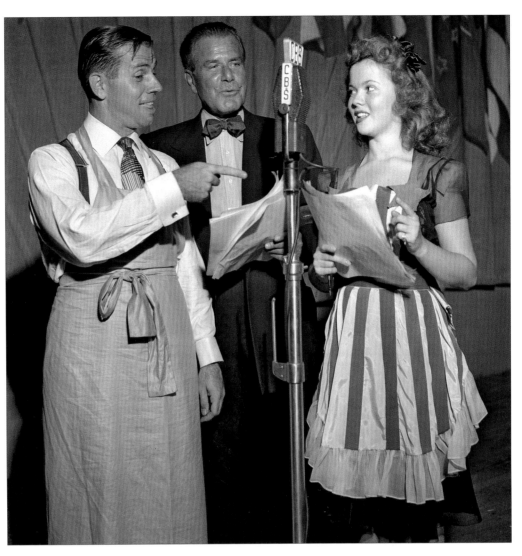

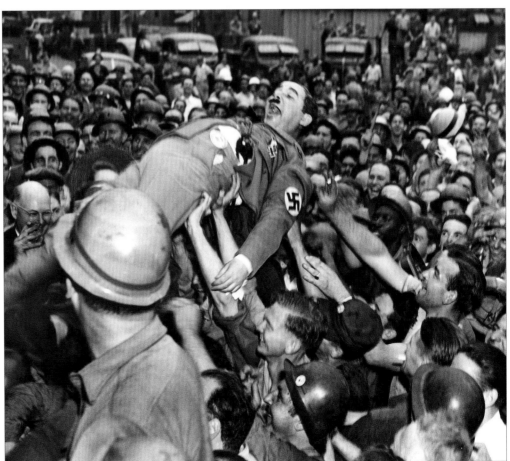

THE VICTORY PLAYERS
(LATER THE COMMUNITY PLAYERS)

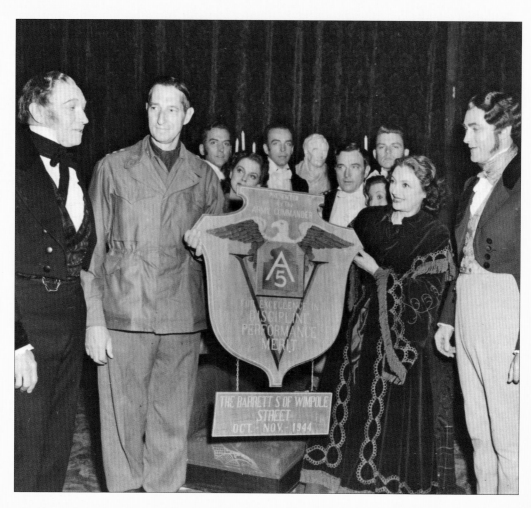

"WELL, WHAT I TELL YA? TOLD YA IT WOULD BE BETTER THAN GOING TO A CATHOUSE."

–A SOLDIER TO HIS FRIEND FOLLOWING A VICTORY PLAYERS PERFORMANCE OF *THE BARRETTS OF WIMPOLE STREET* ON TOUR IN WAR-TORN EUROPE.

ABOVE: *In the fall of 1944, Katharine Cornell and the Wing's Victory Players presented* The Barretts of Wimpole Street *in war-torn Europe and were feted for their morale-building effort.*

"The tour opened in Santa Maria, a small town 15 miles north of Naples, in 1944. G.I.s lined up three hours ahead of time and profusely thanked us afterwards. The manager overheard a tough burly paratrooper say to his buddy, 'Well, what I tell ya? Told ya it would be better than going to a cat house.' Convinced of its success, the Army brass sanctioned two more weeks. The company eventually played for six months, from August 1944 to January 1945, throughout Italy. We then played in France.

In Paris, Gertrude Stein and Alice B. Toklas wanted to see the play, but found that performances were strictly limited to enlisted personnel. They were nonetheless given disguises and were able to see the play. Additionally, the cast made a point of visiting hospitals every day throughout the entire tour. We performed in the Netherlands just eight miles from the front and concluded the tour in London amid exploding German V-2 bombs."

–BRIAN AHERNE, IN HIS MEMOIR *A PROPER JOB*

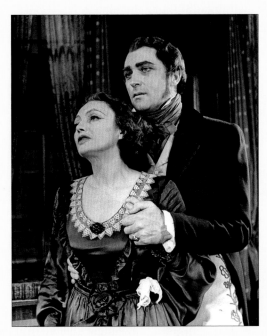

"General George C. Marshall asked [Katharine] Cornell to do a play to entertain the troops in Europe. Cornell decided to take *The Barretts of Wimpole Street* to the troops in Europe. However, nobody thought G.I.s would sit for a three-hour costume drama about two middle-aged Victorian poets. They suggested some sort of "ribald farce" in case *Barretts* proved a failure. Cornell insisted upon *Barretts,* saying that if she was going to entertain the soldiers, she must take them her very best, and her very best was *Barretts.* The Army then asked that they cut the love scenes, as the play was far too long at three hours; they wanted someone to 'explain' the play to the men beforehand, and prepared her for what they saw as rude, tasteless and ignorant troops. The entire company, backed by Cornell and her husband Guthrie McClintic, resisted all entreaties and played their roles with every degree of authenticity as the Broadway original. At the first production, the army's fears seemed to be validated. At the start of the play, which takes place in damp, chilly London, the doctor advises that Elizabeth Browning go to Italy for rest. The audience, G.I.s fighting in war-torn Italy, exploded in laughter, hooting, yelling and stamping."

–BRIAN AHERNE

"We thought they would go on laughing and it would never stop and the Barretts would go under a tidal wave of derision. But we were wrong. Kit and Guthrie were holding the laugh, just as if they had heard it a hundred times, not showing any alarm, not even seeming to wait for it, but handling it, controlling it, ready to take over at the first sign of its getting out of hand. It rose and fell and before it could rise again, Kit spoke. The play continued, and outbreaks of an occasional catcall, guffaw or heckling were quickly shushed by others. Kit had a shining light in her. With that strange sixth sense of the actor that functions unexplainably in complete independence of lines spoken and emotions projected, she had been aware of the gradual change out front from a dubious indifference to the complete absorption of interest. At first they hung back, keeping themselves separate from us, a little self-consciously, a little defiantly, and then line by line, scene by scene, she had felt them relax and respond and give themselves up to the play and the story, til at last they were that magic indivisible thing, an audience. 'We must never forget this, never,' said Kit. 'We've seen an audience born.'"

MARGALO GILMORE, VICTORY PLAYERS CAST MEMBER IN *THE BARRETTS OF WIMPOLE STREET*

"Thank you for the most nerve-soothing remedy for a weary G.I. You brought a yearned-for femininity and for reminding me that a woman is not all leg and for the awakening of something that I thought died with the passing routine of military life in the foreign service."

–A SOLDIER, GIVING THANKS TO KATHARINE CORNELL FOR *THE BARRETTS OF WIMPOLE STREET*

WOMEN OF THE AMERICAN THEATRE WING

By Patrick Pacheco

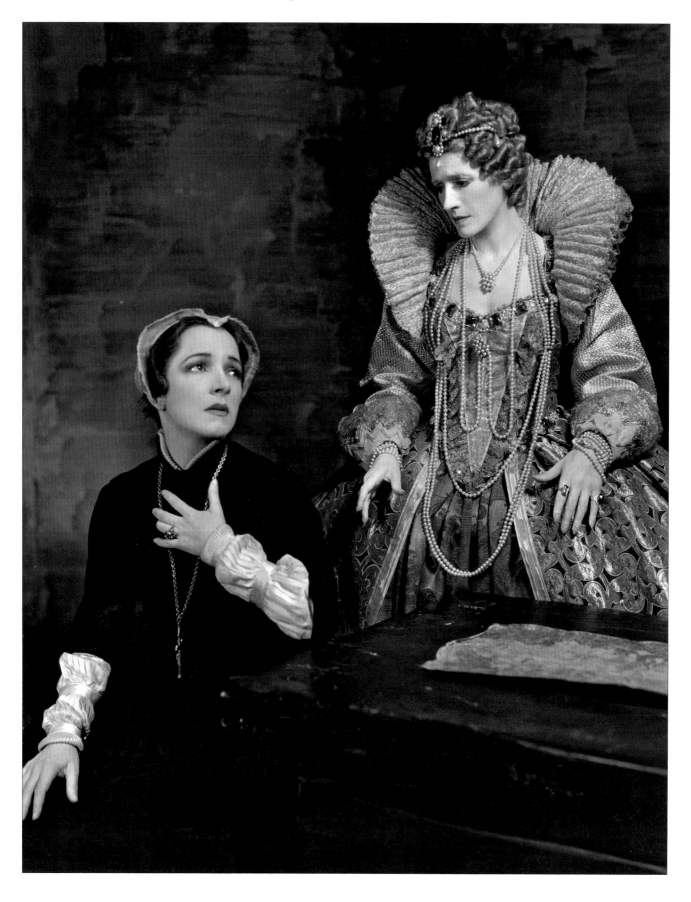

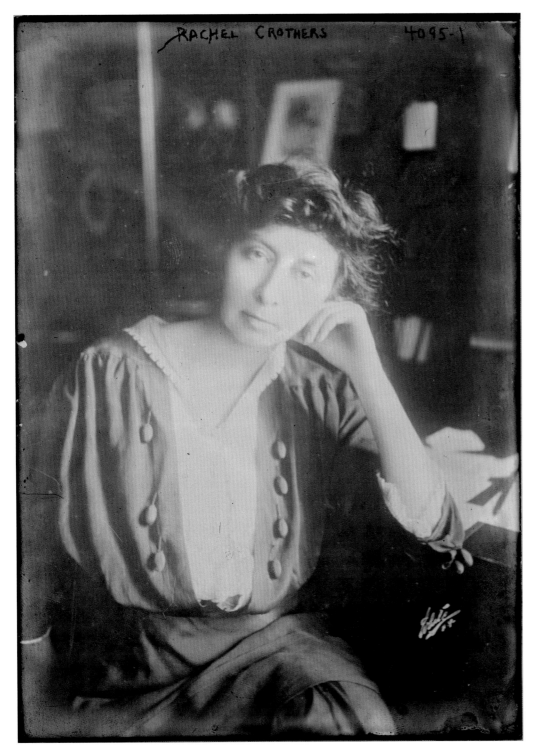

ABOVE: *Rachel Crothers, a co-founder of the Stage Women's War Relief, was a suffragette and successful feminist playwright (*Susan and God*), who worked tirelessly on behalf of the organization.*
OPPOSITE PAGE: *In 1933, Helen Hayes and Helen Menken, two future leaders of the American Theatre Wing, starred in Maxwell Anderson's* Mary of Scotland. *Hayes played the title role while Menken took on her nemesis, Elizabeth Tudor.*

Rachel Crothers
The Most Ardent Feminist

When Rachel Crothers' comedy *He and She* was revived at the Brooklyn Academy of Music in 1980, the New York Times described her as "The Neil Simon of her day."

Prior to her death in 1958, Crothers had become the most successful female playwright in history, from her smash Broadway debut *The Three of Us* in 1906 to *Susan and God,* the 1937 career capstone that three years later was made into a film starring Joan Crawford. Over three decades and thirty-five plays,

she was a trailblazer in espousing the middle-class conundrums and values of "the new woman." She made good on her feminist standards by also casting, directing and producing her work.

Yet, despite her popularity in the early part of the twentieth century, Crothers is now best remembered for her philanthropic work, chiefly as a co-founder of the Stage Women's War Relief in 1917 and as the first president of its successor, the American Theatre Wing. Her tireless activism on behalf of both organizations reflected the feistiness of her plays' heroines who boldly questioned the era's double standards. Though tamer than the socialist manifestos of the Group Theatre, Crothers' plays were hailed as provocative and attracted the leading actresses of her day, including Katharine Cornell, Tallulah Bankhead, Gertrude Lawrence and Ethel Barrymore.

"The world is so old and the new freedom for women is so new, so painfully young, groping," she told a reporter in the 1920s. "The modern woman who would lead her own life as a man does has but cracked a shell."

Born in 1878 in Bloomington, Illinois, Crothers first imagined a career on the stage, an ambition that earned a rebuke from Eli Kirk Crothers, her physician father. However, the fierce independence she'd grow up to preach stemmed from her mother Marie-Louise who went to medical school at forty and became the first woman doctor in Illinois. With the encouragement of producer David Belasco, Crothers moved to New York and charged into the largely male preserve of Broadway. From the beginning, she found her niche in writing about the travails of women struggling under the yoke of men. In *He and She,* a marriage between two sculptors is thrown into crisis when

71

the distaff member decides to enter an art competition and triumphs over her husband.

The compassion with which Crothers would imbue both the Stage Women's War Relief and the American Theatre Wing is evident in her work as well. In 1913, she crafted a play about prostitutes from interviews that she conducted with women jailed for the offense. In the aptly titled *Ourselves,* the playwright called out the hypocrisy of

American society and put the blame on their johns who generally escaped censure. The drama, which was praised by one critic as "the best of all the white slave plays," was regarded as Shavian in its moral wit.

Describing herself as "the most ardent of feminists," Crothers saw women as her natural allies. Never marrying, she came to rely on one woman in particular, Eula Seely Garrison, with whom she lived for

decades. Upon her death, she left her entire estate to Garrison's niece. Her confidence and trust in women left a lasting marker on the DNA of the American Theatre Wing. As she told the novelist Djuna Barnes in 1931, "For a woman, it is best to look to women for help; women are more daring, they are glad to take the most extraordinary chances. I think I should have been longer about my destiny if I had to battle with men alone."

ABOVE: *ATW co-founder and popular playwright Rachel Crothers touted "The New Woman" in works such as* Nice People. (1921). *From left to right, Katharine Cornell, Francine Larrimore and Tallulah Bankhead.*
OPPOSITE PAGE: *Antoinette Perry, for whom the Tony Award is named, was an actress of uncommon beauty and grace before she focused on directing and producing. The classic comedy* Harvey *was her greatest triumph.*

Antoinette Perry
Lady Dynamo

Antoinette Perry, for whom the Tony Award is named, had a singular approach to money.

In 1905, when she was seventeen, her grandfather Charles Hall, a former Colorado state senator and mining magnate, disinherited her of a million dollars when she refused to give up the stage. At thirty-four, she inherited millions when her husband, Frank Frueauff, left her widowed. Six years later, she became a director, scoring big with the 1929 play *Strictly Dishonorable.* The earnings from that comedy hit would help her recover when the Depression left her millions in debt. During the 1940s, as secretary and president of the American Theatre Wing, she would use the breaks during board meetings to place bets with her bookie.

"My mother was an inveterate gambler," said her daughter Margaret Perry Frueauff. "The seed money for many a Wing activity or show investment came from her track winnings."

An American original, Perry was born Mary Antoinette to William Henry Perry and Minnie Hall in Denver, Colorado on June 27, 1888. She knew from an early age that she was destined for the stage. Years later, Perry told a reporter, "When I was a child, I didn't say, as most children do, I was going to become an actress. I felt I was an actress and no one could convince me that I wasn't."

A beautiful and charming presence, Perry joined her uncle George Wessells' touring company at the age of fifteen, soon graduating to Shakespearean pants roles. Three years later, she made her Broadway debut in *Lady Jim,* a 1906 comedy that she followed with *A Grand Army Man,* a David Belasco hit opposite

ABOVE: *Antoinette Perry is shown directing the 1940 production of* Glamour Preferred. *The cast included her daughter, Elaine Perry who played a role described in the playbill as "A Strange Girl".*

ABOVE: *Antoinette Perry's profile would later become famous for having been embossed on one side of the award named in her honor, a medallion eventually known by its nickname: the Tony Award.*

the popular actor David Warfield. In 1909, Perry tossed away impending stardom to marry a hometown suitor, handsome oil executive Frank Frueauff, and settled in Denver to raise their two daughters. But the stage lights still beckoned, first as an investor—Perry became an "angel" to producer Brock Pemberton on Zona Gale's Pulitzer Prize-winning *Miss Lulu Bett*—and then as a director and producer.

Perry's association with Pemberton proved fruitful. After Frueauff's death in 1922, she resumed her acting career in several Pemberton

productions and in 1928, she made her directorial debut with *Goin' Home,* the first in over a dozen productions that would profit from her keen eye. Given how well-heeled she was—Frueauff had left an inheritance of over $13 million—Perry always looked out for those less fortunate.

"My mother generously lent money and bailed actors and playwrights out of overdue hotel bills," said daughter Margaret. "Later she ran apprentice auditions to help young actors who otherwise couldn't break in. When the Depression struck, mother

awoke two million dollars in debt. It took seven years to recover."

During this time, Perry and Pemberton eventually became entwined personally as well as professionally. They co-directed productions and when World War II commenced, they both supported the allied forces through the American Theatre Wing. Perry worked to exhaustion in promoting the organization but was self-effacing about it.

"Hobbies? I don't have any hobbies," Perry said at the time. "My mother said, 'You're not a person anymore. You're a Wing.' I don't care how I look. Of course, some of that may be sour grapes because I've let myself get too fat." The journalist Gordon Merrick observed, "[Antoinette Perry] gives the impression of a woman in the presence of a miracle—about to burst into tears at the sheer splendor of it."

When she died of a heart attack on June 28, of 1946, a day after her fifty-eighth birthday, the Broadway community was shocked since she had not told anyone that she was ailing. Pemberton suggested that she be honored the following year with an award named for her that would cite "distinguished achievement in the theater." At the first ceremony, he called the award, "the Tony," a nickname that stuck.

According to journalist Ellis Nassour, Perry was once asked why she would devote so much time and money to such "thankless activities" as the theater. She dismissed the characterization. "Thankless? They're anything but that. I'm just a fool for theater."

She died $300,000 in debt. But a winner in every other regard.

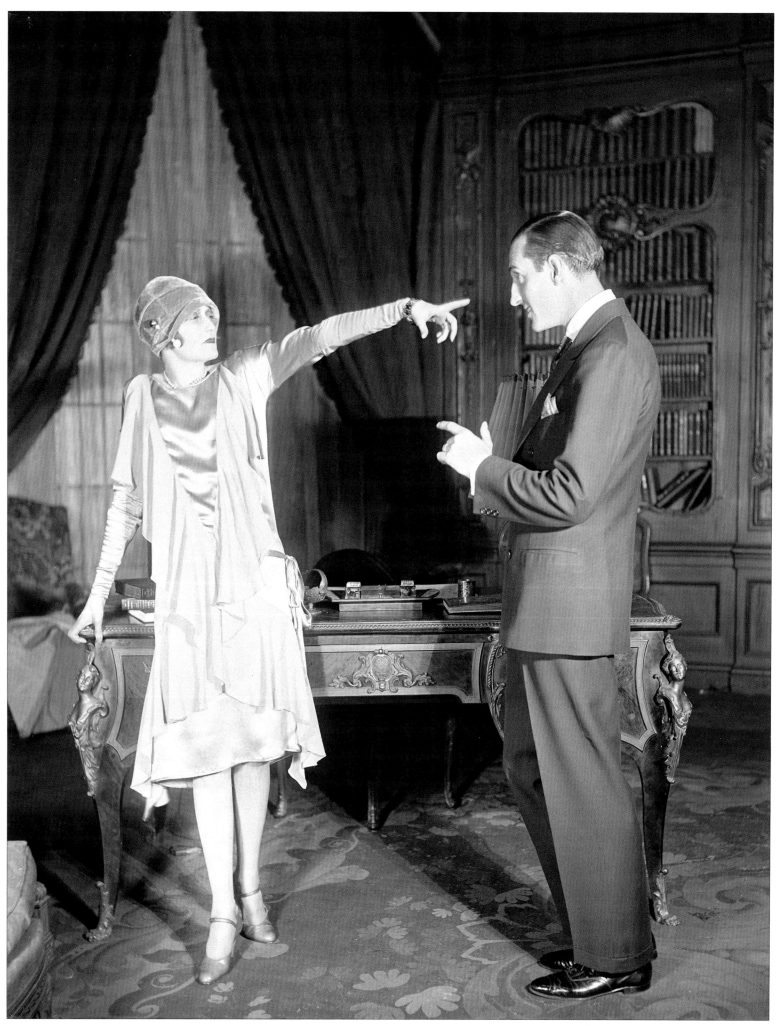

ABOVE: *Helen Menken was featured in the pages of* Vanity Fair *in this 1920s Edward Steichen glamor shot capturing her at the apogee of her career. She would later lead the American Theatre Wing.*
OPPOSITE PAGE: *Helen Menken caused a sensation on Broadway in the 1926 French drama,* The Captive. *Even though its allusions to lesbianism were veiled, the cast was arrested on a morals charge but eventually acquitted.*

Helen Menken
Warrior Woman

Helen Menken was used to being embattled, long before the events of World War II drew the actress into the activities of the American Theatre Wing. It was an organization that, as president from 1957 to her death in 1966, she would lead through many crises.

Chalk it up to being born in New York City on December 12, 1901 to Frederick and Catherine Menken, both of whom were deaf. Their daughter would not learn to speak until she was more than four years old. This she did through the magic of the stage and her debut as the fairy Peaseblossom in *A Midsummer Night's Dream* in 1906. "Hail, mortal," may well have been among the first words she ever uttered. The playfulness and humanity of Shakespeare's comedy guided Menken through the rest of her eventful life which included an obscenity trial, a brief first marriage to Humphrey Bogart, and a burning devotion to the Wing.

"Helen was an eccentric lady and apparently a terrific actor," recalls Harold Prince who knew her in the 1960s when he served as both a board member of the American Theatre Wing and president of the League of American Theatres and Producers. "I'd never seen her act, but she was energetic, determined and I liked her very much."

Menken's devotion to the theater was forged in touring the provinces

ABOVE: *Born of deaf parents, Helen Menken, President of the American Theatre wing from 1957-1966, championed the disabled throughout her life. Once briefly married to Humphrey Bogart, she financed the ATW projects with financial help from her broker husband, George Richard.*

long, engrossing play" wrote Brooks Atkinson—the creative team of *The Captive,* ended up in criminal court for offending the public morals. Acquitted by a jury, Menken spoke out against the banning of the play.

"Hasn't America had enough of prohibitions?" she asked the press. "Has the liquor problem taught the country anything? Let me tell you what I think. If they put a censor of plays in the country to such an honest presentation as *The Captive,* the theater will go the way of the pantaloon."

The controversy reportedly contributed to her divorce from Bogart, then typed as a tennis-playing young man in flannels on Broadway. Menken herself went on to a distinguished stage career, creating the role of Elizabeth in Maxwell Anderson's *Mary of Scotland* opposite Helen Hayes and as Charlotte in Zoe Akins's *Old Maid* with Judith Anderson. But after 1936, she begged off the theater and helped to establish and fund the Stage Door Canteen for the American Theatre Wing while serving as radio director of the organization. She dedicated herself to addressing the problems of the handicapped, eventually acting as vice-president of the Institute for the Crippled and Disabled.

After the war, Menken was a pivotal force in creating theatrical and educational opportunities for returning vets and later opened a school for theater training for civilian performers as well. She became involved in the creation of the Wing's Community Players whose mission was to school the public in the post-war afflictions of drug addiction, race relations and mental illness. "A play is worth a thousand speeches," she said.

Menken's presidency of the Wing was marked by both great strides in

and braving the rigors of chilly, flea-infested hotels and cheap meals. "The chorus girls looked after me," she told a reporter. "Chorus girls are wonderful people. We played mostly one-night stands and in every town the girls took me to the public library for two reasons: to teach me to read and because the library was the warmest place in town."

Making her Broadway debut in 1917, Menken was soon established as one of the brightest ingénues of the flapper era in such dramas as *Seventh Heaven* and *The Makropoulos Secret.* She was celebrated when she was cast as the tormented heroine in *The Captive* by the French playwright Edouard Bourdet. The 1926 drama told the story of "...a hapless lady enslaved in the noxious chains of abnormality"— or so Percy Hammond described the lesbianism at its center in the New York Herald Tribune. Even though the production received good notices—"a

educational programs—a school building opened on the Upper West Side—and dramatic resignations when Menken did not see eye-to-eye with the board. The first came in 1962 after she'd suffered a heart attack and another in 1965 in a fit of pique over the lack of funding for the school. ("I convinced her to rescind her resignation, and I'm glad I did," says Harold Prince.) It was also during this critical period that the League of American Theatres and Producers under the leadership of Prince offered to act in an advisory capacity to the Wing. After Menken's death in 1966, the League, now known as the Broadway League, took on a more formal role co-presenting the Tony Awards with the Wing.

Throughout her storied life—which included four marriages, the final to a rich stockbroker—Menken was a unique blend of imperious actress, socialite, and community organizer given to dramatic gestures. Even her heart attacks were inadvertently theatrical. Her first came after a Tony Awards ceremony; the final and fatal one occurred at the Lambs Club, a famed Broadway watering hole. While she often entered a room with a brisk, "Hello, dahling!," her essence was authenticity. Once when the subject of "the Method," as a style of acting came up, Menken bristled. "Don't talk about 'The Method.' There's no method but belief and honesty. Actors are too sensitive. They're not used to lowdown, realistic, yelling rehearsals. They wilt."

That could never be said of Helen Menken.

Isabelle Stevenson
Doyenne of the
American Theatre Wing

During her long tenure as president and later chairwoman of the American

ABOVE: *Isabelle Stevenson began her career as part of Nice, Florio and Lubow, a glamorous, if slap-happy, vaudevillian trio. After playing a Royal Command Performance, she gave up the footlights to raise a family and was later elected to lead the Wing.*

Theatre Wing, Isabelle Stevenson was known for myriad qualities: elegance, energy, gutsiness, fierce devotion to education, and protecting the Tony Award as a symbol of theatrical excellence. What many people didn't know, however, was another key to her personality: she had big feet.

"Very big feet, size nine or ten," says Francine Ringold-Johnson, her niece and foster daughter. "The way her feet gripped the earth is a very good way of describing her. It says something about

her stability. You know what dancers say, 'If your feet really grip the earth, then you can spring off more effectively.'"

This combination of earthy and ethereal held Stevenson in good stead as she traded in her early stage ambitions for marriage and motherhood and then in the last five decades of her life, fused her personality with the Wing so tightly that her 2003 New York Times obituary read, "Isabelle Stevenson, Doyenne of the Tony Awards, dies at 90."

"She genuinely knew what the

power of the theater was," says Susan Brown, one of Stevenson's daughters. "She admired and respected actors, was in awe of them, knew what they had to go through, because she was one of them."

Born in Philadelphia in 1913 to Sonia and Samuel Lieberman, Stevenson adopted her mother's maiden name when she became part of a vaudeville trio after a stint in the famed Earl Carroll Vanities. The act billed as Nice, Florio and Lubow, toured the provinces, played the Palace, and peaked at a Royal Command Performance in London in the 1930's.

"Isabelle came out in a beautiful gown and the boys were in tails," says Ringold-Johnson. "They were doing these sweeping gestures across the stage, and then my mother slapped one of the young men and the act turned into a combo of slapstick and ballroom dance."

In 1937, at the age of twenty-four, Isabelle Lubow married John Stevenson, a British-born newspaper executive with whom she raised two daughters, Laura and Susan, and a niece, Francine. She gave up her career to work with her husband in marketing and to see that her girls received the education that she herself had been denied. Stevenson was as even-tempered as his wife could be impulsive. "My mother wasn't exactly a wallflower," says Brown. "During some of the more trying times, my father was a calming and supportive influence. He counseled her on how to be diplomatic."

In 1956, Stevenson joined the board of the American Theatre Wing which at the time was undergoing a leadership change as Helen Hayes turned over the reins to Helen Menken. Upon the death of the latter in 1966, the board elected Stevenson as president. The steely determination she brought to

the organization had been tempered in the school of hard knocks—the hardest having literally occurred just a few years earlier. Stevenson was at New York's Penn Station with her daughter Laura when a careening baggage cart ran over her, crushing and breaking her legs in multiple places.

"The doctors told my mother that she would never walk again," recalls her daughter, Laura Maslon. "She replied, 'That's not going to happen to me.' She was one of the strongest people I've ever met." The recovery took over a year. Maslon recalls visiting her in the hospital and finding her doing leg lifts in a body cast that extended from her waist to her toes. "She was never going to be defeated."

Energized by her belief in the theater, Stevenson set out to awaken the somnolent Wing. She inaugurated the *Working in the Theatre* seminars, funded grants and fellowships, sent professionals to talk about theater in high schools, and presented shows in hospitals and prisons. On one occasion, when she brought a troupe to New York City's Riker's Island, one incarcerated inmate spied Stevenson and shouted, "Hey, blondie. What are you in for?"

What Stevenson was in for were habitual run-ins with people whom she thought did not have the best interests of the Wing at heart. One such was Alexander Cohen, the flamboyant and colorful producer of the Tony Awards telecast, for nearly two decades. ("A cheerful rogue," is how one Broadway producer described him.) Stevenson managed to prevail not only over Cohen but other nemeses through street fighter instincts and the chits of loyalty she'd collected over the years. "Even as she got older and slightly diminished," says Maslon, "she still had an incredible force of personality. And she could work

a cocktail party like nobody's business."

Stevenson was so addicted to the theater that on Monday evenings, when most of Broadway was dark, she and her gay friends would seek out Off-Off-Broadway fare in remote areas of the city. Her dedication to the Wing kept Stevenson rooted even as serious illness threatened. At one of her last Tony Awards ceremonies, recalls Maslon, she was deathly ill but still managed to walk up the aisle at the end of the event and lecture Harvey Weinstein for not

doing more for Broadway. "She got to her apartment building and collapsed on the sidewalk," says Maslon. "She had a burst aorta and was sent off to the hospital in an ambulance."

Included among the many highlights of her Wing tenure was a 1999 special Tony and her unique exit from the stage at one of her last Tony Award appearances. "She was already so sick that the producers were afraid that my mother wouldn't be able to get off the stage fast enough," recalls

Ringold-Johnson. "So they came up with this inspired idea." Frank Langella, one of Stevenson's favorite actors, appeared with her for the one minute on each telecast devoted to an enumeration of the Wing's programs. At the end of the segment, Langella swept Stevenson off her size ten feet—and carried her into the wings.

ABOVE AND OPPOSITE PAGE: *Isabelle Stevenson's serious illness led to a charming moment at the 2003 Tony Awards when Frank Langella swept her off her feet. She died later that year.*

CHAPTER II

EDUCATION
Opening Doors

By Allison Considine

I n June 2014, LaTanya Richardson Jackson was holding forth in a room at the Manhattan Theatre Club studios in Times Square.

"Try to get into the city and get your footing," she said of starting a career in the arts. "Keep your center in God. I'm a God person. Have some place to put the 'crazies.' Because the crazies will come for you."

The room full of three dozen performing arts students from across the country, who were all part of the American Theatre Wing's Springboard program, laughed in agreement.

"Everybody's journey is different, but just make yours yours," she effused. "It is nobody's journey but yours."

Hailing from rural Pennsylvania, I was in that room, scribbling down every bit of advice offered by Jackson as one of the guest speakers of SpringboardNYC, the

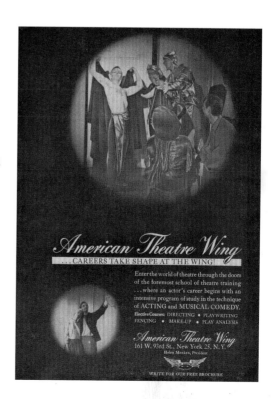

RIGHT: *Since its beginnings, the American Theatre Wing has made education a dynamic part of its mandate, from scholarships to a 14-year-old Angela Lansbury in 1940 to its SpringboardNYC programs instructing students in the rigors of the stage to the Andrew Lloyd Webber Initiative to provide aid to under-served schools.*
OPPOSITE PAGE: *James Earl Jones and Christopher Plummer, both of whom took lessons at the American Theatre Wing's professional school, starred in a Tony-winning revival of* Othello *in 1982.*

ABOVE: *Actor-composer Lin-Manuel Miranda shares a laugh with the SpringboardNYC group just after penning the 2008 Tony-winning musical* In the Heights *and before he'd make Broadway history with the ground-breaking* Hamilton.
OPPOSITE PAGE: *LaTanya Richardson Jackson, actor and an American Theatre Wing trustee, counsels the aspiring artists participating in the Wing's SpringboardNYC two-week summer intensive program in 2014.*

American Theatre Wing's two-week summer intensive, which helps to bridge the gap between isolated theater programs and the theater industry. The day-long workshops, seminars, and master classes ran the gamut from learning how to file taxes, to how to apply for temp work, and what to know when signing a lease for an apartment. It also rekindled some of the theater magic that led my sights to the stage in the first place, with talk-back sessions with artists who work onstage and workers behind the scenes, even including a glimpse at a stage manager's call sheet. Without sugarcoating the gruesome side of the industry, the program provided support to us new arrivals and treated us as fellow artists. A running mantra of the program is "your path is your path," and guest speakers and mentors would continually tell us that everyone has a different track and timeline to achieving

LaTanya Richardson Jackson advised us to "...have some place to put the 'crazies' because the crazies will come for you."

their personal goals. But what was most memorable about this boot camp was the encouragement to think of ourselves as "of the community," not in awe of it—a reminder that the Broadway ecosystem is within the same world as the many ancillary community theaters,

high school theater clubs, and college training programs across the country that we all come from.

This idea of community is the lodestar of the many diverse educational programs under the sponsorship of the American Theatre Wing. Their roots date back to 1940 when the organization offered free classes to returning G.I.s to reclaim their place in a post-war America. Aspiring writers like Joe Masteroff (*Cabaret*) learned under the tutelage of a seasoned playwright like Robert Anderson (*Tea and Sympathy*). Three years later, this professional training program opened its doors to civilians as well as vets. Its alumni—James Earl Jones, Tony Bennett, and Christopher Plummer, among many others—became as well known as their teachers, which over the years included Oscar Hammerstein, Jule Styne, Eva LeGallienne, Tennessee Williams, and Martha Graham. You

can see those antecedents today not only in Springboard, but also in the Theatre Intern Network, the *Working in the Theatre* films, and the Excellence in Theatre Education Award. Most recently, the Andrew Lloyd Webber Initiative expands the Wing's commitment to theater education with grants for training, university scholarships, and school resources-- providing opportunities for underserved young people and under-resourced public schools across the United States.

After the two-week Springboard program, alumni are invited to join the American Theatre Wing's Theatre Intern Network (TIN), a networking group that brings interns at theater organizations in New York City together for monthly panel discussions and pizza. I returned to the Manhattan Theatre Club studios a few weeks later for my first TIN meeting to some familiar faces. Panels have featured literary managers at theater companies, downtown theater producers, company managers working on national tours, and theater publicists marketing for Broadway. It was as part of the TIN that I attended a live taping of a panel discussion of *The Humans* at the Helen Hayes Theatre. It was just the latest installment of the *Working in the Theatre* series, a growing library of films dating back to 1973, which includes in-depth interviews with over 1,000 artists of every discipline.

The discussions are always as freewheeling as they are provocative and the one on *The Humans* was no exception. Hosted by Frank Rich, it featured the cast of the Tony-winning drama as well as writer Stephen Karam and director Joe Mantello. An arresting moment came when actor Reed Birney, who plays the patriarch of a dysfunctional Pennsylvania family, spoke of "getting lost in the play."

"AS THE CAMERAS BEGAN ROLLING, THE STRAP OF MY HEEL BROKE. THE PROGRAM DIRECTOR HANDED ME A PAIR OF FLATS AND I TOOK OFF RUNNING UP AND DOWN THE AISLES."

Rich asked for further explanation: Did he mean that it was a trance-like experience? To which Reed responded, to laughter from the audience, "I'm always aware I'm in a play, I don't have a psychotic break!" This caused Cassie Beck to admit that she had "weird psychotic moments." She added, "When I look at Reed and think, 'That's my dad!'"

In the course of both Springboard and TIN, there were many such nuggets of advice and counsel, some of which are more fun than I could've imagined. Who could fail to feel "of the community" by being a "seat filler" at the 68th Annual Tony Awards? It was our duty to run from a holding section at the back of the house and fill a seat when a participant went onstage to receive an award or to perform. With a motion from the CBS production team, I would hold my breath and run down the aisles of red velvet seats, curious to find out who I might be seated next to. Throughout the evening I was seated near Samuel L. Jackson and Harvey

Fierstein, in front of Cherry Jones, and beside Judith Light. I sat in a sea of leading ladies, among them, Sutton Foster, Idina Menzel, and Kelli O'Hara.

The winners that night invariably thanked their theater educators, motivators, and mentors. The Tony Awards puts the spotlight on theater educators with the Excellence in Theatre Education Award, a special honor made possible through a partnership between Carnegie Mellon University and the Tony Awards. The honor lauds one K-12 theater educator who is selected from a pool of thousands of teachers nominated by the public. Established in 2015, the award is an important reminder that the theater community spans coast to coast, and that the journey to becoming a theater artist is perhaps just as important as the end-goal.

What's also important--at least to a seat filler at the Tonys--is to have a good pair of shoes. As a production assistant motioned that the cameras would begin rolling for the live broadcast of the 68th Annual Tony Awards, the strap on one of my heels broke. The Springboard program director handed me a pair of flat shoes, and I took off running up and down the aisles of Radio City filling seats next to theater legends. And the following year, when my pathway took a turn toward theater journalism, the American Theatre Wing was there every step of the way to provide me with the tools I needed to put my best foot forward.

OPPOSITE PAGE: *A popular perk of the SpringboardNYC program is for students to participate in the annual Tony Awards ceremony as "seat fillers," occupying the places of celebrities when they move from audience to backstage.*

THE VOICES OF EDUCATION

"Think clearly, feel deeply, and know the strength of spiritual understanding. Bring to the theater an education as broad as your opportunities. The more you know, the more you understand, and the more you understand, the clearer is your recognition of the viewpoints of other men and women, and the easier will be your task of interpreting their characters. Read, study, enlarge the horizon of your thought. 'Get wisdom, get understanding, forget it not.' In short: mirror the world and the stars in your understanding and never cease striving for perfection. And when your offerings are heaped high in your arms then, in confidence, bring them to the door and knock—knowing at last you have earned the right to begin."

–Antoinette Perry, actress, director and producer

"I go way back. Not as far back as 1917, but way back to the days when the American Theatre Wing was a full-fledged conservatory for the study of the performing arts. I must salute the ghosts of all the beloved teachers I had when I studied there in 1955. These teachers gave us training and knowledge. They taught us speech for Shakespeare and speech for Arthur Miller and speech for Tennessee Williams....They taught us movement, fencing, and Afro-Cuban dancing to awaken our viscera. They taught us theater history and scene study and warned us not to put ethnic or gender limits on the characters we were studying. 'You want to play a woman? Go ahead and play a woman. Try it!' [Laughs]We were encouraged to see everything in the theater, to sneak into second acts if we couldn't afford the price of a ticket. Because they considered the critics not as the enemy, but as part of the process, they encouraged us to read reviews of everything until we gained the wisdom not to read reviews of our own work. After two years of training, we were challenged to dedicate the rest of our lives to the journey of the theater. When you've been around as long as I've been around there are a lot of ghosts to acknowledge."

–James Earl Jones, actor, multiple Tony winner

Above Right: *In April of 1942, stage star Gertrude Lawrence helps Ursula Weaitt with her makeup as kids prepare to present* Gratefully Yours, *a show to benefit the American Theatre Wing scholarship fund and the British American Ambulance Corps.*

Opposite Page: *Julie Andrews, Edie Adams, Janet Blair and Shirley Jones appeared together at a 1957 gala to raise money for the American Theatre Wing scholarship fund.*

ABOVE: *Like many returning G.I.s, Donald Saddler studied on a scholarship from the American Theatre Wing. Prior to enlisting, he toured with Ballet Theatre, joining, from left to right, Nicholas Orloff, Antony Tudor, Jerome Robbins, and Maria Karnilova. He'd eventually win Tony Awards for choreographing* Wonderful Town *and* No, No, Nanette.

"I was in the army in Alaska during the war when Jerry [Robbins] wrote to tell me he wanted to be a choreographer. I wasn't surprised. We all had had so many influences at Ballet Theatre, we all assumed we could make up our own dances. When I got out of the service, Jerry called me to take over a role in *Fancy Free.* So I went to London to do the bartender role there. When I came back to New York, I went to the American Theatre Wing, where returning veterans could study whatever they wanted to for free. I took voice, diction and other courses. Then, one day, Jerry called me to replace my friend Paul Goodwin in *High Button Shoes.* 'Okay,' I said, 'but I want to come and audition, because I don't want to be known as just an old friend of yours taking on the role.' George Abbott was the director, and all he wanted was to see if I could say the lines. Soon I was making my Broadway debut singing and dancing a tango with Helen Gallagher."

—DONALD SADDLER, CHOREOGRAPHER, MULTIPLE TONY WINNER

ABOVE: *Tony Bennett, as a soldier in the 255th infantry regiment, joined the army band which also included pianist and composer Freddy Katz (left) who would become a lifelong friend as would his brother Stan Katz. After surviving serious combat during World War II, Bennett pursued a career in jazz, helped by a scholarship from the Wing.*

"After I got out of the service, under the G.I. bill, I went to the American Theatre Wing's Professional School and it was the best education I ever had. I had a teacher, Mimi Spear on 52nd Street, who was so inspiring. She said, 'Don't imitate singers. You'll just be one of the chorus if you do. To learn how to phrase, study musicians.' I took her advice. I used to have favorite trumpet players and favorite saxophone players and favorite piano players. Art Tatum, Dizzy Gillespie, all the greats. Mimi also taught me the bel canto style of singing. It's for opera singers but I sang it in an intimate way. I use the same technique to warm up the voice and my voice is still in great shape, even now that I'm in my nineties. Mimi also taught me to only sing quality—intelligent songs. I learned that from my mom, too. We were very poor. My mom had to raise three children on her own and she took odd jobs, sewing. And sometimes she'd take a dress and throw it over her shoulder and say, 'Don't make me work on a bad dress.' And that sentence saved my life. Because I'd never work on a bad song. Never."

—TONY BENNETT, SINGER

ABOVE: *Among the teachers at the American Theatre Wing's Professional Training School was composer Jule Styne (shown here with Jerome Robbins, right), who headed the musical theater unit in the early 1950s.*

"I am aiming for a program for professionals. I am not interested in what happened yesterday in musical comedy. I am interested primarily in what is going on today. I hope to develop a program that will enable students to go out and get great jobs in today's market."

–JULE STYNE, TONY-WINNING COMPOSER, DIRECTOR OF THE MUSICAL DIVISION OF ATW'S PROFESSIONAL THEATRE SCHOOL IN THE EARLY 1950S

"When I was about twenty-four, in the early '50s, I had the very good fortune of taking classes through the American Theatre Wing with Eva LeGallienne, or as she was affectionately called, 'Le G.' She was a marvelous woman and a wonderful teacher. She was legendary, of course. As the founder of the Civic Repertory Theatre she could be called a pioneering figure in the movement now known as Off-Broadway. Eva was possessed of a wonderful intellect and she spoke a number of languages.

French, a little Russian and I think Norwegian. She also had the most wonderful speaking voice. Not only was she a great actress but she did adaptations of the classics she appeared in, like *Ghosts, The Cherry Orchard* and *The Three Sisters*. Eva had a lot of fire as I remember and I watched her intensely. Thanks to her, it wasn't very long before I managed to worm my way onto Broadway."

–CHRISTOPHER PLUMMER, MULTIPLE TONY WINNER

ABOVE: *Theatrical polymath and legend Eva LeGallienne was one of the most influential teachers at the American Theatre Wing's professional training school. The writer, actor, director and producer called on her students to think of the theater as a vocation for a higher purpose.*

"THE THEATER SHOULD BE AN INSTRUMENT FOR GIVING, NOT A MACHINERY FOR GETTING."

–Eva LeGallienne, actor, director and producer

"I valued those few individuals who saw a spark of something creative in me, and kindled that fire, and made sure that it wasn't snuffed out by shame."

–NEIL PATRICK HARRIS, ACTOR, TONY WINNER, *HEDWIG AND THE ANGRY INCH*

THE AMERICAN THEATRE WING'S PLAYWRIGHTS UNIT

"I always knew I wanted to be a playwright. But when the war started I joined the army and was put in a desk job because I had a college degree from Temple University. At the end of the war, I was in Piccadilly Circus on VE Day when all the marquees of the theaters, which had been dark for six years, suddenly were ablaze with lights. The streets were crowded with people laughing and crying. I remember dancing in the streets with a sailor who was a complete stranger. Who cared? The war had finally ended.

When I came back to the states, I headed to Florida. I'd been cold for four years in the army and needed to warm up. I got warm and got material for a play. Then I made my way up to New York. People said, 'You can't just go up to New York and break into show business. You need to know people.' I didn't know a soul. I got a job as an elevator operator down on Wall Street. I was terrible. I couldn't line up the elevator car to the floors. People practically had to crawl out.

One day, on my coffee break, I picked up the New York Times, opened it, and there was this ad from the American Theatre Wing offering free writing classes for G.I.s. They were taught by Robert Anderson. I knew his play *Tea and Sympathy*. It was a lucky break, as if the heavens had opened and thrown it in my lap.

I met with Bob right away. He asked me if I had written any plays. I had a shelf full! I'd been writing for years. I got accepted and was in a class of nine or ten guys. We had to write something every week. Bob was a great

teacher—'This isn't very good, but you have talent.' His wife [Phyllis Stohl] was encouraging: 'Keep writing, keep writing.' I don't know if I'd have written *The Warm Peninsula*, my first Broadway play [which starred Julie Harris] if it hadn't been for that early encouragement. Probably. But it was the best welcome to New York I could have had."

—Joe Masteroff, librettist, Tony winner, *Cabaret*

> "I WAS IN PICADILLY CIRCUS WHEN THE WAR ENDED AND ALL THE MARQUEES OF THE THEATERS, WHICH HAD BEEN DARK FOR SIX YEARS, WERE SUDDENLY ABLAZE. THE STREETS WERE CROWDED WITH PEOPLE LAUGHING AND CRYING."

ABOVE CENTER: *Joe Masteroff, who studied through the American Theatre Wing's playwriting program for returning G.I.s, made his Broadway debut in 1959 with* The Warm Peninsula, *starring Julie Harris, Larry Hagman, Farley Granger, Ruth White, and June Havoc.*
OPPOSITE PAGE: *As a student of the Wing's professional training school, Masteroff was taught by the esteemed playwright Robert Anderson. The lessons took. Masteroff went on to write two musical classics:* Cabaret *and* She Loves Me.

ABOVE: *Joel Grey created the emcee of the "divinely decadent" Kit Kat Club in the landmark musical,* Cabaret, *written by songwriters John Kander and Fred Ebb and librettist Joe Masteroff.*

" Robert Anderson was teaching evening classes at the American Theatre Wing, and I got into his class. My basic diet at the time was gallons of thick, black coffee, which I had read that Balzac drank, and day-old bread that a neighborhood baker sold for pennies. I enjoyed the fantasy of being a starving young writer, but my body didn't. One night, in the middle of Bob's class, I got so weak and dizzy I had to leave. I had no idea that Bob knew it was because I hadn't eaten for days, until about midnight there was a knock on my door and there was Bob Anderson, having walked up five flights, with two enormous paper bags of groceries. In the morning I found an envelope he had stuck into my mailbox. In the envelope were five hundred-dollar bills. There's no way I can describe the impact that this act of pure kindness had on me and no way to repay it except to pass it on, which I've tried to do ever since."

—ARNOLD SCHULMAN, PLAYWRIGHT AND SCREENWRITER, *A HOLE IN THE HEAD*

> "When I teach playwriting, I say that half the job is learning how to write a play. The other half is learning how to get along with people."
>
> –ROBERT ANDERSON,
> PLAYWRIGHT, *TEA AND SYMPATHY*

ABOVE: *Robert Anderson, who taught playwriting to returning G.I.s for the American Theatre Wing, wrote* Tea and Sympathy, *starring John Kerr as a sensitive, troubled youth and Deborah Kerr as his sympathetic confidante.*
BELOW RIGHT: *Joe Masteroff wrote the 1963 musical,* She Loves Me, *starring Jack Cassidy(right), Barbara Baxley, and Nathaniel Frey.*

"We had mock auditions in front of professional casting directors like Michael Cassara. I was incredibly nervous: 'Everybody relax, we just want to see what you can do as a person not as an automaton.' I prepared 'I Hate the Bus' from *Caroline, or Change,* and 'Fly into the Future' from *Vanities.* As I was leaving the room, he stopped me. 'You forgot to put contact information on your resume.' And I was like 'Oh, right. Good point.'"

–Anissa Felix,
SpringboardNYC 2013,
Motown, national tour,
Sunset Boulevard, Broadway

Above Right: *Tom Hanks was a guest speaker at the 2013 SpringboardNYC program. Among the participants was Anissa Felix, who later starred as Diana Ross in* Motown *and was featured in the 2017 revival of* Sunset Boulevard.

Below Right: *Anissa Felix picks up pointers in a workshop at 2013 SpringboardNYC.*

Opposite Page: *Michael Xavier, as Joe Gillis, leads the ensemble in a number from the 2017 Broadway revival of* Sunset Boulevard. *Anissa Felix appears in a purple costume.*

"I WOULD TELL THE STUDENTS, WHAT YOU NEED TO LEARN AS EARLY AS HUMANLY POSSIBLE IS THAT THE THEATER WORLD IS NOT FAIR."

ABOVE: *Chanté Adams, an alumna of Detroit's Cass Technical High School, and mentor-actor Peter Francis James, delight in one of the lighter moments at a 2016 SpringboardNYC training session.*
BELOW: *Scott Keiji Takeda works on material at a SpringboardNYC training session. The actor has since gone on to several professional stage roles, including playing Henry in an East-West Players production of the musical* Next to Normal.

"When you come to Springboard, you know nothing. You've had maybe one audition to get in. You're all eager beavers ready to learn. And, ten years later, when I came back to speak at Springboard, I would tell the students, what you need to learn as early as humanly possible is that the theater world is not fair. And as soon as you can learn that, you can let go of the many frustrations and emotions that have nothing to do with you or your performance or your talent or your personality."

–PATTI MURIN, SPRINGBOARDNYC STUDENT AND MENTOR, *FROZEN, THE BROADWAY MUSICAL*

"Springboard is almost a surreal time because you're connecting on so many levels: working on your own material, working on audition material, speaking with artists, actors, producers about their own experience. We got to hear Kathleen Marshall [director-choreographer of *Anything Goes*] talk about how vulnerable, fallible, talented and gifted Sutton Foster was navigating the role of Reno Sweeney. And then later that week to see her commanding performance in the show was breathtaking."

–Adam Hyndman,
SpringboardNYC, *Aladdin*

Above: *Adam Hyndman, a 2011 SpringboardNYC participant, starred in a radically re-conceived production of* Pippin *at Princeton in 2012.*
Below Left: *Adam Hyndman listens intently at a 2011 SpringboardNYC session, one of many geared toward helping college students prepare for a life in the theater by counseling them in all aspects, from housing and financial management to auditions and performance.*

RIDING A *CYCLONE*

"I attended Springboard in the summer of 2014 and one of the most memorable speakers was Kelli O' Hara. She came in and, like a lot of the others, spoke about all the disappointments that we were sure to encounter. And in a particularly vulnerable moment she spoke about her own recent disappointment. She'd lost the Tony Award—for the fifth time—for *The Bridges of Madison County*. She said that she'd have loved to have gotten up to the podium and thanked her parents and teachers. But she added that no matter what setbacks her career faced, she remained grateful for what she'd been given and so should we.

About a year later, I was cast in the Chicago production of *Ride the Cyclone,* my professional debut, which was a dream come true. Even more exciting was the news that it would be moving to New York and play Off-Broadway at the Lucille Lortel Theatre. Then I received a phone call from the director [Rachel Rockwell] telling me that I was one of three members of the cast who would not be going with the production. I kept remembering

what Kelli had said. Her words of gratitude for what you've been given really stuck with me. I mean, having been cast in *Ride the Cyclone* right after graduating from school was a miracle. But it still took me a couple of months before I could let it go.

And then six days before the show was to open in New York, I got another call from the director. It was midnight, my mom had just flown in to spend Thanksgiving with me and suddenly my phone lit up. I wondered, 'Why would the director be calling me at this time of the night?' The director said, 'Can you be on a plane and get out here?' I looked over at my mom, who'd just brewed tea

for us. She said, 'Say, "Yes!"'

I was just dumbfounded. I'm such a planner. I love to count down the days to something. But originating a role in a new musical in New York, a dream of a lifetime, and not to have any notice? And at that very moment, I was doing a musical for an audience of about eight or ten in a no-pay, non-Equity theater in a neighborhood of Chicago. It was a quick change of scenery. [Laughs] Two days later I was on the stage of the Lucille Lortel making my New York debut in *Ride the Cyclone*. The next day was Thanksgiving. And two days after that was my birthday. So, yeah, be thankful for what's given to you--and ride out all the rest."

–TIFFANY TATREAU,
SPRINGBOARDNYC 2014,
RIDE THE CYCLONE

ABOVE: *When Kelli O'Hara spoke to the SpringboardNYC attendees of disappointment, she had just lost a fifth Tony for* Bridges of Madison County. *She later won on her sixth try as Anna in* The King and I.

OPPOSITE PAGE: *Tiffany Tatreau, a Springboard alumna, is flanked by Emily Rohm and Jackson Evans in the Chicago Shakespeare's 2015 American premiere production of* Ride the Cyclone, *directed and choreographed by Rachel Rockwell. The show transferred to Off-Broadway the following year.*

ABOVE: *Ryan McCurdy, newly arrived in New York, got a job through the American Theatre Wing's Theatre Intern Network as a production assistant on the Tony Award-winning Broadway musical* Once. *McCurdy teamed with Eric Love, an ATW Springboard alumnus, to spoof* Once, *for which Steve Kazee (top) won a Tony, at the 2012 Easter Bonnet Competition, a benefit for Broadway Cares/Equity Fights AIDS.*

Gold! So I went and found myself surrounded by people my age. It was a TIN night. Later, eating pizza with about twenty-five other interns, I learned this was an organization whose goals were camaraderie and making sure you got to see shows so your pilot light didn't go out while you were struggling as an intern. Three years after that first TIN meeting, I had health care, an Equity card, I was making money, and I had met someone in Baltimore that I am head over heels in love with. If you could trace all the most important encounters, e-mails, phone calls of my life, the one that changed everything was David wanting to take his date to a romantic restaurant instead of theater."

–RYAN MCCURDY, ACTOR,
THEATRE INTERN NETWORK

"When I first heard about the ATW's intern program, I thought it was a joke. The first thing you learn when you move to New York is that the city, wonderful as it is, doesn't care about you. And here was this organization that cared. Really? I arrived in New York from the South. I was twenty-six and heartbroken from a bad relationship. I had two bags and no plan because I thought I was in a '60s musical. I got a job working as an intern at the Signature Theatre and one day my co-worker David Bruin hands me tickets to *Mrs. Warren's Profession* because he didn't want to go. Two comp tickets to a Broadway show?

"I COULD TRACE ALL THE MOST IMPORTANT ENCOUNTERS OF MY LIFE TO THE ONE THAT CHANGED EVERYTHING: *MRS. WARREN'S PROFESSION.*"

ABOVE: *Jerron Herman and Theatre Intern Network members at a workshop in 2015.*

ABOVE: *Theatre Intern Network alumna Rachel Sussman, center, with her creative team on* The Woodsman. *The production was a winner of an Obie Award for its puppet design in 2016.*

"I was working at 321, a theatrical management group, when I paid my $10, ate my pizza and became a member of the Theatre Intern Network. People were from totally different backgrounds, many who'd never studied theater in college, some who were interested in sports, some in finance. It was a great testing ground. What we all had in common was commitment and passion. My goal was to test my own limits. I found that I really like 'making the thing' not being added to the thing so I gave up acting to be a producer. Pushing boundaries is what I learned at NYU Tisch [School of the Arts]. I ended up in the Experimental Theatre Wing and I remember the teacher came into the classroom and said, 'You're all pre-schoolers' and left us alone. It was wonderfully weird. She was saying, 'There are no boundaries. Come as you are. Take risks.' Now, as a 'theatrical yenta,' I like to create that same safe space, introducing early career writers to directors and producers."

–RACHEL SUSSMAN, THEATRE INTERN NETWORK, DIRECTOR OF PROGRAMMING, NEW YORK MUSICAL FESTIVAL

"A TEACHER CAME INTO THE ROOM AND SAID, 'YOU'RE ALL PRE-SCHOOLERS' AND LEFT US ALONE. IT WAS WONDERFULLY WEIRD. SHE WAS SAYING, 'TAKE RISKS.'"

Excellence In Theatre Education Honors

ABOVE: *Corey Mitchell of the Northwest School of the Arts in Charlotte, North Carolina, received the Excellence in Theatre Education Tony Honor at the 2015 Tony Awards and showed up with what he called "my plumage" on his lapel—a homage of sorts to the production of* Hair *which he directed at the school.*

OPPOSITE PAGE: *21-year-old Eva Noblezada, a student of Corey Mitchell at North Carolina's Northwest School of the Arts, made her Broadway debut as Kim in the 2017 revival of* Miss Saigon *and was nominated for a Tony Award.*

"I taught Eva [Noblezada] and she was this nice, sweet, quiet little girl. She told me how her aunt did *Miss Saigon* and I said, 'You know, sweetie, one of these days you're gonna have your own Broadway show.' I had no idea how prophetic that was going to be. As a middle school child, she was Maisy LeBird in a production of *Seussical Junior* and I watched her and I thought this girl has something truly spectacular. I couldn't take my eyes off of her. In that same show, playing Gertrude McFuzz, was Abby Corrigan who is now playing [Medium] Alison in *Fun Home.*"

–COREY MITCHELL, 2015 EXCELLENCE IN THEATRE EDUCATION TONY HONOR, NORTHWEST SCHOOL OF THE ARTS, CHARLOTTE, NORTH CAROLINA

"I SAID, 'SWEETIE, ONE OF THESE DAYS YOU'RE GONNA HAVE YOUR OWN BROADWAY SHOW.' I HAD NO IDEA HOW PROPHETIC THAT WAS."

"One day I noticed a young man sitting in the wings during our rehearsals of *Rent.* He wasn't in the arts, he was in the curriculum for electronics and robotics. But I invited him to work on crew and he reluctantly joined in. I noticed him singing songs and hanging out even when we didn't need him. I recall saying to him, 'Do you want to be in the show?' And he said, 'Oh, no. No. No. No. My parents won't let me do this. My dad says this is sissy stuff.'

At any rate, he eventually auditioned and did get a smaller part. But then the young man playing Mark had to have surgery and my boy said, 'I can do that part.' I re-auditioned him and everybody in the cast said, 'He's it!' He got the part. I had to drive him home from rehearsals each night because he had nobody else. He lived with his grandmother—his mom had just gotten out of prison and was living in Chicago—and his father wouldn't pick him up. They knew he was working on the show; they just didn't know he was in it. On our drives, he confided in me that he was

having these [homosexual] feelings and several experiences and didn't know what it all meant. He was only sixteen or seventeen and still exploring.

One night, his grandmother and I talked and she said, 'I figured he was in the play. I seen him singin' and dancin' and doing all this stuff.' One day, after he got home from rehearsal his father and several of his uncles met him at the door and proceeded to beat him up. 'We're going to beat this thing out of you.' We had to call the police. It was absolutely insane. The kids at the school knew

about it since it had been on the news. The father was eventually sent to prison. The young man went to the hospital and after he got out, he and the grandmother moved. But that incident made him stronger and even more motivated. He vowed he was going to do the play. And he did do it.

To this day he's still performing, working in Chicago. I know that it was theater that saved his life, you know what I'm saying? And when he came back to the show? You know I had football players in *Rent,* and they all just embraced him when he came back. That wouldn't have happened in math class."

–Marilyn McCormick, 2016 Excellence in Education Honor, Cass Technical School, Detroit, Michigan.

Above Center: *Josh Groban was on hand to present the 2016 Excellence in Education Tony to Marilyn McCormick of the Cass Technical School in Detroit, Michigan. Prior to her retirement, McCormick directed a production of* Rent, *which featured a life-saving role for one of her students.*
Opposite Page: *Ma Rainey (Arnetia Walker) sings and Dussie Mae (Chanté Adams) swings in a revival of* Ma Rainey's Black Bottom *at New Jersey's Two River Theatre. Adams, a pupil of Marilyn McCormick at Detroit's Cass Technical School, has also scored with a film,* Roxanne Roxanne, *co-starring Mahershala Ali, Oscar winner for* Moonlight.

THE ANDREW LLOYD WEBBER INITIATIVE
Schooling the Next Generation

What's in a name?

For Dina Perez, a junior at the Chicago High School of the Arts, quite a lot—especially when that name is Andrew Lloyd Webber and it is attached to a scholarship that is helping her realize a dream to be in musical theater.

"Andrew Lloyd Webber's name in the title of the scholarship is a reminder to me how much a person is capable of with the right resources," says Perez, a beneficiary of the Andrew Lloyd Webber Initiative administered by the American Theatre Wing and founded in 2016. "I hope one day to touch audiences the way he does."

Lloyd Webber's touch, of course, is global—now and, seemingly, forever---especially since the legendary composer has a new hit on Broadway and the West End. *School of Rock* tells the story of private school kids whose listless lives are electrified when a slacker masquerading as a substitute teacher turns them on to the raucous joy of making music.

Empowering that exuberance for other, less fortunate, young people was what Andrew Lloyd Webber had in mind when he came to the Wing with a proposal for what would be an extension of sorts to what his foundation had been doing in Britain since 1992. "I feel strongly that one is obliged to put back something into a profession that has been so good, certainly, to me, " says the composer.

Paying it forward came in the form of financial support providing arts education to beleaguered schools and individuals. The need was acute. Some of the schools, like Calumet New Tech High School in Gary, Indiana had theater equipment in serious disrepair. Many of the recipients of scholarships come from single-parent families and are experiencing difficult circumstances softened by balm only the arts can provide.

"Theater became my sanctuary, my home, my platform for self-expression," says 16-year-old Collette Caspari of Cumming, Georgia, the recipient of a scholarship that allowed her to attend an intensive summer camp program. The money was manna from heaven for this child whose single mom moved her from Los Angeles to the small-town South to take care of an ailing parent. She says the culture shock she had to endure was complicated by the bullying she experienced as "a pleasantly curvy, drama geek."

The same could be said of another scholarship recipient, Daelin Elzie of Manvel, Texas, a self-described "shy, sensitive, nerdy and just plain different child" who saw theater as "a haven." It was one that could allow him to escape the limited options of the inner-city for the limitless dream of attending London's Royal Academy of Drama Art.

Asked if he can relate to theater as a harbor, Lloyd Webber quickly responds, "Yes, I can. I mean, when I was a kid myself, that's very much how I felt. I completely understand because I think it's a world in which, when you're a child and maybe if you're not happy at home, you can inhabit and therefore release yourself."

Lloyd Webber says that this release of the empowering force of music is a mandate of the Wing program. "We all know that music transcends all barriers of class, race, money, whatever you like," he says. "And it's much harder for people who don't have the financial resources to get into the theater. I thought it was something the American Theatre Wing was uniquely able to advise on. And so far, I've been very excited by what the choices have been."

Those choices include students wanting to pursue careers in various theatrical disciplines from acting to dance to lighting and stage management. Lloyd Webber agrees with the implicit acknowledgement that all the elements have parity. "I'm

ABOVE: *Covington High School in Louisiana, a recipient of the Andrew Lloyd Webber Initiative, presents a wide range of productions from* The Addams Family *to* The Little Mermaid *to, above, Shakespeare's* Julius Caesar. *Cameron Harmeyer played the doomed emperor in a recent production.*

BELOW: *Quinn Chisenhall of Quinton, Virginia is a recipient of an Andrew Lloyd Webber Initiative scholarship. The teenager aspires to be a lighting designer, happy to take a behind-the-scenes role in stagecraft.*

OPPOSITE PAGE: *Andrew Lloyd Webber with producer Cameron Mackintosh won the 1988 Tony Award for Best Musical for* Phantom of the Opera. *Lloyd Webber would later launch the Andrew Lloyd Webber Initiative with The American Theatre Wing.*

very acutely aware that I am only part of a theme," says the composer. "I'm a theater animal and I realize I need the director, the choreographer, the lighting and design team. Everything is absolutely vital. I'm a cog in the wheel and all the other cogs have to be right."

Quinn Chisenhall, an eleventh grader in New Kent High School in Quinton, Virginia is quite happy to be a "cog" in lighting design, having devoured text books on what he calls his "lifeblood" and having volunteered at local theaters to learn as much as he can. Recently, an Andrew Lloyd Webber scholarship made it possible for Chisenhall to spend a summer at

ABOVE: *Dina Perez of Chicago has received a scholarship from the Andrew Lloyd Webber Initiative which seeks to address the challenges in arts education among the underserved communities in America.*

Emerson College's Stage Design Studio Program in Boston. It was an invaluable step in a career path the teenager has been "fervently pursuing since I stepped onto a catwalk for the first time."

That sort of passionate response is echoed among the scholarship recipients. They also seek to create and extend safe havens to future generations. Destiny Cable, a junior from Pacoima, California, states that the scholarship she received will help her to realize the goal of becoming an "influential young black woman in media"—one who can get beyond the stereotypes and clichés. "I want to change the world with my art, my mind and my voice," she says.

Lloyd Webber appreciates the geographic reach of the Initiative, even to a fairly remote Los Angeles suburb like Pacoima. "I think the Wing does a tremendous job of getting the money

to all the right places and which I wouldn't necessarily know," he says. The composer brightens when he is reminded that Pacoima was the birthplace of Ritchie Valens, whose hit, "La Bamba" in the 1950s, pioneered the Spanish rock 'n' roll movement.

"I remember Ritchie Valens when I was a kid, so it goes on," he recalls, acknowledging something of a debt. And he once again expresses his delight that something which started in Britain and New York could find its way to the far reaches of the West Coast. "That's what I very much hope, and I hope this is but the beginning."

The following are among the recipients of college grants from the Andrew Lloyd Webber Initiative. The program, funded by the composer's foundation, was launched in 2016 to provide financial assistance in the form of classroom resources for K-12 schools, training scholarships to high school students, and four-year partial university scholarships in theater disciplines.

"When I was two months old, my mother made the decision to illegally cross the Rio Grande in order to start a new life, away from my father and closer to her family. My mother left because her life was falling apart and she had nowhere to go. My grandmother was already settled here in America and could offer my mother shelter and the promise of a job. My mother worked day and night to provide for me. She is a part of me in every way I am of her. She is the reason I want to pursue a higher education so that I can

make her proud and not let her sacrifices for us go to waste."

–NATALIA AVILA, PRODUCTION DESIGN, HOUSTON, TEXAS, ATTENDING UNIVERSITY OF OKLAHOMA

"When my mom gave up her parental rights and put me in the foster care system, I had a song ready to comfort myself. When I was struggling through a performance, I had my ensemble available to ground me. Every time I find out that yet another black person has been shot by the police, I have my voice to articulate how I feel. The arts live within me and I will use [them] to change the world for good."

–KAISHEEM FOWLER BRANT, ACTOR, BRONX, NEW YORK, ATTENDING HOWARD UNIVERSITY

"When I was a child I loved to make lists. I would take a pencil and a piece of paper and make a list of everything in my kitchen, then the living room and I would move throughout my house. Obsessively planning it out. I quickly learned stage management was my calling. Not only was I able to always know what was going on, but no one made fun of my organizational skills. In fact they were praised! This is why I want to be a stage manager: to serve my fellow cast mates while giving an outlet to the stranger parts of my personality."

-Carrli Cooper, stage manager, Winter Garden, Florida, attending University of Michigan

"During my transition from Kenya to Oregon, I learned that I am not only a creative being, but a fierce one. William Shakespeare said it best, 'And though she be but little, she is fierce.' I pursue a degree in the arts because it allows anyone from any background, race and ethnicity to have a voice. Continuing my education will help me understand the crazy world we live in. I want to understand why we as a society do the things that we do so that I can be a part of the positive change in this nation. I want to be the one leading—with fierce ambition. "

-Grace Pruitt, actor, Ashland, Oregon, attending Azusa Pacific University

"Ralph Ellison wrote, 'When I discover who I am, I'll be free.' For a while I looked around for that thing that would allow me to discover myself and set me free. I tried it all and soon realized it was performing. Theater is a way of giving. Whether it's giving the audience a two-hour escape from the harsh realities of life or simply giving them a reason to laugh, I feel that theater is a form of community service that brings people joy and a new understanding."

-Marcus Gladney, actor, Huntsville, Alabama, attending Carnegie Mellon University

Working In the Theatre

In 1972, Isabelle Stevenson, then president of the American Theatre Wing, launched the Working in the Theatre seminar series in which professionals from every aspect of the theater gathered to share information. The seminars, which were taped and are now available on YouTube, were freewheeling, spontaneous and often ran for hours. In 2013, Margarita Jimeno, a filmmaker and visual artist, was hired to produce and direct documentaries which have since been honored with numerous awards. With the advent of the Internet, the entire series became available to fledgling artists around the world, from Pocatello to the Philippines.

ABOVE: *In 2001, Brian Stokes Mitchell* (Ragtime) *and Natasha Richardson* (Cabaret) *were the guest panelists in an American Theatre Wing* Working in the Theatre *seminar hosted by ATW chairwoman Isabelle Stevenson. The topic: "Performers on Preparation and Professional Discipline."*

"When I was at Tisch [School of the Arts], we had studio time that would go on to the wee hours of the morning. Someone had recordings of *Working in the Theatre,* and we would just listen to designers and writers and directors talking about their work. And it was fascinating. I grew up in the Philippines in a family of lawyers so theater was a foreign concept to me, and it wasn't until I got to the United States that I discovered that there was this enormous resource. We couldn't get enough of it."

–CLINT RAMOS, SET AND COSTUME DESIGNER, OBIE AND HEWES AWARD, TONY WINNER, *ECLIPSED*

Excerpts From *Working In The Theatre* Seminars

ABOVE: *A 1981* Working in the Theatre *episode, simply called "Performance," featured a large panel comprising of American Theatre Wing chairwoman Isabelle Stevenson, Estelle Parsons, Jerry Orbach, Wanda Richert, critic Henry Hewes, producer Jean Dalrymple, Seret Scott, Ian McKellan, and Carole Shelley. The discussions often ran for nearly two hours.*

BELOW RIGHT: *In 1991, Jonathan Pryce, Mercedes Ruehl, Sarah Jessica Parker, and Brendan Gill participate in an American Theatre Wing's* Working in the Theatre *panel discussion that was then broadcast on CUNY-TV.*

On Auditioning

ABOVE: *In 2007, Tony winner John Lloyd Young (*Jersey Boys*), Alison Pill (*Blackbird*), and Jonathan Groff (*Spring Awakening*) represented the new crop of actors in "The Next Generation," an episode in* Working in the Theatre.

"I always wanted to be an actor since I was five years old. It was either a missionary or an actress. My mother wanted me to be a missionary. I feel it's almost the same thing."

–ELIZABETH FRANZ, ACTOR, TONY WINNER, *DEATH OF A SALESMAN*

"One of my colleagues said to me once, 'When I go into an audition, I look around and I say, 'Ten or twenty-five years from now, you will all be dead and I will still be alive!' And that gave him the courage to do it."

–MAXIMILIAN SCHELL, ACTOR

"When I auditioned for something and I thought I screwed up, my father once told me, 'Maybe they did.'"

–MATTHEW BRODERICK, ACTOR, MULTIPLE TONY WINNER

"When an actor auditions for a play or musical, we don't make the decision. They walk into a room, open their mouths—they're that part and they own it. That's what you look for. Because when someone walks into the room and reads a part, there can be no argument among the creative staff because [that person] owns it."

–JAY BINDER, CASTING DIRECTOR

"I go in there knowing that I'm going to get it. No, I do. That is my attitude. I go in there, I'm going to get it, and nothing stands in my way. And if I don't get it, they're STUPID!"

–NELL CARTER, ACTOR, TONY WINNER, *AIN'T MISBEHAVIN'*

"I'D SAY, 'WELL, HOW DO YOU WANT THIS? WOULD YOU LIKE IT, LIKE, TALL? SHORT? FUNNY? YOU KNOW, SERIOUS?' AND THEY WOULD BE DUMBFOUNDED."

–*Roger Rees, director and actor, Tony winner,* The Life and Adventures of Nicholas Nickleby

"Cut the variables. Make sure everything under your control is under control. Realizing this was the part of a lifetime for a young actor [Harold in *Master Harold…and the boys*], I did everything that I possibly could to be right for the role: I got a haircut, I bought contact lenses, because I thought they wouldn't want a little Jew with glasses. I wore a school jacket and shoes—which I haven't worn since—I really went after it hard."

–LONNY PRICE, ACTOR, DIRECTOR, AND PLAYWRIGHT

On Acting

ABOVE: *A 2005 episode of* Working in the Theatre *featured Richard Easton, Marian Seldes, Frances Sternhagen and Robert Prosky talking about acting with Ted Chapin, a former chairman of the American Theatre Wing.*

"All this stuff is just theory. It's true, you can talk all you want to about it. But there's only one place finally to learn. That's up on the stage with your hair on fire!"

–F. MURRAY ABRAHAM, ACTOR

"I heard once that Ralph Richardson occasionally would have a live mouse in his pocket. And the reason why, he said, 'To keep my mind off myself.'"

–ROBERT PROSKY, ACTOR

"Alfred Lunt said to his wife, the brilliant Lynn Fontanne, 'Why do I miss the laugh on that line when I ask for the sugar?' And she said, 'Alfred, darling, you're not getting the laugh because you are asking for the laugh, not for the sugar!'"

–MARIAN SELDES, ACTOR, MULTIPLE TONY WINNER

"I took a crash summer course at the Stella Adler Studio. I didn't work with Stella Adler. I was working with her cousin or something. It was a little too abstract for me. She would say, 'Go to the window and tell me what you see—you know, describe.' And people would go, 'I see a homeless person. I see the poverty of the world. I see dark clouds, and I see the tragedy of life.' She asked [me], 'What do you see?' And I said, 'I see $400 going down the drain.'"

–NATHAN LANE, ACTOR, MULTIPLE TONY WINNER

117

"BEFORE THE CURTAIN GOES UP, I SAY A PRAYER EVERY NIGHT. I PRAY FOR THE AUDIENCE. I REALLY DO. I SAY, 'LORD, HELP THEM.'"

–Heather Headley, actor, Tony winner, Aida

On Producing

ABOVE TOP: *A 1997 American Theatre Wing panel featured the creative team of the musical,* Side Show, *some of whom were dressed in Gregg Barnes' inventive costumes.*

ABOVE BOTTOM: *In 2004, Obie-winning puppeteer Basil Twist (*Symphonie Fantastique*) was a guest on the American Theatre Wing's* Working in the Theatre: Puppetry & Theatre *which explored the intersection between humans and puppets.*

OPPOSITE PAGE: *Heather Headley was appearing in the title role of the Disney musical* Aida, *for which she won a Tony Award, when she was part of a* Working in the Theatre *panel discussion which included Alan Cumming, Daniel Davis, Maximilian Schell, Lily Tomlin and Faith Prince.*

"It's all on-the-job training. For all of us."

−RICHARD FRANKEL, PRODUCER, MULTIPLE TONY WINNER

"Producing is about balance. That's the art of it: being able to follow the passion of the artists, giving them what they need and getting completely taken away by the process of it, but still being able to make proper business decisions."

−DAVID STONE, PRODUCER

"It's a crapshoot. And it's a cultural crapshoot, which in my mind justifies it for myself— we're trying to do something to nudge the world. That heartfelt commitment justifies your behavior."

−MANNY AZENBERG, PRODUCER, MULTIPLE TONY WINNER

"We're in the business of making something out of nothing. That's what we do. We take a piece of paper and we read it. And a director says, 'I can spin a web with that piece of paper.' We make a total commitment of faith. We are the last of the believers."

−LIZ MCCANN, PRODUCER, MULTIPLE TONY WINNER

"Making [Off-Broadway] into an adjunct of Broadway? We will never win that battle because Broadway's always going to win. It has more money, more media attention. We need to define ourselves for what we do best: more cutting-edge, more sophisticated, more intelligent material."

−ALAN SCHUSTER, PRODUCER

"If you take something fascinating for 500 people and make it boring for 500,000 people, then it's a crime against the art."

−LINDA WINER, THEATER CRITIC

On Writing

ABOVE: *In 2011, playwrights Young Jean Lee and Tarell Alvin McCraney (who would later win an Oscar for the film* Moonlight)*, talked about "Compelling Stories" in an episode of* Working in the Theatre.

"Sometimes, playwrights don't know what they've written and you have to explain it to them."

–JOHN TILLINGER, DIRECTOR

"For me, fear has to do with facing the blank page—not knowing what I'm going to write about."

–NILO CRUZ, PLAYWRIGHT

"I don't think anything I do is either risky or safe. I don't think you can think about it. You're so lucky, you feel so happy to have a germ of an idea. You can't say, 'Oh, too damn risky, too damn safe.' It's just an expression of your unconscious more than anything else."

–NICKY SILVER, PLAYWRIGHT

"[Director] Jon Jory gave me a great piece of advice: 'When you're looking for a subject, look to a time in your life when you were terrified—when you were really frightened, when you were frozen in fear.' And that does, indeed, turn out to be a great place to look for subject matter."

–MARSHA NORMAN, PLAYWRIGHT, TONY WINNER, *THE SECRET GARDEN*

"I met another playwright who was not really a very good playwright, but one of the most confident human beings I've ever met. And she was so sure of her own genius that at the end of each day of writing, she would put the pages she'd worked on in the freezer, so in case her apartment caught on fire, they would be saved—or at least chilled."

—PAUL RUDNICK, PLAYWRIGHT

"**YOU KNOW YOU HAVE A GOOD COLLABORATION WHEN YOU HAVE REALLY GOOD FIGHTS.**"

–Paula Vogel, playwright

"I'm quickly learning that one of the most important tools a playwright must have is to be able to filter out the voices that he or she should not listen to for a second."

—JONATHAN TOLINS, PLAYWRIGHT

'The trick is to try to write a play, actor-proof, and director-proof, critic-proof and audience-proof."

—EDWARD ALBEE, PLAYWRIGHT, MULTIPLE TONY WINNER

ABOVE: *In 2012 in a* Working in the Theatre *episode, Alan Menken explains the anatomy of a song from his hit musical,* Newsies, *with an assist from the show's star, Kara Lindsay, and his co-writer, Jack Feldman.*

"I didn't really want to be a writer. I just wanted to be onstage and I had to find some way to do it—because the message was getting back to me that I was a little too offbeat and weird. So I started writing my own material and I became a writer out of necessity."

—CHARLES BUSCH, PLAYWRIGHT

"Craft can be self-taught because there are so many brilliant examples in terms of playwriting. The craft is all around you. Just go to the library, pick up Chekhov if you want to know about craft."

—AUGUST WILSON, PLAYWRIGHT, TONY WINNER, *FENCES*

"If your goal is only a two-thousand-seat theater, then maybe you'll have some problems. There are a lot of good sympathetic theaters around this country, many as far away from New York as you can get."

—EDWARD ALBEE

"Beyond just nurturing the writer, I think that the regional theater, more than Broadway, has given writers and artists the right to fail."

—MICHAEL PRICE, EXECUTIVE DIRECTOR, GOODSPEED MUSICALS

"Most writers now, I think, say 'Avoid New York as long as possible. Let your play live.'"

—EMILY MANN, PLAYWRIGHT, PRODUCER AND DIRECTOR

Working In The Theatre: The Documentary

ABOVE: *Billy Porter is the subject in* Working in the Theatre: Before the Show *directed by Margarita Jimeno.*

"*Working in the Theatre* is now being made by a bonafide filmmaker, Margarita Jimeno. That's a 'quality' issue. It's an extraordinary thing to have done. I'm a big fan of the work she's done and the way she has injected some class in the series in a cool and intelligent manner. It's a synthesis of intellect and emotion. The films manage to bring people into the experience of making theater so that anybody, not just theater people, are interested in the process."

–TED CHAPIN, FORMER CHAIRMAN OF THE AMERICAN THEATRE WING

"This is generalizing but I think theater-making is very intellectual and I love that because there is a lot of anti-intellectualism in America. People should be confronted with big ideas. My film on clowning [*Working in the Theatre: Clowning*] makes an intellectual connection: the history, the stigmatization, the different types of humor. But it also makes an emotional connection because 'the last clown' lives his whole life like a clown and makes very important statements about how, as humans, we don't preoccupy ourselves with the need to be happy. And it was a very positive way to end last year. Because everybody was so depressed."

–MARGARITA JIMENO, PRODUCER, AMERICAN THEATRE WING'S EMMY®-NOMINATED *WORKING IN THE THEATRE* DOCUMENTARY SERIES

"I often ask a question to create a reaction. When I was interviewing Billy Porter—he was playing the drag queen in *Kinky Boots*—I asked him, 'Do you understand women as much as you understand men?' And, for a moment I thought, 'Oh, my gosh, did I piss him off?' But when we edited the film, it was fantastic."

—MARGARITA JIMENO

ABOVE: *Ramin Karimloo does a cold reading of* White Rabbit Red Rabbit *by Iranian playwright Nassim Soleimanpour. No actor was allowed to read or know anything prior to the performance of the play.*

"I do think I understand women as much as I understand men. I actually think I understand women better. I was raised by women. There were always very strong women around me. And it's amazing as an actor to express both sides of the coin. [The character of] Lola was always living inside of me. Being in a woman's high-heeled shoes is very empowering and it makes me feel more masculine."

—BILLY PORTER, ACTOR, *WORKING IN THE THEATRE: BEFORE THE SHOW*

"I CARE A LOT ABOUT VOICES THAT HAVE BEEN SILENCED."

"I have agreed to do a play called *White Rabbit Red Rabbit*. And the gist is that I have never seen this play or read this play before stepping out onto the stage and being handed an envelope and opening it and beginning to perform this play in front of a packed audience. That's all I know. I mean, that's closer to life than theater is. We only get one shot to do most things. I'll just look at this as a special, once-in-a-lifetime experience and do my best."

—JOSH RADNOR, ACTOR, *WORKING IN THE THEATRE: WHITE RABBIT RED RABBIT*

"Life doesn't have any rehearsals, does it? You just wake up in the morning, today is today, you don't repeat it tomorrow. On the other hand was my situation of not having a passport. All those things together pushed me to come

to a point that if I write a play which can travel on my behalf, it can be written in English. It can be about the nightmare I had. It can find its way around the Iranian structure of supervising the arts. It's in your computer. You can just e-mail it to anyone around the globe. And it can be performed. So that's what I did."

—NASSIM SOLEIMANPOUR, PLAYWRIGHT, *WHITE RABBIT RED RABBIT*

"We believe that theater, social experiment, means giving voice to someone whose voice may not otherwise be heard and doing it in a way that is challenging and entertaining and exhilarating. For my own personal value set, I care a lot about voices that have been silenced."

—TOM KIRDAHY, CO-PRODUCER, *WHITE RABBIT RED RABBIT*

"It's a miraculous thing that's happened. In 1944, the U.S. War Department thought it was important during battle to have musicals written by privates, to be performed by soldiers, on their time off. The reason they did that was to boost morale, so if you think about it, in 1944, the U.S. War Department thought it was important to have musical theater as a form of art therapy for people living in some of the most dire situations."

—ARIAN MOAYED, ACTOR, CO-ARTISTIC DIRECTOR OF WATERWELL THEATRE COMPANY IN *WORKING IN THE THEATRE: BLUEPRINT SPECIALS*

"As a soldier myself and as a veteran who benefitted during the late 1980s and early '90s, when programs existed in a huge way, on Fort Hood, in Texas, we had theater programs. Those sort of programs made those of us who were artistic but also brave military service members, those programs made us whole. What I think our nation can learn from theater is how to put themselves in other people's shoes, whether it be a military character or a minority character or any character that can actually change your perspective."

—VICTOR HURTADO, PRODUCER AND VETERAN, *BLUEPRINT SPECIALS*

"There was a need to bridge [the gulf] between the two worlds of this project. All great civilizations are remembered for their wars and for the art. Which one do you want to be remembered for?"

—WILL SWENSON, ACTOR, IN *BLUEPRINT SPECIALS*

BELOW: *A poster card from* Working in the Theatre: The Blueprint Specials *for the American Theatre Wing.*

to be seen. I'm talking about where we are culturally: that things are beginning to change, but 'changing ain't changed.' It's a funky moment for gender in America right now, and it's cool to work on this play and knowing that when I started this process, I was a completely different person with a different name and a different pronoun."

–WILL DAVIS, DIRECTOR, *COLOSSAL*

"I'm a trans-identified person, artist, human in the world, and this show is immensely wonderful because my experience as myself, as Will Davis moving through the world, is about performing masculinity. From what I can see, we're all performing our gender in one way or another. We're all getting up in the morning and putting it on and then going out and asking people to see us as we want

ABOVE: *The betrayal of the body is one of themes in Andrew Hinderaker's award-winning drama,* Colossal, *which was presented at the Dallas Theatre Center in 2015 and which is the subject of a* Working in the Theatre *documentary. The ensemble included a star athlete who suffers a traumatic injury.*

ABOVE LEFT: *Director Will Davis marks the script of* Colossal *with actor Mike Thornton in the background in a scene from the American Theatre Wing's documentary on the groundbreaking production.*

ABOVE: *Actor Mike Thornton, as an injured football player, recalls the past glories of a star athlete in this rehearsal shot from the Wing's* Working in the Theatre: Colossal.

" Colossal immediately spoke to me as a tale of masculinity and a question of 'What makes a man?' 'How do you define what a man is?' And you also have three different visions of what it is to be a man. There's a father, Damon, a legendary modern dancer... But the father was rejected by the son. Young Mike turned away from modern dance and went to football. That is certainly another way of expressing masculinity. And then finally, you have this gentle soul, Older Mike, played by Mike Thornton, who comes on stage in his wheelchair quiet, reserved, emotionally blocked off from the world, trying to figure out how he can be a man and what it is to be a man for him."

—JASON LOEWITH, ARTISTIC DIRECTOR OF OLNEY THEATRE CENTER IN *WORKING IN THE THEATRE: COLOSSAL*

shared his story, his experience, and that character began to be built around his body."

—ANDREW HINDERAKER, PLAYWRIGHT, *COLOSSAL*

"This is a guy, the actor Mike Thornton who had a freak spinal stroke in 2003.... We're asking him to relive the moment of that break every night, seven nights a week, in public, in front of an audience. That is an enormous thing to ask a person to do. And to live in that moment for an hour and a half in front of all of these witnesses takes great courage, great artistic courage."

—JASON LOEWITH

"*COLOSSAL* IMMEDIATELY SPOKE TO ME AS A TALE OF MASCULINITY AND A QUESTION OF 'WHAT MAKES A MAN?'"

"Mike's an actor who uses a wheelchair. About 10 years ago he had a spinal stroke and we've worked on a number of projects that are specific to disability. But, when I realized what this role would be, I reached out to Mike and he really graciously

ABOVE: *Marlee Matlin, Daniel N. Durant, Joshua Castille, Sandra Mae Frank, and Amelia Hensley were among the cast members of Deaf West's revival of* Spring Awakening *featured in the Wing's Emmy-nominated documentary,* Working in the Theatre: Sign Language Theatre.

BELOW: *Austin P. McKenzie, as Moritz in the Deaf West revival of* Spring Awakening, *seems to epitomize the musical's theme of the desperate attempt of the young to light the darkness of fear and repression with truth.*

"The world is finally seeing us. I mean, we've always been here. But the world is finally waking up to us. We're not going anywhere and we're going to keep making noise no matter what."

–SANDRA MAE FRANK, ACTOR, *SIGN LANGUAGE THEATRE*

"Anything that you think is your limitation can actually be the thing that makes you so special and the perfect person for a project. I'm sure many of these actors grew up wondering if they were going to make their way in a business that is not inclusive of them. But it's those very actors who've made this unlike anything on Broadway. It allows you to look at your own ability and think, 'What do I think about me that I think of as a limitation that could actually be my superpower?'"

–ANDY MIENTUS, ACTOR, *SIGN LANGUAGE THEATRE*

"Deaf theater didn't begin with the National Theatre of the Deaf in 1969. It began long before that in deaf clubs in the early part of the twentieth century. There would be vaudeville and different comedy shows. When silent films first appeared, deaf people would go to Hollywood to find work as actors. Charlie Chaplin saw that. He started hanging out with deaf actors. He even hired some of them as advisors. Chaplin knew that deaf actors had physical qualities. They had to communicate through their bodies, movements, language, timing. And he couldn't find that anywhere else."

–D. J. KURS, ARTISTIC DIRECTOR, DEAF WEST THEATRE, *SIGN LANGUAGE THEATRE*

"LOOK AT YOUR OWN ABILITY AND THINK, 'WHAT DO I THINK ABOUT ME THAT I THINK OF AS A LIMITATION THAT COULD ACTUALLY BE MY SUPERPOWER?'"

COMMUNITY
When Your Story Becomes Our Story

By David Henry Hwang

My playwriting career began in 1979, when my play *FOB*, written to be performed in my college dormitory, was accepted by the prestigious O'Neill Playwrights Conference in Waterford, Connecticut. As a twenty-one-year-old Chinese-American kid from Los Angeles, I marveled at this amazing opportunity to have my work supported by the East Coast theater community. Then, as rehearsals for my show began, I overheard a sound designer ask, "So what are we going to use for this show? Chink music?"

Less than a decade later, I became the first Asian or Asian-American dramatist to have my work performed on Broadway, with the opening of *M. Butterfly*, which received the Tony Award for best play in 1988. The drama is about a French diplomat who carried on a twenty-year affair with a spy who dressed and passed himself off as a woman but who was biologically a man. *M. Butterfly* was produced just as the culture wars began marching into the national discourse and the term "political correctness" was becoming weaponized. Though the play received much praise, it was also attacked from both the left and the right. One prominent critic wrote, "If David Henry Hwang hates America this much, then maybe his father should have stayed in China." At the same time, I was invited to symposiums where Asian-American academics criticized me for reinforcing Asian male emasculation.

OPPOSITE PAGE: *Ruy Iskandar and Yuekun Wu starred in the 2013 Signature revival of David Henry Hwang's* The Dance and the Railroad. *The drama of Chinese immigrant workers in 1867 America was a breakthrough when it premiered in 1981 at the Public Theater, not only for the playwright but for long-neglected Asian-American writers.*

ABOVE: *John Lithgow and B.D. Wong starred in* M. Butterfly, *David Henry Hwang's 1988 Tony-winning drama about a French diplomat who wittingly—or unwittingly—falls in love with a male Chinese opera star he believes to be a woman. The stunning costumes were designed by the late Eiko Ishioka.*

Now that the culture wars are back, we might ask ourselves, "How are they similar and how are they different? And how do we work through them so that our country can advance towards realizing its highest ideals?"

When I was growing up as the child of immigrant Chinese parents in Los Angeles, I assiduously avoided any movies that featured Asian characters. Most of them were inhuman—either inhumanly good or inhumanly evil. They were not like anyone I knew. And though they were made up to look like me, I felt no association with them. Since then, over the past five decades, I have seen the Asian stereotype evolve from Fu Manchu and the Yellow Peril, to martial arts superstar. We've gone from

"I OVERHEARD A SOUND DESIGNER ASK, 'SO WHAT ARE WE GOING TO USE FOR THIS SHOW? CHINK MUSIC?'"

poor, uneducated menial laborers to a race with too much money, too much education, and kids who are going to raise the curve in math class. None of these images are healthy. There are no good stereotypes.

A turning point for me came when

I was introduced to East West Players, a company of Asian-American actors who created nuanced, individualistic, and complex human beings onstage. These characters looked like me and I could associate with them. But I also knew non-Asians in the audience could relate just as much, because here were characters who may have acted differently in superficial matters but who were fundamentally and universally human. That's what art can do. That's what East West players did for me. They shaped the all-important perception that art can change how we see other people, and the world.

Once I achieved some success, I found myself on both sides of the culture wars. I was among those who

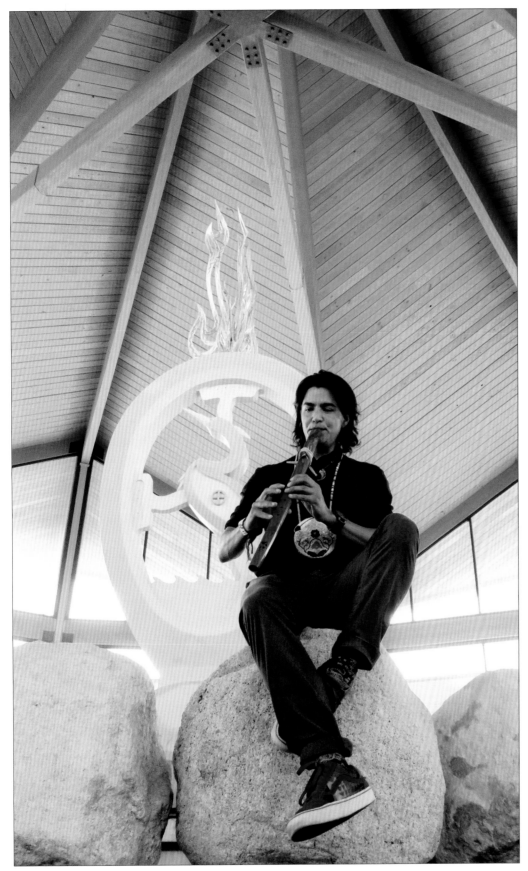

protested the musical *Miss Saigon* as it was about to make its American premiere. A non-Asian actor, Jonathan Pryce, had been cast in the role of the Eurasian Engineer, and Asian-American actors, customarily excluded from all but the few Asian roles available, were incensed. It was not only a question of social justice, it was about employment and survival in a profession they loved. *Miss Saigon* was a case in which we lost the battle—Pryce went on to win the Tony—but won the war. The producer Cameron Mackintosh promised that henceforth the role would be played by an Asian actor. These debates can be hurtful, but they are healthy, even when it's my own work being criticized.

Today, once again, the question is being raised: "Whose story is the American story?" Though empires have always used culture to reinforce dominance and superiority, art is also a tool through which a people defines itself. Whose story? Ultimately it's "your story." But the hope that theater provides is that by increasing the diversity of the stories onstage, "your story" becomes "our story." That means diversity not only among the races but a multiplicity of voices speaking within each community. No one playwright can represent a community, be it LBGTQ or Asian-American or African-American.

ABOVE LEFT: *Ty Defoe is a Native American artist who with his Thai-born collaborator Tidtaya Sinutoke is the recipient of a 2017 Jonathan Larson Grant. Their work, which is a confluence of alternative culture and gender, brings an intersectional dimension to musical theater.*
ABOVE RIGHT: *A group of 2009 SpringboardNYC students listen intently as guest mentors of the program instruct them to consider themselves as part of a community, a diverse and polycultural family reflecting the American theater of today. From left to right: Kate Postotnik, Angelina Leis, Cameron Kirkpatrick, Kathryn Malloy, Ben Samuels and Michael James Shaw.*

BECKERS RULES
1. **NO** overcharging
2. Keep car **CLEAN**
3. **NO** Drinking
4. Be Courteous
5. Replace and **CLEAN** tools

When culture really works, as in the plays of August Wilson, two things happen at once. His characters may not look like my family, their way of speaking and their foods may seem unfamiliar. But then there's the moment when "that guy onstage is like my uncle Frank." He can be your uncle Frank without erasing his blackness. In fact, it is his very specificity as that person from the Pittsburgh Hill district that makes possible his universality. When we perceive both difference and humanity simultaneously, we move one step closer towards the American ideal of *E Pluribus Unum*—"from the many, one."

The American theater has a long way yet to travel to become a truly inclusive community. But over its hundred-year history, the Wing has helped move us toward this goal, and will continue to do so in the future. It has helped to diversify our stories and storytellers, created opportunities to tap the potential of future artists from all socio-economic and racial backgrounds, and honored the authentic artistic impulse.

The story of inclusion is baked into the DNA of this organization. The Wing was founded by women at a time actresses were considered "low." Rachel Crothers, a co-founder and first president, was a playwright who imagined the "New Woman" during the 1920s; she and Antoinette Perry fought for equality and inclusion in the face of great resistance. In March, 1942, the American Theatre Wing established an interracial policy at the famed Stage Door Canteen where soldiers—black, white, Hispanic, Asian and multi-ethnic—socialized together, espousing the democratic ideals then under threat.

That mission continues today with programs such as the Andrew Lloyd Webber Initiative, which provides grades K-12 arts education funding designed to diversify the pipeline of talent coming into the industry. Similarly, the National Theatre Company Grants support the most innovative and exciting young professional companies around the country, including those devoted to developing and presenting the works of African-Americans, Muslims, Latinos and the LGBTQ community. And in 2015, the Wing joined with the Village Voice to present the Obie Awards, Off-Broadway's most prestigious honor. Carrying on the spirit of its founders, the Wing fosters a community where all are welcome, in order to advance and celebrate the highest ideals of our art form and our nation.

In 2016, I was elected chairman of the American Theatre Wing, the first person of color to hold this position. As we look towards a second century whose challenges seem no less daunting than the first, the Wing of today takes its inspiration from its past. As a U.S. Army private, Henry Hall, wrote, "While serving overseas I visualized the United States as a better place to return than the United States that I had left... In a sense, the Stage Door Canteen has fulfilled that vision." Not only a place of entertainment, the theater also embodies the soul of a people. We are not only artists, but also citizens, of this nation.

OPPOSITE PAGE: *John Douglas Thompson, Michael Potts, Anthony Chisholm and Brandon J. Dirden were featured in the 2017 Tony-winning revival of August Wilson's* Jitney. *The drama, which had previously enjoyed a long Off-Broadway run, was the last of Wilson's ten-play cycle to arrive on Broadway.*

ABOVE: *In 1942, legendary caricaturist Al Hirschfeld captured the American Theatre Wing's bold interracial policy established six years before the armed forces were integrated. The Wing stood up against Senator Theodore Bilbo's denunciations of white hostesses fraternizing with black servicemen.*

Memo #1 "One hears a good deal of talk about the Reds and long-haired radicals who want to tear down the Constitution. The Reds and long-haired radicals only want to tear it down. The people who deny Negroes democratic equality actually are tearing it down."

Memo #2 "You unconsciously, but arrogantly, assume that no male Negro can so much as glance at you without wanting to get you with child. The truth is, that while you are an attractive group of young women, there isn't a single one of you who's THAT good."

Memo #3 "There's one way to make absolutely certain that neither the Negros nor any other section of our population feel impelled to rebel. That is to see that they have nothing to rebel against."

Memo #4 "The way to protect your honor is to be honorable. If we have any secret yearning to think of ourselves as the Master Race, we have only to pick up a newspaper to see that nobody is giving odds on the Master Race these days."

-MARGARET HALSEY

The Voices of Community

"I was in *House of Flowers* in 1954, my Broadway debut. Pearl Bailey ousted Mr. Brook [Peter Brook, the director]. I think he was a little rude calling the black cast 'you people' or something like that and they brought in Herbert Ross. And Herb brought me and Alvin [Ailey] in. I'm an East LA girl, so for me to come to New York, it was like coming to Oz. The show was in a little trouble—I think they locked Truman Capote in a hotel room—but a lot of good came out of it. I met [my husband] Geoffrey Holder, and Alvin started his company, and so did Donald McKayle and Louis Johnson. All of these choreographers of color came out of *House of Flowers.*"

—CARMEN DE LAVALLADE,
DANCER AND ACTOR, OBIE AWARD

ABOVE: *Shows featuring a largely African-American cast were rare on Broadway with 1954's* House of Flowers *as a notable exception. Carmen de Lavallade met future husband Geoffrey Holder who would go on to direct, choreograph and design the all-black* The Wiz *two decades later.*

ABOVE: *In 1979, the Public Theater's* Spell #7, *a "choreopoem" by Ntozake Shange was presented as part of the Wing's prison outreach. The cast included Dyane Harvey, Ellis E. Williams, Reyno, Laurie Carlos, LaTanya Richardson, Mary Alice, Larry Marshall, Beth Shorter and Avery Brooks. Richardson's husband, Samuel Jackson, later joined the company.*

"The first time I heard about the American Theatre Wing was when I performed Ntozake Shange's *Spell #7* with Mary Alice, Peter Fernandez, Avery Brooks, Ellis Williams and my husband, Samuel Jackson, as part of the Wing's program to bring theater to prisons. Later I did For *Colored Girls* in a maximum security woman's prison. The [inmates] were so involved with the play. Not only was the play inspiring. But they were also grateful that someone was engaging in what was going on in their world. It was intriguing to be in lockup and still deliver a play as free as we possibly could."

–LaTanya Richardson
Jackson, American
Theatre Wing Trustee

137

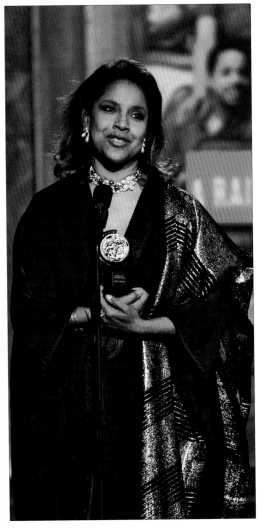

ABOVE: *History was made in 1962 when Diahann Carroll was the first actress of color to win best actress in a musical for Richard Rodgers'* No Strings. *(Here she is with fellow winners Robert Morse, Margaret Leighton and Paul Scofield.) More than four decades later, Phylicia Rashad (at right) was the first black actress to win the Tony in a dramatic role in a 2004 revival of* A Raisin in the Sun. *Twelve years later, it was a clean sweep in the musical categories when three actors from* Hamilton—*Daveed Diggs, Leslie Odom, Jr., and Renée Elise Goldsberry—were joined by Cynthia Erivo who triumphed in* The Color Purple.

"I think the first time the Tony Award and the American Theatre Wing came on my radar was when I went to see *Angels in America* when I was in high school. That was sort of the first real play I went to see. I think I knew it won the Tony and [therefore] was an important American play. That was when my interest in theater really got started. I realized theater will be the place where people are asking questions and pushing boundaries and normalizing the experiences of outsiders forever."

—SAM GOLD, DIRECTOR, TONY WINNER, *FUN HOME*

ABOVE LEFT: *Sono Osato was the first Asian American to star in a Broadway show in 1944's* On the Town. *Her Ivy "Miss Turnstyles" Smith is paired here with John Battle's Gabey. A scholarship in Osato's name is administered by the Career Transition for Dancers which won a Special Tony Award.*

ABOVE RIGHT: *Montego Glover and Chad Kimball were the star-crossed lovers in the 2009 Tony-winning musical,* Memphis. *The interracial romance also won Tony Awards for its creators, David Bryan and Joe DiPietro.*

"When we did *Death of a Salesman* with George C. Scott, he said, 'I wanna have the family next door be an African-American family.' I said, 'Great idea, George!' Because when Arthur wrote the play, the neighborhood was Jewish, Italian, Polish. But twenty-five years later, Brooklyn had changed. So I called Arthur Miller and told him George's great idea. Silence. 'But that's not what is written,' he said. So I had a meeting with George, and he said, 'Oh, it's not a big problem.' And I was relieved. I thought, 'What a great guy!' And then George added, 'I just won't do the play.' Either we had to change Arthur's mind or we had to change George's mind. And then while I was on a cruise down to Bermuda, I got a cable. It was Arthur. 'Go ahead with George's idea.' And we found a wonderful black actor, Arthur French, and it was much more powerful when Bernard, the son in the family, comes back and wants to say 'Hello' to Willy. And after he leaves, Willy wonders why Bernard has to catch a train and go back to Washington. And his friend Charlie says, 'He's done pretty well. He's arguing before the Supreme Court.' And for a black man to be arguing before the Supreme Court landed so much more powerfully at that time, in the 1970s."

–PAUL LIBIN, PRODUCER, LIFETIME ACHIEVEMENT TONY HONOR

ABOVE: *When the groundbreaking* West Side Story *premiered in 1957, Latino surnames were few and far between, Chita Rivera's brilliant Anita notwithstanding. It would take Lin-Manuel Miranda's* In the Heights *and* Hamilton *decades later to toss out the welcoming mat to Latinos in a big way.*
OPPOSITE PAGE: *Chita Rivera received the tenth of her record-breaking number of Tony nominations for* The Visit, *the 2015 musical by John Kander and Fred Ebb who also wrote* The Kiss of the Spider Woman *for her.*

"As my husband [Jack Noseworthy] reminds me all the time, I *am* the American dream. I came to this country illegally from Colombia, and I was able to overcome adversity to get my green card and do what I love. I owe the first opportunity to [director-choreographer] Jerry Mitchell, who hired me [as a dancer] for *Jerome Robbins' Broadway.* And in the summer of 1989, I was hired as a replacement in the Broadway production. For a long time, I felt like an outsider. This was long before Lin-Manuel Miranda and *In the Heights* and *Hamilton.* When I was in *Jerome Robbins' Broadway,* I was one of only three Hispanics in the cast, playing Sharks in the *West Side Story* scenes. And even after *Kiss of the Spider Woman,* there were few of us. I think diversity in the theater starts with education. I came late to the theater because my family had no interest in it. I think first and foremost you have to invite people into the playground that is Broadway. And then to embrace their stories."

—SERGIO TRUJILLO,
CHOREOGRAPHER

ABOVE: *Mexican-born Sara Ramirez won a Tony Award as the Lady of the Lake in Mike Nichols' production of* Spamalot *by Eric Idle and John Du Prez..*

"I want to write [about] the people who scare us the most in society because if we can really start to understand why they scare us and what they represent and see their humanity, we can have a more nuanced understanding of ourselves and the world we live in. I wrote this play specifically for an American audience to root for an immigrant to cross the border illegally by the end of the play. *The Ghosts of Lote Bravo* is about what people will do to survive and protect their families. I grew up yearning to see strong, fierce, unapologetic courageous women. I thought these stories are not being told and this world is populated with those women."

–HILARY BETTIS, PLAYWRIGHT, *THE GHOSTS OF LOTE BRAVO* IN AMERICAN THEATER WING'S *WORKING IN THE THEATRE*

ABOVE AND BELOW RIGHT: *Alba Jaramillo, at one time an undocumented Mexican, is a featured actor in Hilary Bettis'* The Ghosts of Lote Bravo, *at Borderlands Theater in Tucson, Arizona. The play—the set of which is featured above—was a subject of American Theatre Wing's* Working in the Theatre *documentary as a National New Play Network Rolling World Premiere.*

"I'm an immigrant, I grew up undocumented in this country and the wait to even sit before an immigration officer is fifteen years. And then when it became my turn to become a legal resident, everything changed. Because at that point, I could become legitimate and not fear that something could go wrong and I could be sent to Mexico, a country that I didn't even know. America is my country."

–ALBA JARAMILLO IN
AMERICAN THEATRE WING'S
*WORKING IN THE THEATRE:
THE GHOSTS OF LOTE BRAVO*

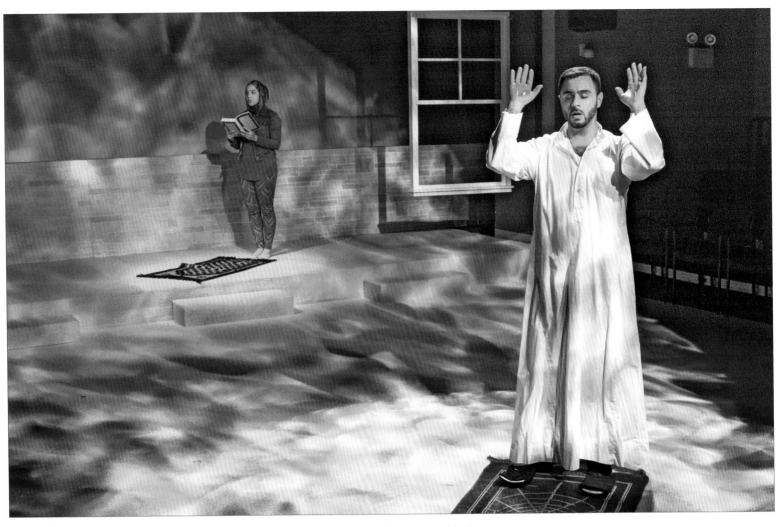

ABOVE: *Sahar Dika and Frank Sawa are featured in Jamil Khoury's* Mosque Alert, *which was inspired by the national uproar over Cordoba House, the proposed mosque and community center to be built two blocks from Ground Zero. The defeated plan gave rise to the Silk Road Rising production which premiered in 2016.*

"In certain segments of the organized Muslim community, there has been a great deal of anxiety about us being a gay couple. This has resulted in the cancellation of speaking engagements and a lot of walkouts during speaking engagements. It's almost become routine. But the flipside is that a lot of people from within the Muslim community have 'outed' themselves as our allies. We obviously defend Muslim civil rights but intentionally align ourselves to progressive Muslim, Muslim feminists, Muslim queers. We're not at all apologetic. And that creates a certain strain with some of the more traditional and conservative people in the community. But we've been told by so many people over the years: 'We're just really grateful you exist.'"

–JAMIL KHOURY, CO-ARTISTIC DIRECTOR WITH MALIK GILLANI, SILK ROAD RISING, CHICAGO, ILLINOIS, NATIONAL THEATRE COMPANY GRANT

"We call ourselves polycultural as opposed to multicultural because so many of us have multiple identities. Jamil's father is from Syria, and I was raised in a Christian Eastern Orthodox community. I'm not dissing multiculturalism. But what about the overlap, the intersecting? What happens when cultures meet, collide, merge? What is the transformation that occurs? That's really exciting."

–MALIK GILLANI, CO-ARTISTIC DIRECTOR WITH JAMIL KHOURY, SILK ROAD RISING

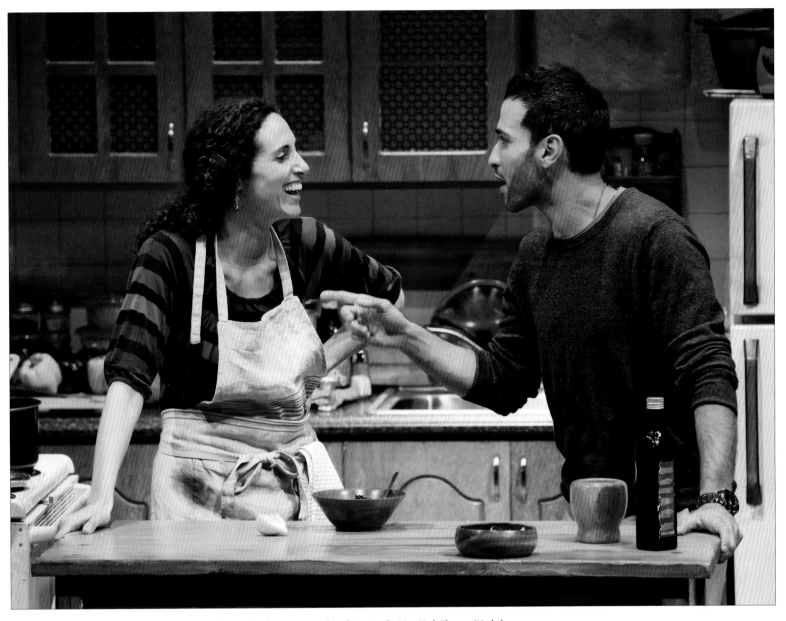

ABOVE: *Lameece Issaq and Haaz Sleiman tangle over lost love among other things in the New York Theatre Workshop production of* Food and Fadwa. *The drama by Issaq and Jacob Kader centers on West Bank Palestinians and émigrés trying to pull off a wedding while dealing with checkpoints and curfews.*

"The way I approached the hot topic of Israel and Palestine was to write *Food and Fadwa,* about a family trying to hold a wedding and dealing with checkpoints and curfews and all the other stuff while living on the occupied [West Bank]. So it comes from a deeply personal place of having a lot of love and respect for my family and those traditions. And it allows people an entry point into that world using comedy, using the ideas of food and togetherness. In talkbacks, some people thought I wasn't hard enough on the Israelis. I literally had a couple of Jewish audience members who said they love the story but they thought it was anti-Semitic because we were talking about the occupation. Another Jewish-American wrote to Jim [Nicola, artistic director of NYTW] to say: 'It has given me a perspective I didn't know I needed.' There are a lot of triggers in those conversations, but that shouldn't prevent us from have a conversation."

—LAMEECE ISSAQ, ARTISTIC DIRECTOR, NOOR THEATRE, NEW YORK CITY, OBIE AWARD

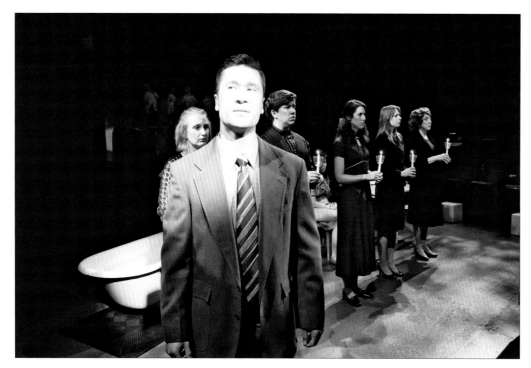

ABOVE LEFT: *Barter Theatre of Virginia brought attention to the tragedy of mental illness when they presented Douglas M. Parker's* Thicker Than Water. *The drama was based on the horrific events of 2001 when Andrea Yates methodically drowned her young children. Among the cast was Andrew Slane as the woman's husband.*
ABOVE RIGHT: *John S. Green's 2001 drama,* The Liquid Moon *brought out protestors to Appalachia's Barter Theatre since it featured male and female nudity in its prismatic look at marital infidelity.*

"This is gonna sound weird but two shows with which the community really connected were two of the less popular shows. One is *Thicker Than Water,* about [the true story of] Andrea Yates who drowned her children in 2001 in Texas. It was a beautiful, highly emotional play that was nominated for a Pulitzer while it was here. We did it for the purpose of beginning a discussion of mental health, and it became a landmark piece for the mental health agencies in the region. The talk-backs were stunning. It was like people testifying in church about how they'd thought about drowning their kids, about troubled marriages, different problems, different things. While *Thicker Than Water* was running here, there was a shooting at the naval base in Virginia. The show helped bring attention to mental health issues that are often swept under the rug. Another show was John Green's *The Liquid Moon* which had religious ramifications since it dealt with the question, 'Are we going back to the Garden of Eden? Or are we going farther away?' The animal side of us. The spiritual side of us. And where does that all meet? It also had full male and female nudity, so we got picketed early on and even legislators told us to take it off our stage. And the Southern Baptist convention condemned us. But we fought back. At one talk-back, there was a guy who asked to speak with me afterwards. He looked like your typical hillbilly from the hollers of Appalachia. He said, 'I'm a Baptist preacher. I have a small congregation in the hills. I heard what the conference said. But I wanted to see it for myself. I have to say this. If I could bring every family in my church to this, I would.' We exist in a rugged frontier of very, very independent people."

–RICHARD ROSE, PRODUCING ARTISTIC DIRECTOR, THE BARTER THEATRE, ABINGDON, VIRGINIA, FIRST REGIONAL TONY AWARD WINNER, 1948

ABOVE: *Stephan Wolfert, traumatized by his experience in the military, discovered therapeutic value in Shakespeare which he shares in his solo show,* Cry Havoc! *Through his outreach program at New York's Bedlam Theatre, he has further explored theater as a healing force for other veterans.*

"I decided that for the stage I wanted to interweave Shakespeare with original writings by veterans, and for that communal experience of vets getting together sharing stories. The best description of post-traumatic stress disorder is Lady Percy's speech in *Henry IV, Part 1* where she describes her husband Hotspur, who's come home from being in combat. So Shakespeare gave me the language to identify what the hell is wrong with me. I then found out that other veterans felt the same way. I first found a home at Native Voices in Los Angeles and then at Bedlam in New York. I'd met Eric Tucker [co-founder of Bedlam] at Trinity Rep. He was a Navy veteran so he really got it. He provided a space where we could meet weekly which was really important because successful vet groups are built on that camaraderie. And ours just happens to be camaraderie built in creativity and in the performing arts, and more specifically Shakespeare. When we started four years ago, an average of one to three veterans attended the free classes and performances. Now we have twenty-five or more with an e-mail list of over a hundred. We're doing the same for female veterans. They didn't know how much they wanted or needed a space for themselves because they'd never had one."

—STEPHAN WOLFERT,
DIRECTOR OF VETERAN
OUTREACH, BEDLAM THEATRE,
NEW YORK CITY, NATIONAL
THEATRE COMPANY GRANT

ABOVE: *Joel Perez, a Springboard alumnus here speaking with director-choreographer Kathleen Marshall, broke through when he was cast in multiple roles in the 2015 Tony-winning musical,* Fun Home.

OPPOSITE PAGE: Fun Home, *based on Alison Bechdel's illustrated memoir, boasted an all-female writing team and a sympathetic lesbian protagonist. It won five Tony Awards, including best musical, best score (Lisa Kron and Jeanine Tesori), and best director (Sam Gold). Designer David Zinn was nominated for his brilliant set at the Circle in the Square Theatre.*

"My parents are conservative Christians, Pentecostal. Seeing me in *Fun Home* was a great moment to open up conversations that we hadn't had before about my own personal journey through homosexuality. It's still ongoing because my father is pastor of a church, It wasn't an easy choice for them to see *Fun Home.* It took a bit of kicking and screaming on my part, because they had a misconception of what it was about. My parents had to acknowledge the truth of [the *Fun Home*] family and their relationships. As Christians, wouldn't you rather have a congregation who live honest, open and authentic lives than people who are forced to live in secret and hurt the people around them? So it caused them to question some of the [tenets] of their faith and to want to know more about my life as a gay man. And that's what the best theater does: open up honest conversations."

–JOEL PEREZ, ACTOR, ALUMNUS OF SPRINGBOARDNYC, *FUN HOME*

"As a young, queer kid in the middle of rural North Carolina, the Tony Award telecast was my 'Ring of Keys' moment, like the young Alison in *Fun Home* when she sees the butch lesbian in the diner. Watching the Tonys made me think, 'That feels spiritually like me.' When I saw Debbie Allen doing a number from *West Side Story* [in 1980], I thought, 'I wanna kick like that.' When Jennifer Holiday was singing, 'And I Am Telling You That I'm Not Going' [in 1982], it felt like she was reaching in through the screen and grabbing my heart."

–COREY MITCHELL, 2015 EXCELLENCE IN THEATRE EDUCATION TONY HONOR

ABOVE: *Lane Flores, Matt Farabee, Nathan Hosner and Derrick Trumbly were featured in the About Face Theatre production of* Abraham Lincoln Was a F*gg*t *by Bixby Elliot.*

"An artistic director asked me recently, 'Do we really need a gay theater in this day and age?' And I shot back, 'Well, do we really need a black theater? A woman's theater? An Asian theater?' I think theaters that represent marginalized communities are always going to be necessary. That said, the stories now being told on gay and lesbian stages are much more complex. About Face has tackled what it's like to be gay and undocumented [*Checking Boxes*], women in a relationship who want to adopt [*The Kid Thing*], new stories featuring trans people's voices [Sylvan Oswald's *Pony*], and what it means to grow up gay in a 'post-gay' world. [*Abraham Lincoln Was a F*gg*t*]. Our youth theater is incredibly activist both in their outreach shows—actors travel to high schools, colleges and corporate environments to share their personal stories—and in their performances. They recently developed *What's the T?*, a play that was meant to explore trans lives and trans identities. But in the course of research, there was an incident in Boystown [the gay neighborhood of Chicago] where young people of color were being pushed out because older gay residents thought they were causing problems. So our actors went out and interviewed both groups, and the play ultimately became about trans lives and where is the safe place for queer youth in Chicago. In a world of xenophobia and immigration reform, our youth theater is asking people to take a closer look at these thorny issues."

—ANDREW VOLKOFF, FORMER ARTISTIC DIRECTOR, ABOUT FACE THEATRE, CHICAGO, ILLINOIS, NATIONAL THEATRE COMPANY GRANT

"I was aware of plays like *Torch Song Trilogy* and *La Cage aux Folles*, but I have to be honest. If anything, the overtness of the gay movement and LGBT awareness in New York, at my age [eleven], made me almost embarrassed. If I was caught listening to *La Cage aux Folles* it would prove I was gay. So I kind of avoided it… that was just my own internal homophobia. That *Hedwig* now gets to tour in arenas and gets seen by thousands of people at a time, yes, I think gratitude is important. I think when a person is forced to use a certain bathroom, they can recognize through the theater and through [shows like] the Tony Awards, they are not alone."

–Neil Patrick Harris, actor, Tony host and Tony award winner, *Hedwig and the Angry Inch*

Right: *Neil Patrick Harris made Hedwig, the East German transsexual, into a Broadway sensation when he starred in a 2014 Tony-winning revival of* Hedwig and the Angry Inch, *the rock musical by John Cameron Mitchell and Stephen Trask.*

ABOVE: *Jelani Remy stars in the title role of Disney's* The Lion King, *directed by Julie Taymor, which brought an infusion of African and African-American talent to the Broadway stage.*

"Something that's never talked about is that twenty years before *Hamilton* we had a show [*The Lion King*] that was mixed race but wasn't about race. We brought in 80 to 90 percent of non-white performers into a show, and that had never been done before. There have been other shows, *Ragtime* and *Jelly's Last Jam,* but they were mostly about racism or race. White audiences look at *The Lion King* and they don't see race. Black Americans see *The Lion King,* and it's all about race, because they're able to see a black king. So I said to Disney, 'You may call it reverse racism, but black actors have to play these lead roles.' This was pre-Obama. There was no black president. Black kids saw Mufasa, this incredible character. And then you can have hyenas that are black, white, mixed and have inner-city language, but it's not racist because you've got bad white and good white, bad black and good black, the whole lot. I mean, I could go on, story after story, racial things that we've experienced all over the world that are just beyond, they make you cry, they're really beautiful. And now it's really fun for me to see all my Simbas doing *Hamilton.* I love, love, love it!"

—JULIE TAYMOR, DIRECTOR, TONY WINNER, *THE LION KING*

ABOVE: *Jordan E. Cooper stars in his play,* Ain't No Mo', *which was a stellar attraction of the Fire This Time Festival.*

"When I started the Fire This Time Festival, it was for a purely selfish purpose. I wanted to be a part of the community of black writers. It was a quest for camaraderie and shared resources. And then it just exploded. Clearly there was a void that we were filling. We wanted to provide a space where writers would not be boxed in by some preconceived notion. We didn't know where we were going at first, none of us were producers. But the only thing I'm really good at is organization because I'm one of ten children from Baton Rouge, Louisiana. Back then we were all kind of pissed off that there seems to be a standard for black theater that you either fit in or don't fit in, a standard defined by August Wilson and Amiri Baraka. Of course [August] should be done all the time, but that crowded out many new plays by black artists that represented the spectrum of who we are. I read a play, *Ain't No Mo'* by Jordan E. Cooper, a phenomenal writer from Texas who's only nineteen years old. And it scared me. It's basically about, after the election of Barack Obama, 'Now there's going to be no more racism.' How those hopes were crushed by Eric Garner and Trayvon Martin and Ferguson [Missouri]. I told my fellow producers that this play had to be put on first in the festival. We have to just shake up everybody right off the bat."

–KELLEY NICOLE GIROD,
PLAYWRIGHT AND PRODUCER,
THE FIRE THIS TIME FESTIVAL,
NEW YORK CITY, OBIE AWARD

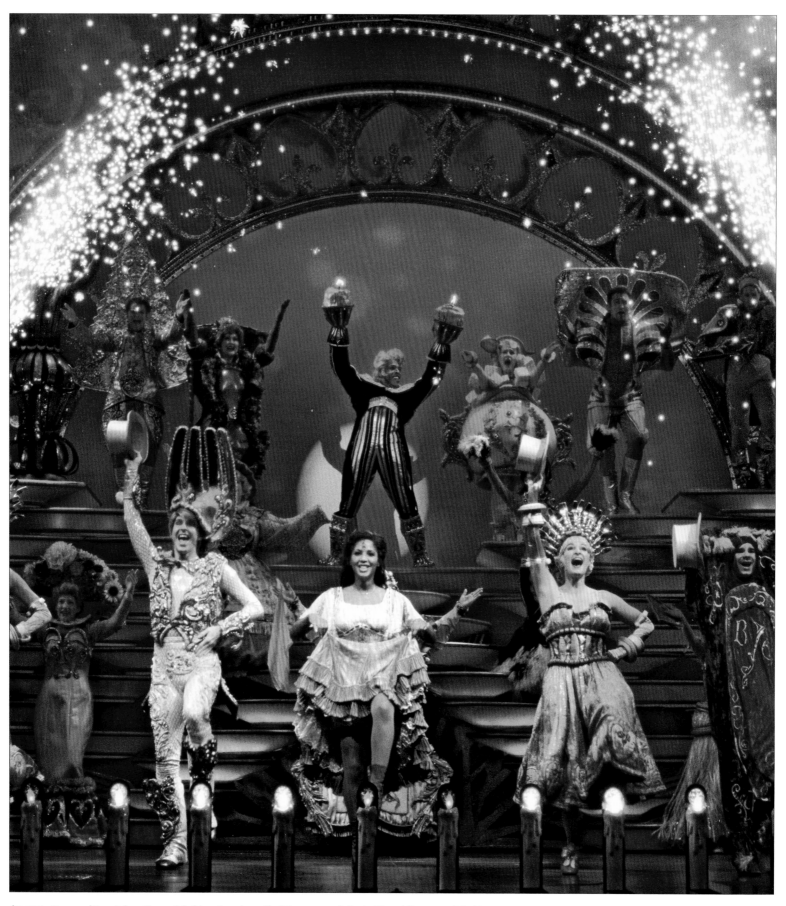

ABOVE: *Once multi-racial casting took hold on Broadway, Toni Braxton, as Belle, in Disney's* Beauty and the Beast *was a no-brainer. Mesach Taylor played Lumiere.*

OPPOSITE LEFT: *Lea Salonga, born and raised in the Philippines, and Brit Jonathan Pryce both won Tony Awards when they starred in the 1991 production of* Miss Saigon, *the epic romance which like* M. Butterfly, *was inspired in part by Puccini's* Madame Butterfly.

OPPOSITE RIGHT: *Norm Lewis was featured as Triton in Disney's* The Little Mermaid, *the 2008 adaptation of the blockbuster animated film.*

"It's hard to underestimate [the reaction] when Lea Salonga won a Tony Award. Everybody in the Philippines was aware of what a great honor it was. There'd been a huge search for the girl who was going to play Kim in *Miss Saigon*, and it was a big deal when Cameron Mackintosh came to Manila and scoured the country. Lea Salonga was already sort of a national treasure, just having won the part. And it was a big deal she'd won the Olivier. But when she won the Tony, *that* was a great moment for the country, because we were once a colony of America, in a sense, and we were familiar with America. So as a young gay kid in the Philippines, my dream was (a) to see a Broadway show and (b) maybe work in the theater some day."

—CLINT RAMOS, SET AND
COSTUME DESIGNER,
OBIE AND HENRY HEWES
AWARDS, TONY WINNER

"When we were creating *The Little Mermaid*, Howard Ashman [lyricist and scenarist] suggested that Sebastian—originally conceived as white—be Jamaican. So the idea that we would have Toni Braxton play Belle [in *Beauty and the Beast*] doesn't seem odd at all. You look at *Mermaid* and, Norm Lewis, that's King Triton. And you look at all of Ariel's sisters, and it's the 'United Colors of Benetton' and big people, short people, heavy people, whatever."

—THOMAS SCHUMACHER,
PRESIDENT, DISNEY
THEATRICAL GROUP, TONY
WINNER, *THE LION KING*

ABOVE: *Marlee Matlin, who starred in Deaf West's revival of* Spring Awakening, *is featured in the Wing's Emmy-nominated documentary,* Working in the Theatre: Sign Language Theatre.

"We have a young woman in *Spring Awakening* who is the first-ever woman in a wheelchair on Broadway. And there are now more deaf actors on Broadway than ever been. This idea of incorporating deaf actors and a woman in a wheelchair in a show, will have a ripple effect in the rest of the world."

–KEN DAVENPORT, PRODUCER, *SIGN LANGUAGE THEATRE*

"I had a couple of people tell me I was crazy to write about AIDS and an epidemic that was disproportionately hitting African-American women and African women [*In the Continuum*]. 'No one is interested in the stories.' So for me *In the Continuum* was definitely driven by outrage and my passionate commitment to [Zimbabwe] and to the stories that were never being told from the African female perspective around the epidemic of HIV/AIDS. When we got the Obie Award, it wasn't something I quite anticipated. [But] I do think that artists can often foresee what the public wants to see but doesn't quite realize it."

–DANAI GURIRA, ACTOR AND PLAYWRIGHT, OBIE AWARD

ABOVE: *Golden Thread Productions presented* The Fifth String: Ziryab's Passage to Cordoba, *a playful musical about an Islamic cultural icon who was a musician and poet in the Baghdad court before emigrating to Europe. The show, written and directed by Torange Yeghiazarian, featured Naima Shalhoub and Maruf Noyoft.*

"When 9/11 happened, we were two weeks away from opening a festival of short plays and most of the Middle East-related arts cancelled. But we decided to go on. It's such times that our work is absolutely necessary. The Middle East unfortunately continues to be steeped in misunderstanding and stereotypes and that have only worsened over the years. The American news media is so superficial and so much is driven by trauma and drama. We only meet people when bombs are dropping and their lives are falling apart. We don't know anything about their lives in peacetime, their aspirations, their dreams, their hopes, how hard they work. And we present these alternative perspectives. A [Middle Eastern] family sitting around a table having a peaceful dinner is the most revolutionary concept that you can imagine in the United States today."

-TORANGE YEGHIAZARIAN, ARTISTIC DIRECTOR, GOLDEN THREAD PRODUCTIONS, SAN FRANCISCO, NATIONAL THEATRE COMPANY GRANT

ABOVE: *Lin-Manuel Miranda created the role of Usnavi in his 2008 Tony-winning musical,* In the Heights. *The show, set in his old neighborhood of Washington Heights, marked his Broadway debut and was a high-water mark for Latinos in Broadway theater.*

"We did Suzan-Lori Parks's *Topdog/Underdog.* The Drop Inn Center was a homeless shelter three blocks from the theater and we would invite people from there to come to our dress rehearsals. It was so fascinating to watch an audience that was so close to the economic circumstances of the characters in the play. At one point, Booth asks Lincoln to lend him $5. And one guy in the audience shouted, 'Don't give it to him! Don't give him the $5! You'll never get it back.' That's definitely the theatricality of the live experience! The shelter relocated but their issues continued to be explored in another play we presented, Christina Anderson's *Blacktop Sky,* about a teenager and a homeless young man."

—ANDREW HUNGERFORD, PRODUCING ARTISTIC DIRECTOR, KNOW THEATRE, CINCINNATI, OHIO, NATIONAL THEATRE COMPANY GRANT

ABOVE: *Much to the delight of its creators and cast, Barack Obama, the first black president of the United States, was the First Fan-in-Chief of Lin-Manuel Miranda's multi-cultural and ground-breaking* Hamilton.

"It's funny, every time a parade comes around, everyone comes up with these bumper stickers that say, '100% Boricua [ethnic Puerto Rican],' '100% Dominican,' and I promise you there's no such thing. I'm 3/4 Puerto Rican and a quarter Mexican. I have a cousin who's half Puerto Rican, half Dominican. We're all mutts. It's very easy to talk about the differences between us, and I thought it would be harder and ultimately more rewarding to write about the commonalities."

–LIN-MANUEL MIRANDA,
IN THE HEIGHTS, HAMILTON,
MULTIPLE TONY WINNER

Harvey Fierstein, Tony and Broadway's Not Just For Gays

By Patrick Pacheco

At the 1984 Tony Awards, Harvey Fierstein was resigned to losing to James Lapine in the category of Best Book of a Musical. He was up for *La Cage aux Folles* which was in a tight race in several categories, including best musical, against *Sunday in the Park with George.* Then Alexander Cohen, the producer of the telecast, gave a pre-show speech that made Fierstein's blood boil.

Recalls Fierstein, "He said, 'Let us not repeat the embarrassment of last year' and everybody in the audience turned and looked at me, some with sympathy and some with not."

Cohen was referring to a remark made at the podium following the triumph of Fierstein's *Torch Song Trilogy,* which starred the playwright and which had walked away that night as the surprise winner of best play and best actor. The exultant team of producers at the podium included John Glines, the founder of the eponymous gay arts theater, who chose that historic moment—the first Tony win for a play with a gay protagonist—to thank his male lover.

"So many people talked about how *Torch Song* winning had changed the world and that nobody was going to be that way anymore and here was dear Alex who should have known better," says Fierstein, who was then only thirty. "I really didn't care about winning the award for *La Cage* until that moment. But down in my soul roiled up a feeling which is hard to describe. I said to myself, 'I

RIGHT: *The Tony-winning musical* La Cage aux Folles *brought plumage and a respite from the AIDS epidemic to Broadway in 1984. In a musical that mixed the boys with the girls—and vice-versa—Deborah Phelan played Angelique.*

OPPOSITE PAGE: *Harvey Fierstein's groundbreaking* Torch Song Trilogy *was the surprising winner of the best play and best actor Tony Awards in 1983.*

ABOVE LEFT: *Stephen Spinella and Marcia Gay Harden starred in Tony Kushner's landmark* Angels in America, *a two-part epic which won Best Play Awards in 1993 and 1994.*
ABOVE RIGHT: *Among the multiple Tony Awards that went to* Hairspray *was a win for Best Score. Songwriters Marc Shaiman and Scott Wittman celebrated with a kiss heard 'round the world.*
OPPOSITE PAGE: *Harvey Fierstein, who started in Off-Off-Broadway, brought his drag artistry to a pinnacle as Edna Turnblad in the Tony-winning* Hairspray.

hope I win, so if I do, I can thank my lover. Because this cannot stand.'"

Fierstein did win and did thank his lover. Cohen's reaction is not part of the record. But the Tony Award and its relationship to the struggle for equal rights is. Now that gay marriage is a constitutional right, it's hard to fathom just how brave it was for gays to acknowledge their partners in a nationally televised awards show more than three decades ago. It's even more significant to consider that a play like *Torch Song Trilogy,* with its unapologetic exploration of gay sex, adoption of children, and loving relationships, could have taken the top Tony Award against such prestigious competition as David Hare's *Plenty,* Lanford Wilson's *Angels Fall,* and Marsha Norman's Pulitzer Prize-winning *'Night Mother.*

Before 1980, gay-themed plays on Broadway had been very rare. *The*

Captive, starring Helen Menken, was a 1926 lesbian-tinged French import whose creative team was charged with, and eventually acquitted of, offending the public morals. Eight years later, Lillian Hellman's *The Children's Hour,* which dealt honestly with a teacher caught up in a lesbian scandal, was a Broadway hit, although it was banned in Boston. In 1966, Frank Marcus' play, *The Killing of Sister George,* became a sensation with its veiled lesbian references. The play was nominated in three Tony categories, including Best Play and Beryl Reid won for her performance. But it wasn't until 2015, when *Fun Home* won several Tonys, including Best Musical, that a play with a tender lesbian love story came into full flower with the first female writing team—Lisa Kron and Jeanine Tesori— winning the top award.

In terms of gay male sexuality,

Torch Song Trilogy broke ground that would later yield a Tony nomination for William Hoffman's *As Is,* a victory for Tony Kushner's two-part *Angels in America,* a best play Tony for Terrence McNally's *Love! Valour! Compassion!,* and Best Musical wins for Fierstein's *Hairspray* and *Kinky Boots.* Larry Kramer's *The Normal Heart* was a political *cause célèbre* when it opened at the Public Theater in 1985. But thirty years later, it was the play's heartbreaking pathos that won it the Tony for best revival.

In the course of accepting awards for these plays, some of the winners invariably thanked their same-sex partners. But Marc Shaiman and Scott Wittman went further. They celebrated their win for the score of *Hairspray* with a full-on smack of the lips.

"Now, what's wonderful is that nobody flinches when that happens,"

ABOVE: *In 2013, Harvey Fierstein joined forces with pop singer-composer Cyndi Lauper to create the smash hit,* Kinky Boots, *which won a fistful of Tonys, including best musical and one for Billy Porter as the irrepressible Lola.*

says Fierstein, remembering a time when a far more modest expression sent shock waves through the culture. "The night that *Torch Song Trilogy* won, Johnny Carson on the *Tonight Show* thanked his 'lover,' Doc Severinsen." The playwright also recalls that Barbara Walters in a 1983 televised interview reminded him, "I couldn't put a homosexual on TV before this year." To

which Fierstein replied, "Of course you could have—and should have." Fierstein, as one of the éminences grises of gay rights. says that no laurels are in order for facing down prejudice and social hostility. "Not to sound highfalutin' here, but as an artist you really don't have a choice: You either tell the truth or stay home."

Such forthrightness serves to move

the needle. Indeed, Broadway's embrace of gay subject matter eventually led in 2011 to one of the wittiest opening numbers ever on the telecast. Host Neil Patrick Harris with a chorus of dancing sailors and long-legged beauties launched into "Not Just for Gays Anymore," by David Javerbaum and Adam Schlesinger (*Cry-Baby*).

ABOVE: *Neil Patrick Harris got the 2011 Tony Awards off to a rousing start with his satiric opening number,*
"Broadway: It's Not Just for Gays Anymore."

If you feel like someone that
this world excludes,
It's no longer only for dudes
who like dudes.
Attention every breeder
You're invited to theater
It's not just for gays anymore!
The glamour of Broadway is

beckoning straights—
The people who marry in all fifty states.
We're asking every hetero
To get to know us better-o.
It's not just for gays anymore!
So people from red states and
people from blue,
A big Broadway rainbow is

waiting for you.
Come in and be inspired
There's no sodomy required
Oh, it's not just for gays,
It's not just for gays,
We'd be twice as proud to have you
if you go both ways,
Broadway's not just for gays anymore!

EXCELLENCE
A Place in the Sun

By Kenny Leon

"YES! YES! YES! YES!" That was me at the 2014 Tony Awards.

My ecstatic reaction was for Sophie Okonedo who had just won a Tony Award for her brilliant portrayal of Ruth Younger in the revival of *A Raisin in the Sun*. That joyful moment had occurred just minutes after I myself had gone to the podium to accept the award for Best Director of a Play for our revival of the Lorraine Hansberry classic. I was in the pressroom when the journalists paused in their questioning, and the monitor in the room showed Sophie's name flashing as the winner. Beaming, I turned to the assembled press in the room and said of Sophie, "She works harder than anyone!" Then I turned to the screen and yelled, "Sophie, I love you!" The production also won Best Revival. It was an emotional night.

My friend August Wilson, who I think of almost every day, once told me, "We're not owed the awards. We're only owed the work."

But the awards, and the Tony especially, can be encouraging. Even just being nominated is an honor. It's a cliché, I know, but it's true. I was honored when I was among the nominees in 2010 for the revival of August's *Fences* which had garnered a record ten nominations altogether —including for Denzel Washington and Viola Davis who both won. When I heard of the nominations, I felt as though I had finally become worthy to be mentioned along with some of the

OPPOSITE PAGE: *"Bigger," a specialty song written by Lin-Manuel Miranda and Tom Kitt, opened the 2013 Tony Award telecast to a standing ovation at Radio City Music Hall. Host Neil Patrick Harris concluded the number, considered among the best openings ever, by hanging from a giant reproduction of the iconic statuette.*

artists I admire most, including Mike Nichols, Lloyd Richards, and George C. Wolfe.

And when you win? Oh, what a feeling! You have a forum to thank the extraordinary company, teachers and friends who have helped you to get to this point. But also, as I said in my acceptance speech, I thanked "the folks who get on the buses, planes, and trains to see our shows. We do it for you!" And I added what is an article of faith for me: "I'm looking for the day when every child in America can have a little piece of theater in their daily education life."

> ## "MY FRIEND AUGUST WILSON, WHO I THINK OF ALMOST EVERY DAY, ONCE TOLD ME, 'WE'RE NOT OWED THE AWARDS. WE'RE ONLY OWED THE WORK.'"

The mandate came from my grandmother, who raised me in the impoverished back roads of Tallahassee. She'd had thirteen children, and I became the fourteenth when her daughter, my single mom, left home with my sister to seek work. I often tell kids that "I am the product of generational prayer." My grandmother

LEFT: *The ensemble cast of the 2014 Tony-winning revival of* A Raisin in the Sun, *directed by Kenny Leon, included Denzel Washington, Sophie Okoneda, LaTanya Richardson Jackson, Bryce Clyde Jenkins, and Anika Noni Rose.*

ABOVE: *Playwright Neil Simon and director Mike Nichols relax after a rehearsal of* The Odd Couple, *the legendary 1965 comedy that would bring Simon his first of three Tonys and Nichols, his second of ten.*
OPPOSITE PAGE: *The closing of a Chicago public high school ignites a firestorm in Ike Holter's comedy,* Exit Strategy, *which was presented in 2017 at Atlanta's True Colors Theatre, a recipient of the Wing's National Theatre Company Grant. Diany Rodriguez, Lau'rie Roach and Tracey Bonner were featured in the production.*

got down on her knees every night to pray that her grandson would have a better life than her generation did, going out in the fields to earn their daily bread. Because of her, I am a minister of the arts: How do we make the world better? How do we touch lives, change people, tell our stories to show the ties that bind—and strain—the strands of the human family?

The pulpit from which to probe and proclaim our connectedness is not just Broadway, which obviously has the biggest megaphone. But national theater companies dot the country, from the Seattle Rep, to the Fusion, a small theater in Albuquerque, New Mexico, to the Hartford Stage in Connecticut, to the True Colors in Atlanta, a theater I co-founded with

Jane Bishop in 2002 and at which I am the artistic director. Running a non-profit is tough under the best of circumstances. But when the economy tanks or the government pulls back on its obligations to support the arts, then the reliance on organizations like the American Theatre Wing, becomes crucial to the life of a company.

That was the case for True Colors in





ABOVE: *Audra McDonald, six-time Tony Award winner, has used her time at the podium to thank her mentors, including Zoe Caldwell, after whom she named her daughter.*

that car. Storytelling and the creativity it sparks are the gold in the classrooms of Marilyn McCormick, a teacher in Detroit's Cass Technical School, and Corey Mitchell of the Northwest School of the Arts in North Carolina, both of whom the Wing chose to honor with its Excellence in Theatre Education Award.

The commitment of teachers like them in their sacred profession is what still inspires me. I recognize that responsibility when I encounter a script like Katori Hall's *The Mountaintop.* We presented this moving play about Martin Luther King, Jr., at just about the time we received the Wing grant. What it conveyed to an audience, especially to young people, was that King wasn't some guy in the sky you can't touch or just "that civil rights guy." What came through in our production of Katori's remarkable play was that Dr. King was "a cool cat" who was both human *and* extraordinary. Seeing him in that light ignites in people a desire to do good in their own lives and allows them to widen their horizons and possibilities.

The Jonathan Larson Grants are another kind of "okay," addressing and encouraging a whole new generation of musical artists. At an embryonic stage, the grants help them pay the rent so they can again concentrate on what's important: telling stories through song.

August was so right. We aren't entitled to anything but the work. But if we do our work diligently, with passion, grace, and compassion, then perhaps the rewards will come in time, honoring those who helped us arrive at this particular mountaintop. There is so much more work to be done. There is still a long road to travel in giving a voice to the voiceless, bringing the marginalized into the family, and providing opportunities that create hope and community. But with the encouragement that comes from grants and awards like those of the Wing, the dreams of artists and storytellers and poets no longer need to be deferred— they no longer need to dry up like raisins in the sun.

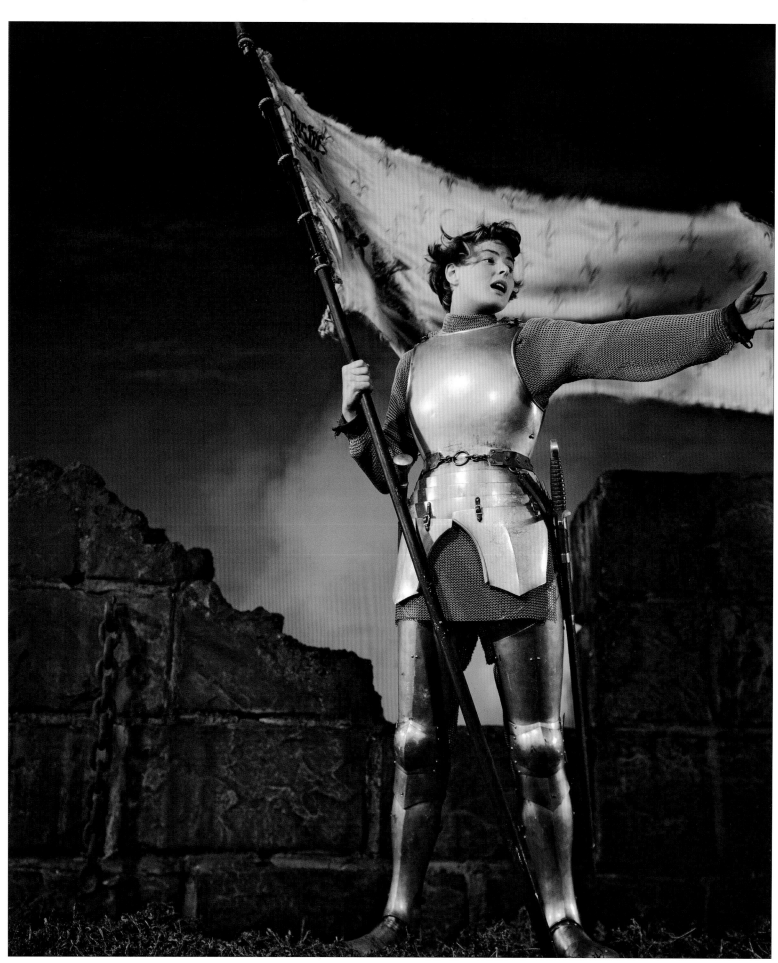

ABOVE: *Stephen Sondheim and Leonard Bernstein, here shown with the cast of* West Side Story *in 1957, forged the gold standard of theatrical excellence. Bernstein won the Tony for* Wonderful Town *in 1953 and a lifetime achievement award in 1969; Sondheim's special Tony came in 2008 after seven competitive wins.*
OPPOSITE PAGE: *Ingrid Bergman starred in Maxwell Anderson's* Joan of Lorraine *for which she won a Tony Award at the inaugural ceremony in 1947. She was nominated for an Oscar when she re-created the role on film a year later.*

"It's a humbling honor to be part of celebrating excellence in our chosen field. Celebrating excellence? What hubris. Who are we to celebrate excellence? We just *aspire* to that without being too pompous. We *aspire* to be above the fray. But human conditions pop up all the time so we must be vigilant to make sure that [the process] doesn't get *icky*. It demands humility because opinions of excellence vary, believe it or not, but there is a very strong through line one can depend upon."

—WILLIAM IVEY LONG, COSTUME DESIGNER, MULTIPLE TONY WINNER, FORMER CHAIRMAN OF THE AMERICAN THEATRE WING

ABOVE: *Chita Rivera rehearses with Liza Minnelli for* The Rink, *the 1984 John Kander-Fred Ebb musical which brought the legendary Broadway dancer her first of two Tony Awards, and the fourth of her ten record-breaking nominations.*

"At the end of the day, it's all about celebrating excellence, the reason the Wing still exists today. The Tonys became the powerful award for the Broadway theater and the fact that the Wing owned the Tonys is what made it survive as an institution in whatever form. And that carries responsibility. The Wing's position in the room should be slightly above the political jockeying that may go on, and ever trying to do the best for the excellence in the theater."

–TED CHAPIN, FORMER CHAIRMAN OF THE AMERICAN THEATRE WING

"The first time I won the Tony Award, it was for *The Rink*. I was so proud that I stood up and I was 5 feet, 8 inches. I mean, four inches taller than I am in real life! Because that was how tall my mother was, and when I stood up, she was standing right beside me. So the Tony Award not only gives you the blessed validation of your peers, but when they announce your name, it adds four inches to your height!"

–CHITA RIVERA, ACTOR, MULTIPLE TONY WINNER

ABOVE: *South African producer and composer Lebo M was critical to the success of the Julie Taymor production of* The Lion King.

"How does it feel to win a Tony Award? When Tom Schumacher and I won for producing *The Lion King,* the pleasure was a bit more intense because everybody told us we were going to lose to *Ragtime.* We had a cocktail party before the ceremony and every single press person there told us we didn't have a chance. And they were a good part of the voting membership! So I can only describe the feeling as comparable to what a friend of mine once told me about winning an international bridge championship. He was quite the ladies' man, and despite the joy he took in that, he said that winning the top tournament in bridge was 'better than sex.' So winning the Tony? 'Better than sex!'"

–Peter Schneider, producer, American Theatre Wing Trustee, Tony winner, *The Lion King*

"When you win awards, it really changes how people think about your work. Awards are more about the next job, the next commission. Then when it's something like *The Lion King* and it goes on and on, you kind of start forgetting about it basically. Because it's lovely and it's wonderful. But alright, already! [Laughs]. At some point, you have to put blinders on and just keep going. What's important now is not awards but grants and support for experimental and non-commercial work. We've been decrying the loss of arts in public schools and the loss of support for the arts and it's just gonna get worse."

-Julie Taymor, director, Tony winner, *The Lion King*

"Getting nominated for *Eclipsed* was awesome, a time of absolute celebration. When I created the play and bought my ticket to Liberia as a twenty-something, I was scared out of my mind and broke as a joke. At one point, I wanted to bail. I definitely had not imagined this journey to the point where we were recognized in the amazing way that we were. I have never stepped further out of myself than I did to create *Eclipsed* because I had to go into a country just out of war and meet these women who shared the most atrocious and traumatic experiences ever. And they entrusted me with them. So then to come to the Tonys seemed so glamorous and so disconnected from that. But then the whole circle itself—from giving a party to raise money to get me to Liberia to going to the Tonys—felt so powerful to have undergone. All the lovely responses we got were deep. Deep. And beautiful."

–DANAI GURIRA, PLAYWRIGHT, *ECLIPSED*

"I've been to the Tony Awards three times. One time hosting. One time with *History Boys*, where I was with eight boisterous boys, who'd already had quite a few drinks. And then on the third occasion, I was lucky enough to win Best Actor [*One Man, Two Guvnors*]. I knew beforehand it was a race between me and Philip Seymour Hoffman. When I went the day before to rehearse my bit at the Beacon, I saw that Philip Seymour was [going to be] seated in the front row and I was way up the aisle on the left. I said to a guy on the crew, 'Well, that's it. I haven't won.' And he said, 'Yeah, kid, you don't have a shot.' I told my girlfriend, now my wife, Julia, 'I've got to get over the fact that I haven't won 'cause I don't wanna be in a mood tomorrow. I know I'm being an idiot.' So then when I did win, the first thing I said was 'best' doesn't exist. You can be the fastest runner in the world. You can be the richest man in the world. You can be any of those things but there's no such thing as best actor."

–JAMES CORDEN, HOST OF THE TONY AWARDS, TONY WINNER, *ONE MAN, TWO GUVNORS*

"When we were developing *Fun Home* downtown, we wanted it to reach a really wide audience, like young, queer writers saying, 'Oh, I never thought I was actually allowed to write about people like me.' I didn't want *Fun Home* to be some little sidelined thing just for people in downtown New York City. I'm very excited for Des Moines to get *Fun Home*. That feels more right, more of a place where people need to see it. And the Tony is exactly the thing that made it possible to take a very small and uncommercial show on a national tour. [We] would never have done that without the Tony."

–SAM GOLD, DIRECTOR, TONY WINNER, *FUN HOME*

OPPOSITE PAGE: *Lupita Nyong'o, fresh off her Oscar win for* Twelve Years a Slave, *starred in Danai Gurira's* Eclipsed, *which told the harrowing story of Liberian women caught up in a civil war. The drama was nominated for six Tony Awards and announced the arrival of a bold new writer on Broadway.*

ABOVE: *Jayne Houdyshell had been a mainstay of regional theater until 2006 when she was cast as the mother in Lisa Kron's* Well, *a play that brought her a Tony nomination. Both Houdyshell and Kron would later win Tony Awards, Houdyshell for Stephen Karam's* The Humans, *and Kron for book and lyrics to* Fun Home.

"After I graduated in '74 and was still living in the Midwest, I started watching the Tonys, but it all seemed so distant and unattainable. All those actors just seemed like exotic creatures that had nothing to do with my aspirations as an actress. That continued to be the case even after I moved to New York in 1980, because I still continued to work in regional theater for over two decades. I didn't even know what it was to originate a role because I was mainly doing classics. By the time I was first nominated in 2006—for *Well,* playing Lisa Kron's mother—I was in my fifties. It was profound and exciting and *scary.* At the Tonys, I kept thinking, 'Please don't say my name, please don't say my name!' I was so relieved when I lost the Tony to Frances de la Tour [*History Boys*] because I'd have been too overwhelmed to speak. By the time I got to *The Humans* I was very happy to hear my name. It's a moment of exquisite joy."

–JAYNE HOUDYSHELL, ACTOR, TONY WINNER, *THE HUMANS*

"Everybody gets in a hustle and a piffle about 'Who's gonna win Best Play?' or 'Who's gonna win Best Musical?' And somewhere down the line there's an actress who's gonna win best supporting actress and those are the ones that really, really, matter. Because there's that brilliant actress, Jayne Houdyshell. Well, you know, she did Lisa Kron's *Well,* which we produced, and she was nominated. And suddenly this woman who'd been doing regional theater for years and years, got noticed in New York for the first time. And the next thing you know, she's got a Tony Award [for *The Humans*] and that's elevated her whole career."

–LIZ MCCANN, PRODUCER, MULTIPLE TONY WINNER

ABOVE: *Lighting designer Natasha Katz won the first of her six Tony Awards in 2000 for.Disney's* Aida, *the Elton John-Tim Rice musical.*

"It never occurred to me that I could be nominated for a Tony and when I was, it was surreal. It took a long time to sink in but once it did, I felt validated. I now view the award as a great way to take the arts and kind of 'finger' them out to the rest of the country. It's a wonderful way to inspire young people to think, 'Maybe I can do that too.' Even today, every time I walk through the stage door of a Broadway theater, I get this flash. 'I can't believe I'm allowed to walk through the stage door' because the child in me is still there, the child that wants to be a part of this world."

–NATASHA KATZ, LIGHTING DESIGNER, MULTIPLE TONY WINNER, AMERICAN THEATRE WING TRUSTEE

"In around 1979, there was a production of Paul Osborn's *Morning's at Seven* in Chicago, and fortunately for the whole project I had broken my leg and my partner Nelle went alone. She called me. 'This is such a funny and delightful play. We have to do it.' It had flopped badly on Broadway in 1939. I asked, 'Are you out of your mind? It's a bunch of old people.' The English director, Vivian Matalon, had the bright idea of setting it in the '20s, instead of 1939. So the revival was a happy accident of people coming along, moving it around a little bit, and casting it beautifully. Weeks before we were to open, our press agent, Josh Ellis, discovered that Walter Kerr, The New York Times critic, had called *Morning's at Seven* a 'terrible play.' That was it. There was no way we could get a break from the all-powerful New York Times. We expected Kerr to hate it. But after he saw our production, he wrote, 'This is something special.' That year we won Tony Awards for best revival, best director, and best supporting actor, David Rounds, who sadly died of cancer three years later. Suddenly we'd found this little gem that everybody else had missed. And now, kind of miraculously, this flop play is considered a classic."

–LIZ McCANN, PRODUCER, MULTIPLE TONY WINNER

ABOVE LEFT AND RIGHT: *Jean Adair, Kate McComb, Dorothy Gish, and Enid Markey were featured in the 1939 production of* Morning's at Seven, *which flopped in its original run. Four decades later, a revival, featuring Maureen O'Sullivan and Teresa Wright, was a hit.*

ABOVE: *Beth Malone starred as the elder of three Alison Bechdels in* Fun Home, *based on the caricaturist's illustrated memoir. The Best Musical Tony Award went to a play with a rarity: an unapologetic lesbian protagonist.*

"Growing up as a kid in Ruidoso, New Mexico, watching the Tonys was less about a desire to escape into what Broadway must be like and more an exciting night of live performance. The first time was the year of *Dreamgirls* and I recognized the diversity of that world. It felt highbrow, honoring the kinds of people that I didn't know. So it felt like I was at a kind of lower-class level being in a small town [in the] Southwest. Watching the Tonys created a benchmark, a utopia to which I could aspire. When I saw my first live play, *Fences,* with James Earl Jones in Los Angeles, I was so moved emotionally that I felt the shell cracking. I was eleven.

Too young to have known the complexities within that world, but to watch these people right in front of me—*real-life people*—really had an effect. I just remember crying and crying and crying over the wife, Lynne Thigpen. She was peeling potatoes and just destroying James Earl Jones with her fierce, formidable monologue. There was no real reason for an eleven-year-old kid to empathize with her, but it was so powerful. And I recognized then the awesome power of the stage."

—NEIL PATRICK HARRIS, ACTOR, HOST OF THE TONY AWARDS, TONY WINNER, *HEDWIG AND THE ANGRY INCH*

"I was not surprised that *Caroline, Or Change* did not win Best Musical, but I was absolutely crushed when it didn't win a Tony for best score. Absolutely crushed. Years later, I was really proud to win one for *Fun Home.* The stakes were so high and the source material was so ferocious and honest. It really was a dream come true. But having lost and been nominated five times was very helpful to know that one can measure oneself without having to hold the shiny thing. But who doesn't want a shiny thing!"

—JEANINE TESORI, COMPOSER, TONY WINNER, *FUN HOME*

ABOVE AND BELOW: *Kristin Chenoweth, as Sally, terrorizes Roger Bart's Snoopy in the 1999 Broadway production of* You're a Good Man, Charlie Brown. *Chenoweth accepted on faith the role created for her by director Michael Mayer and was rewarded with a Tony Award. Chenoweth's star rose higher when she teamed with Idina Menzel for* Wicked *in 2003.*

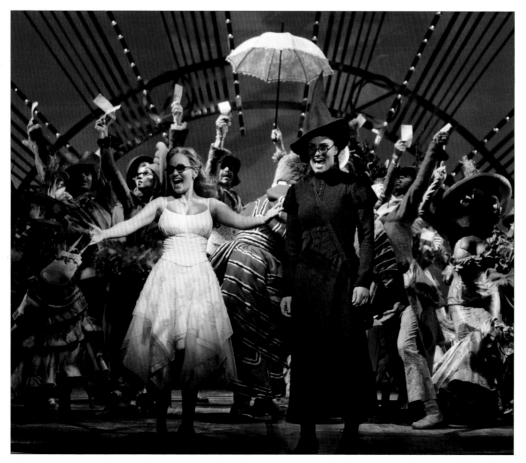

"I went to an audition for *You're a Good Man, Charlie Brown* even though I already had a job offer for the revival of *Annie Get Your Gun.* And [director] Michael Mayer said, 'I have a role in mind here, but it's not for either Lucy or Patty, but I can't actually tell you what it is. I just need you to trust me.' Now that's a carrot dangled in front of a personality like me. I asked, 'Can't you give me a hint?' 'No, I won't be able to tell you until we start.' And my agent and everybody said, 'Are you crazy? You can't go on a nothing. You gotta do *Annie Get Your Gun.*' And I kept praying on it and I felt literally God was saying, 'You gotta do *Charlie Brown.*' And Marc Kudisch, my boyfriend at the time, said, 'Kristin, I think *Charlie Brown* sounds interesting.' But it meant turning down work with my favorite theater artist, Bernadette Peters, and [director-choreographer] Graciela Daniele, and job security and money. But I felt in my heart, 'Do *Charlie Brown.*' And the first day I showed up, Anthony Rapp had all these Charlie Browns sitting in front of him and Ilana Levine had all the Lucy stuff and I sat down and mine was Sally. And that's how Charlie Brown's sister, Sally, was born. By trusting somebody."

–KRISTIN CHENOWETH, TONY WINNER, *YOU'RE A GOOD MAN, CHARLIE BROWN*

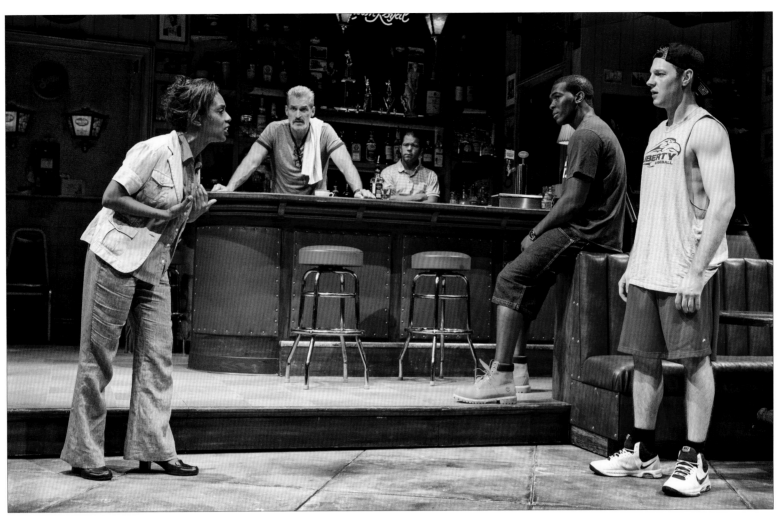

ABOVE: *(From left to right) Michelle Wilson, James Colby, Carlo Albán, Khris Davis, and Will Pullen were part of the ensemble cast of Lynn Nottage's* Sweat, *the 2016 Tony-nominated drama which brought front and center the explosive issues scarring a blue-collar community in Pennsylvania.*

"My plays have had a really robust life in the regional theater, and there's something quite satisfying about the plays traveling the country and touching many different communities, as opposed to sort of sitting on Broadway and touching one larger community. But *Sweat* is a little different, because I think at a time in which we're really struggling with our American identity and when we have a president hell-bent on taking us back to the dark ages, it's important that plays which are socially engaged have a larger forum. I think being on Broadway will give the play an opportunity to have a greater reach and for me it's important. It's really important."

—LYNN NOTTAGE, OBIE AWARD

"It was unbelievable to be nominated for a Tony for *A Raisin in the Sun* because I was just thrown into [the production] in the last minute. [Producer] Emanuel Azenberg told me that I need to write this moment in the 'resume of my soul.' We go to the Oscars because my husband [Samuel L. Jackson] is asked to present a lot, and people ask, 'Aren't you excited?' I'm like, 'No!' I'm not that girl and never have been that girl, especially now. Because going to the Oscars means I have to start starving now to get into a dress. The theater is more forgiving. The Tonys are more fun. It's a heady environment. It's charged. It's electric. You just want to explode."

—LATANYA RICHARDSON JACKSON, ACTOR, AMERICAN THEATRE WING TRUSTEE

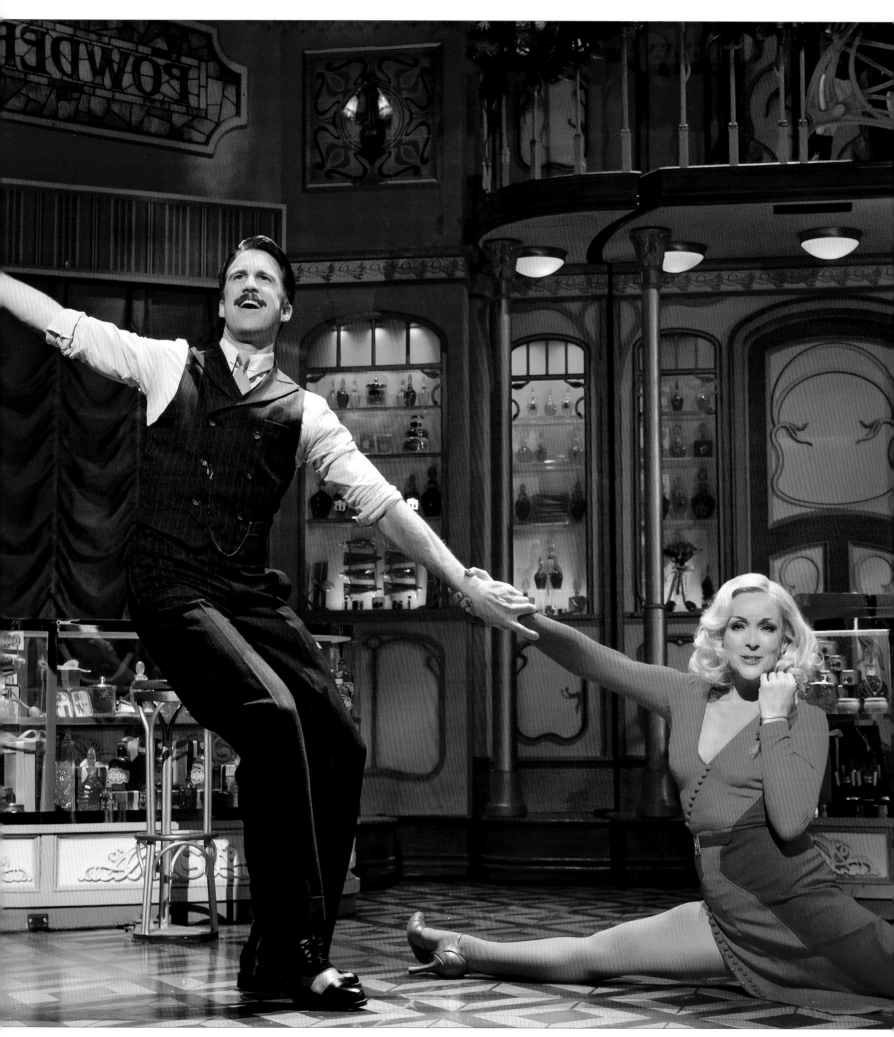

"The Tony Award acknowledges 'a joyful lovefest of family.' Theater is a phenomenal model of collaboration. A hundred people fell in love with making that show happen every single night. And it has to do with the fact that it's all handmade, from the smallest detail to the largest. There were 355 perfume bottles on my set of the perfumery for *She Loves Me.* 'Bespoke' is the most overused word in design, but if you want to talk about bespoke, theater can only happen when you're in that room with that group of performers. And every night is different. And that sense of 'live' can't be replicated in any other art form."

–DAVID ROCKWELL, ARCHITECT AND SET DESIGNER, TONY WINNER, *SHE LOVES ME*

"I think the Tony Award means a lot to the tourists who come to New York. They generally want to see 'that Tony Award-winning musical.' And the show is easier to sell on a national tour. In other countries? I'm not sure. But it does mean a lot to the presenters there. It's a brand of excellence that gives a stamp of approval to their production and what happens on Broadway is very important to the international market. It's very hard to have a hit that has never been to New York. It's even better to have a hit that has some Tony recognition."

–PETER SCHNEIDER, PRODUCER, AMERICAN THEATRE WING TRUSTEE, TONY WINNER, *THE LION KING*

"There were four shows I watched in Broken Arrow, Oklahoma: *The Love Boat,* the Oscars, the Miss America pageant, and the Tony Awards. I thought, 'I don't know what that is or how they got there, but I'm going to be part of that some day.' And my parents would giggle 'cause I'd never been to New York. And I went, 'But that's my people.' I knew. That sounds pretty spiritual and kind of weird, I know, but when I saw Madeline Kahn perform—and I'd never seen her in anything—I thought, 'Oh, I recognize her.' These were my people."

–KRISTIN CHENOWETH, ACTOR, TONY WINNER, *YOU'RE A GOOD MAN, CHARLIE BROWN*

LEFT: *Gavin Creel and Jane Krakowski are battling lovers in a Budapest perfumery in the 2016 Roundabout revival of* She Loves Me. *The musical featured a Tony-winning set by David Rockwell. Nearly 200 perfume bottles were handmade, a reminder that the theater is one of the last art forms to employ this sort of manual labor.*

ABOVE: *Audra McDonald and Norm Lewis starred in Diane Paulus' 2012 revival of* The Gershwins' Porgy and Bess. *The musical was nominated for eleven Tony Awards and won two, including best revival and best actress.*

"I'd say that the [Tony Award] I treasure the most is *Porgy and Bess*, because I got to bring my daughter Zoe, who was then eleven. To see it through her eyes made it more real. It was the first time that I felt super grounded at an awards ceremony. Zoe caught the wonder and the reality. We got to dress up. She got to see Mommy win. But then it's like, 'This is too long. My feet hurt. I'm hungry.' I felt less nervous because the evening was all about making sure she was okay."

—AUDRA MCDONALD, ACTOR, MULTIPLE TONY WINNER

"The first time I heard 'Tony Award' was from my French teacher in high school in Canada. She said, 'One of these days you're going to win a Tony Award' and I wondered, 'What the hell is that?' I learned what it was once I was cast by Jerry Mitchell in *Jerome Robbins' Broadway*, which had won the best musical Tony. From then on, I thought of the Tony as the Olympics of Broadway. When I wasn't nominated for choreographing *Jersey Boys*, it was enough for me that the show had received the recognition. But I did feel slighted when *Memphis* was nominated for a lot of awards and I was

overlooked. That season was a tough one for me. But I just buckled down with the hope that one day I'd be nominated. It took me ten years, but I was glad that it was for something close to my heart [*On Your Feet!*]. Especially because it's about two Latino immigrants, Gloria and Emilio Estefan. I'll never forget as long as I live walking into that Tony Awards breakfast, at last, and seeing the smiling faces of Charlotte St. Martin, Heather Hitchens, Bob Wankel and William Ivey Long. It was like coming home!"

—SERGIO TRUJILLO, CHOREOGRAPHER

"When I received my Tony Award for *Cabaret*, one of the people I thanked was my dresser, Landon Bradbary, because those are the people with whom you really bond. I'd only just arrived from London and didn't know what the Tonys were. After I was nominated, it was an exhausting crash course and murderous for a Scotsman to be at a reception where alcohol's being served and you've got a show that night. Torture! Landon told me later that it was a really big deal for him that I'd said his name on television. He said it changed his father's whole perception of him. You forget how just saying someone's name can really, really make big changes in their lives."

–ALAN CUMMING, ACTOR, TONY WINNER, *CABERET*

"There are many lovely things about winning a Tony, but one of the most wonderful is an opportunity to get up there and give thanks, show gratitude, and show respect. For me, winning for *Lady Day at Emerson's Bar and Grill* had nothing to do with breaking a record and all about showing respect for Billie Holiday. Knowing what that woman went through and knowing what she was able to achieve was an extraordinary thing and she deserved that mention and five million more."

–AUDRA MCDONALD, ACTOR, ON HER RECORD-BREAKING SIXTH TONY AWARD

ABOVE: *At the 2016 Tony Awards, Gloria Estefan duets with "Gloria Estefan" (Ana Villafañe) in a medley of songs from* On Your Feet!, *the biographical musical of the Cuban-born singer's meteoric recording career.*

"I joined the board when I was still at Disney and head of their theatrical division because I wanted to be part of the New York theater scene. Being an LA resident, I felt I could contribute a more national perspective to the American Theatre Wing. It's an honor to be a part of it. You get tickets to see every show—which is both a curse and a blessing—but, better yet, you get to be a small voice in the room about what is excellent in the American theater not just the Tony Award but the Obie, the National Theatre Company and Larson grants, too. And that's a big question. What has helped bring about the answer has been the addition of artists to the board and in positions of leadership—a move for which I strongly lobbied. The Wing has grown much stronger under Heather Hitchens' leadership and with William Ivey Long as chairman. Now a playwright, David Henry Hwang has succeeded William and you also have Natasha Katz, a lighting designer, as vice-chairwoman. Artists as part of the integral leadership mix has been incredibly important to the Wing. Their inclusion exposes the fallacy that someone who has an artistic mind can't be a great manager and leader."

—PETER SCHNEIDER, PRODUCER, AMERICAN THEATRE WING TRUSTEE

"I had never been chairman of anything. I had never even been on a board until three months before Heather and Ted sat me down. I thought they were going to ask me to help pick the tablecloths for the gala because I'm good with fabrics and color. And they asked me if I would consider being chairman. That proverbial feather? You could have knocked me over with it. I was sort of a deer in headlights. But I don't think I could have been of any value had not Ted Chapin, who knows the ways of the world, been previous chairman and had Heather Hitchens not joined me. And she is a take-no-prisoners, honest, and true, ethical leader of the first minting."

—WILLIAM IVEY LONG, COSTUME DESIGNER, MULTIPLE TONY WINNER, FORMER CHAIRMAN OF THE AMERICAN THEATRE WING

LEFT: *The American Theatre Wing diversified its board of directors by adding artists such as lighting designers Natasha Katz and Ken Billington. In 2015, costume designer William Ivey Long was named as Wing chairman and he was succeeded in the position by playwright David Henry Hwang. Long won his sixth Tony Award for* Rodgers and Hammerstein's Cinderella *with Laura Osnes in the title role opposite Santino Fontana.*

A Question of Excellence

By Patti LuPone

The President got it right. But this is, after all, America and show business. Competition, love it or hate it, is here to stay.

Let me be clear. The "joy" *is* the work. You hear it all the time and it's true. It has been for me as a student at Juilliard, a fledgling actor in the Acting Company, and a Broadway veteran. The reason to get up in the morning is to work with directors like Peter Sellars, Liviu Ciulei, Harold Prince, John Doyle, Michael Greif, and Jerry Zaks; writers like David Mamet, Arthur Laurents, Douglas Wright, Douglas Carter Beane, and Jeffrey Lane; lyricists and composers like Stephen Sondheim, Michael Korie and Scott Frankel, and David Yazbek.

Then at the end of every season, "comparison" takes center stage and brings up the actor's age-old insecurities: "What do they think of me? Am I good enough?" If you're eligible and not nominated for a Tony Award you ask yourself, "What happened?" And if you are nominated and you lose? Well, you're a loser ... of sorts. It's not the end of the world. But if you win, it's the greatest feeling in the world.

Even though I've watched the Tonys since they were first televised in 1967—Barbra Streisand presented the best musical to *Cabaret* and a stunned Barbara Harris won for *The Apple Tree*—

"Comparison is the thief of joy."

—THEODORE ROOSEVELT

ABOVE AND OPPOSITE PAGE: *Patti LuPone has had a varied and distinguished stage career bookended by two Tony Awards: creating the title role in* Evita *(1980), opposite page, and triumphing once again as Madame Rose in the revival of* Gypsy *(2008), above.*

awards weren't on the minds of those of us who later on made up the inaugural class of Juilliard's Drama Division. We were too scared of our teachers and of reaching the impossibly high standards they set. Later, as a member of The Acting Company, which originated out of that Juilliard class, I received my first Tony nomination for our production of *The Robber Bridegroom.*

Getting nominated was a surreal experience. This was especially true the first time. It came as a surprise. *The*

Robber Bridegroom had only played a limited run on Broadway—fourteen performances. I learned that I was nominated while in Omaha touring with The Acting Company. It was also a Tony first: two siblings nominated in the same category in the same season. My brother Bobby had also gotten a nod for *A Chorus Line.* I immediately wondered how the rest of the company would react to the news. As I recall, there was not much of a reaction: "Don't let it go to your head. We have a show tonight. Get on with it." I lost and got on with it.

When I played Eva Peron in *Evita* four years later, I won. So did Mandy Patinkin, as Che, and the musical itself. Seven Tonys total. Thrilling! Joyful! That night it was so easy to forget just how brutal and nerve-racking the whole experience of *Evita* had been. Talk about comparison? Julie Covington had sung Evita on the concept album, and Elaine Paige had created the role in the world-premiere London production. We opened to mixed reviews and the vocal demands were strenuous and unrelenting. But when you're taking in all that incoming fire, it's great to have a *mensch* like Mandy in the foxhole with you.

It took almost another thirty years before I stood at the podium with a second Tony Award in my hand. This

time it was for *Gypsy*, which had been a glorious experience, start to finish, with Boyd Gaines, Laura Benanti and my beloved Arthur Laurents. To cap it with a Tony Award? So sweet. In the intervening years, I had been nominated twice, for *Anything Goes* and *Sweeney Todd.* The press and everybody in the world, it seemed, told me that I was a sure bet to win for both roles. I didn't. Word to all future nominees: If everybody tells you you're a lock, take it with a grain of salt. Remember, the joy is in the work.

I've always thought that if there are five outstanding performances, there should be five awards because you can't compare characters. The year I won for *Evita,* I was up against Ann Miller in *Sugar Babies,* Sandy Duncan in *Peter Pan,* and Christine Andreas in *My Fair Lady.* How can you decide which is the best performance? *Evita* versus *Peter Pan* versus Eliza versus Ann herself? It's so subjective, the characters are all so different.

But when you're an actor, comparison, either in the audition room or at the Tonys, is a fact of life. And it takes a lifetime to put that in perspective—if you ever do. To this day when I'm rejected for a role, I wonder, "What am I doing wrong?" I never pick a role because I think it's going to win me a Tony or get me nominated. And yet that thought in the back of my head eventually starts to creep forward. I'm human.

When people say, "I have no regrets," I'm in awe—and a little skeptical. I have tons of regrets. I think of the roles I didn't take. There was one season in which I turned down roles in two different plays. The actors who played them were nominated for Tonys. Did I question my decision? Yes, I did, but not for long.

The role I chose to do was Jolly in *The Old Neighborhood,* by my good friend David Mamet. The reception and the run were disappointing, but I'm proud of the work Peter Riegert and I did. My longtime affiliation with David is something I have always treasured. In fact, years before, when I got the call that I'd won the role in *Evita,* my agent said, "You don't sound happy. Aren't you ecstatic?" To be honest, I was ambivalent because it meant that I couldn't be in David's *The Woods* at the Public Theater, directed by Ulu Grosbard.

You often hear when somebody appears to have "a lock" on an award: "It's her year." Well, every year is your year if you do work that challenges and satisfies you. The greatest lesson I learned at Juilliard was to hold myself to the highest standard of excellence. As long as I can interpret a Mamet play, I know that I am fulfilling my training at Juilliard. It's what I called in my Tony acceptance speech for *Evita,* "the dream of the big skill," "the apprenticeship of wonder." And I was deliriously happy and grateful to share those thoughts from the podium. So thank you, American Theatre Wing.

David once told me, "Dare to live in an area where you do not know what is going on." That holds as true for life as it does for art and awards. What I have come to realize after a lifetime in the theater is: What comes my way will be what is right.

I know it sounds Zen. It is. And it has saved my emotional life.

Passionate Partisans

When Tony Award season rolls around, theater nerds have their favorites, especially when it comes to best musical. Rick Elice, who would go on to write Peter and the Starcatcher and Jersey Boys, was no exception. In 1971, the writer was a young teen living in Queens when his friend Fred Nathan suggested skipping class to take in a matinee of the new Stephen Sondheim musical, Follies. Elice demurred at first. His parents, who policed his theater-going, had told him that the musical, about embittered married couples, was inappropriate. Elice recalls, "Fred said, 'How are they going to know?' And that's how I ended up seeing Follies twenty-five times and believing that Sondheim was God!" As the 1972 Tony Awards approached, the tight race between Follies and Two Gentlemen of Verona reached a fever pitch.

"There was only one television set so my mother, father, brother and I were gathered in the living room watching the Tonys. When Ingrid Bergman announced that the best musical was *Two Gentlemen of Verona*, I was outraged. By that time, [*Follies*] had won seven Tony Awards. I couldn't understand how a show that had won for best direction, best score, best actress, and best choreography could not also win for best musical. I was raging against the machine—in this case the television set—and my parents were puzzled. They couldn't understand my passion for a show they had not enjoyed and that I had not seen—or so they thought. They were rooting for *Two Gentlemen of Verona* because it was Shakespeare and healthy and Joe Papp [the producer] had gone to Eastern District High School in Brooklyn where they had been students. I was jumping up and down in the living room shouting, 'This is insane! This is insane!' I'm sure my parents were sitting there thinking, 'What is insane is you!'"

–RICK ELICE, PLAYWRIGHT, *JERSEY BOYS, PETER AND THE STARCATCHER*

"In a career that lasts as long as mine has, thank God, you win some. You lose some. And sometimes you should have won very clearly and others that perhaps I shouldn't have won. So it evens itself out, finally."

–HAROLD PRINCE, PRODUCER-DIRECTOR, MULTIPLE TONY WINNER

"You should have won, not Mary Martin."

–BILLY ROSE IN A TELEGRAM TO ETHEL MERMAN AFTER HER ICONIC MADAM ROSE IN *GYPSY* LOST TO MARTIN'S MARIA IN *THE SOUND OF MUSIC* AT THE 1960 TONY AWARDS

"I got to go to the Tonys one year as a seat filler and it was the year *Once* was nominated. It was just a beautiful bit of coincidence since I'd been working as a production assistant on the musical. I was being moved around the room, until, unbeknownst to me, I ended up in the very middle of the creative team for *Newsies,* which was the main competitor that year of *Once.* When they announced the best musical winner, *Once,* I jumped up from my seat and started clapping and whooping. The three rows around me just turned to stare at me, silently. And then I recognized some of the faces, and I said, 'Oh, you guys, uh, good job, too!' and slunk back into my seat."

–RYAN MCCURDY, AMERICAN THEATRE WING'S THEATRE INTERN NETWORK

"There are an awful lot of shows that are ahead of their time and everyone catches up later. I mean, you know, *The Music Man* is a terrific show but it isn't *West Side Story.*"

–HAROLD PRINCE, PRODUCER-DIRECTOR

OPPOSITE PAGE: *Tony winner Alexis Smith led a stunning ensemble of ladies in* Follies, *the Stephen Sondheim-Harold Prince musical that won seven Tony Awards in 1972 but lost the main prize, best musical, to* Two Gentlemen of Verona. *The latter show, an irreverent and hip take on the Shakespeare comedy, featured Jonelle Allen, Raul Julia, Diana Davila, and Clifton Davis.*

The History of The Tony Award

The American Theatre Wing inaugurated the Tony Awards in 1947 in order to celebrate excellence in the theater. The suggestion came from producer Brock Pemberton to honor his friend and colleague Antoinette Perry, who had begun her career as an actress before establishing herself as a successful director (*Harvey*). During World War II, she chaired the Wing and her tireless efforts on its behalf led to her untimely death of a heart attack at age fifty-eight in 1946.

The Antoinette Perry Awards—soon shortened to "the Tonys"—made their official debut at a dinner in the Grand Ballroom of the Waldorf Astoria Hotel on Easter Sunday, April 6, 1947. Vera Allen, Perry's successor as chairwoman of the Wing, presided over an evening that featured entertainment by the likes of Mickey Rooney, Ethel Waters, and David Wayne. Eleven Tonys were presented in seven categories, and there were eight special awards, including one for Vincent Sardi, proprietor of the eponymous eatery on West 44th Street. Big winners that night included José Ferrer, Arthur Miller, Helen Hayes, Ingrid Bergman, Patricia Neal, Elia Kazan and Agnes de Mille. The awards were a scroll accompanied with a money clip for the men and a face powder compact for the women.

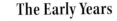

The Early Years

From the beginning, the Broadway community embraced the Tonys. While the awards ceremony in its early years was smaller than it is today, the annual gala dinner quickly became one of the highlights of the New York theater season. More than a thousand guests attended the first Tony dinner in 1947. In the eighteen years that followed, the dinner and Tony Awards presentations took place in ballrooms of such hotels as the Plaza, the Waldorf Astoria, and the Astor. WOR and the Mutual Network broadcast the awards ceremonies over the radio, and television coverage began in 1956 when Du Mont's Channel 5 telecast them locally for the first time. Entertainment was provided by such Broadway favorites as Katharine Cornell, Joan Crawford, Shirley Booth, Carol Channing, Joan Fontaine, Paul Newman, Geraldine Page, Anne Bancroft, Sidney Poitier, Fredric March, Robert Goulet, Henry Fonda, and many others.

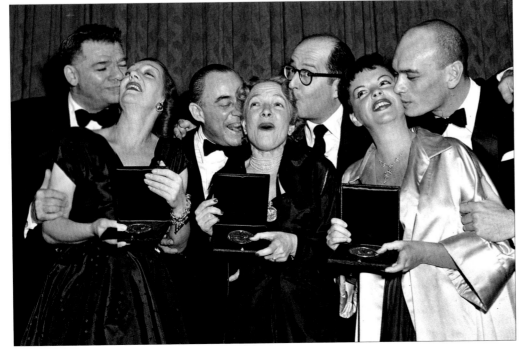

ABOVE: *In 1949, Herman Rosse designed the medallion that would become synonymous with theatrical excellence. On one side, a profile of Antoinette Perry, in whose honor the award was created; on the other, Melpomene and Thalia, the muses of tragedy and comedy.*

BELOW LEFT: *Tonys and kisses were the hallmark of the 1952 Tony Awards with a bonanza going to* The King and I. *Oscar Hammerstein busses Gertrude Lawrence while Richard Rodgers joins Phil Silvers in kissing Helen Hayes. Not to be outdone, Yul Brynner moves in on Judy Garland.*

ABOVE: *Beatrice Lillie clowns it up with Thomas Mitchell at the 1953 Tony Awards at which he won for his performance in the musical* Hazel Flagg *and she was honored for the revue,* An Evening with Beatrice Lillie.

The 1966 Tony Awards were presented at the Rainbow Room under the pall of the death of Helen Menken, then chairwoman of the Wing. The ceremony was subdued and, for the first and only time, held in the afternoon without entertainment. The following year the Tony ceremony was once again a gala affair, but with a key difference. With Isabelle Stevenson as its new president, the Wing invited the Broadway League—then known as the League of New York Theatres and Producers— to co-present the Tonys in 1967, just in time for the ceremony's inaugural broadcast on network television. For the first time, a national audience could watch the presentation of the Tonys.

The Television Era

Alexander H. Cohen produced the historic broadcast, which lasted only an hour and which moved the Tonys from their traditional hotel ballroom setting to a Broadway theater, the Shubert. The telecast was hosted by Mary Martin and Robert Preston, then both appearing in the musical *I Do! I Do!* Barbra Streisand was on hand to present the Best Musical Tony Award to *Cabaret* while the Best Play honor went to Harold Pinter's *The Homecoming.* Cohen continued to produce the awards ceremony and the gala dinner for the next two decades,

overseeing the national telecast on various networks on behalf of the League and the Wing. During his tenure, the Tonys became known as the finest awards program on television, incorporating live performances with the bestowal of actual awards. The Cohen era ended in 1987, and that year the Wing and the League created Tony Award Productions, a joint venture that has continued to produce the awards and their related events to this day. CBS began carrying the awards ceremony in 1978, and has broadcast the Tonys nationally every year since. For six years, beginning with the fifty-first annual awards presentation

in 1997, the Tony Awards program aired under a unique partnership between CBS and PBS. A one-hour PBS special covered ten awards, followed immediately by the CBS broadcast. However, beginning in 2003, CBS devoted an entire three-hour time slot to the Tonys. The result has been a seamless awards and entertainment program broadcast on that network. The Tony program has received numerous Emmy Awards during the CBS era and is broadcast each June in many countries across the globe.

The Tonys celebrated another milestone in 1997 when the awards ceremony moved away from Broadway

"1971 was the year of my bar mitzvah, the Watergate break-in and the twenty-fifth anniversary Tony telecast. We were far enough away from the Golden Age of Broadway but all those people were still alive. So they did excerpts from all the Tony Award-winning shows, and there was Vivian Blaine singing 'Adelaide's Lament,' Angela Lansbury singing 'Mame' and Zero Mostel singing [songs from] *Fiddler.* Robert Freedman, my collaborator on *A Gentleman's Guide to Love and Murder,* and I speak about the Tony Awards that year as a watershed. We were straddling the old world and the new. *Hair* had already opened and Vivian Blaine was still alive!"

–Steven Lutvak, songwriter, *A Gentleman's Guide to Love and Murder*

ABOVE: *Mary Martin and Robert Preston were hosts of the first nationally televised Tony Awards ceremony in 1967. They were then appearing together in* I Do! I Do!, *directed by Gower Champion. Preston won as best actor in a musical while* Cabaret *and* The Homecoming *took top honors.*

for the first time in three decades. For all but one of the years between 1997 and 2010, Tony night took place each June at New York's celebrated Radio City Music Hall. Since 2011, the ceremony has been held either at Radio City or at the Beacon Theatre on Manhattan's Upper West Side. In 2000, IBM joined the Tonys to launch TonyAwards.com, a website that immediately became the definitive resource for information about the awards. The site serves as a year-round home for the Tonys on the Internet, and anchors an online social media presence that includes Facebook, Twitter, Instagram, YouTube, Snapchat, and other platforms.

The Medallion

During the first two years of the Tonys (1947 and 1948), there was no official Tony Award. In 1949, United Scenic Artists, a union, sponsored a contest for a suitable prototype for the award. The winning entry, a disk-shaped medallion designed by Herman Rosse, depicted the masks of comedy and tragedy on one side and the profile of Antoinette Perry on the other. The medallion was initiated that year at the third annual dinner. It continues to be the official Tony Award. Since 1967 the medallion has been mounted on a black granite pedestal with a curved armature. After the ceremony, each award is numbered for tracking purposes and engraved with the winner's name.

ABOVE LEFT: *Lauren Bacall, once a hostess at the American Theatre Wing's Stage Door Canteen, claimed a Tony for her star turn in the musical,* Applause. *Here she ripostes with Walter Matthau who co-hosted the 1970 Tony Awards with Julie Andrews and Shirley MacLaine.*
BELOW LEFT: *Liza Minnelli and director-choreographer Bob Fosse celebrate their respective career peaks at the 1978 Tony Awards. She took a medallion home for* The Act *while he prevailed for his choreography for* Dancin'.

Tony Ceremony Hosts from 1947-2017

1947 BROCK PEMBERTON

1948 BERT LYTELL, HIRAM SHERMAN, HARRY HIRSHFIELD

1949 BROCK PEMBERTON, JAMES SAUTER

1950 HELEN HAYES, MRS. MARTIN BECK

1951 JAMES SAUTER

1952 HELEN HAYES

1953 FAYE EMERSON

1954 JAMES SAUTER

1955 HELEN HAYES

1956 JACK CARTER

1957-1959 BUD COLLYER

1960 EDDIE ALBERT

1961 PHIL SILVERS

1962 RAY BOLGER, ROBERT PRESTON

1963 ABE BURROWS, ROBERT MORSE

1964 SIDNEY BLACKMER

1965 TOM BOSLEY, JOSÉ FERRER, VAN JOHNSON

1966 GEORGE ABBOTT, GINGER ROGERS

1967 MARY MARTIN, ROBERT PRESTON

1968 ANGELA LANSBURY, PETER USTINOV

1969 DIAHANN CARROLL, ALAN KING

1970 JULIE ANDREWS, SHIRLEY MACLAINE, WALTER MATTHAU

1971 LAUREN BACALL, ANGELA LANSBURY, ANTHONY QUAYLE, ANTHONY QUINN

1972 HENRY FONDA, DEBORAH KERR, PETER USTINOV

1973 REX HARRISON, CELESTE HOLM

1974 PETER FALK, FLORENCE HENDERSON, ROBERT PRESTON, CICELY TYSON

1975 LARRY BLYDEN, GEORGE S. IRVING, LARRY KERT, CAROL LAWRENCE, MICHELE LEE, BERNADETTE PETERS, BOBBY VAN

1976 EDDIE ALBERT, RICHARD BURTON, JANE FONDA, DIANA RIGG, GEORGE C. SCOTT, TRISH VAN DEVERE

1977 JACK ALBERTSON, BEA ARTHUR, BUDDY EBSEN, DAMON EVANS, JEAN STAPLETON, LESLIE UGGAMS

ABOVE: *What is it about Norma Desmond in* Sunset Boulevard *that proves irresistible to Tony hosts? Nathan Lane put on the diva in the 1996 Tony Awards.*

FOUR FAR LEFT: *At the 2016 Tony Awards, host James Corden showed off formidable musical chops by spoofing* Les Miserables, The Phantom of the Opera, Jesus Christ Superstar, *and* Fiddler on the Roof.

OPPOSITE PAGE TOP: *At the 2004 Tonys, Hugh Jackman kisses the award given for his Broadway debut in* The Boy from Oz, *the musical about the late Peter Allen, a fellow Aussie entertainer. Jackman also hosted the ceremony which featured a best musical upset:* Avenue Q *prevailed over* Wicked.

OPPOSITE PAGE BOTTOM: *In 1966, Angela Lansbury, the toast of the town in* Mame, *celebrates the first of her five Tony Awards with twin brothers, Bruce and Edgar, both of whom followed their older sister into show business as producers. The popular Broadway and television star also holds the record for the most appearances as Tony host: five.*

1978 BONNIE FRANKLIN

1979 JANE ALEXANDER, HENRY FONDA, LIV ULLMANN

1980 MARY TYLER MOORE, JASON ROBARDS

1981 ELLEN BURSTYN, RICHARD CHAMBERLAIN

1982 TONY RANDALL

1983 RICHARD BURTON, LENA HORNE, JACK LEMMON

1984 JULIE ANDREWS, ROBERT PRESTON

1985 NO FORMAL HOST

1986 NO FORMAL HOST

1987-89 ANGELA LANSBURY

1990 KATHLEEN TURNER

1991 JULIE ANDREWS, JEREMY IRONS

1992 GLENN CLOSE

1993 LIZA MINNELLI

1994 ANTHONY HOPKINS, AMY IRVING

1995 NATHAN LANE, GLENN CLOSE, GREGORY HINES

1996 NATHAN LANE

1997-1998 ROSIE O'DONNELL

1999 NO FORMAL HOST

2000 ROSIE O'DONNELL

2001 NATHAN LANE, MATTHEW BRODERICK

2002 BERNADETTE PETERS, GREGORY HINES

2003-2005 HUGH JACKMAN

2006 NO FORMAL HOST

2007 NO FORMAL HOST

2008 WHOOPI GOLDBERG

2009 NEIL PATRICK HARRIS

2010 SEAN HAYES

2011-2013 NEIL PATRICK HARRIS

2014 HUGH JACKMAN

2015 KRISTIN CHENOWETH, ALAN CUMMING

2016 JAMES CORDEN

2017 KEVIN SPACEY

TONY CEREMONY HOSTS MORE THAN ONCE:

ANGELA LANSBURY (5)

NEIL PATRICK HARRIS (4)

HUGH JACKMAN (4)

ROBERT PRESTON (4)

JULIE ANDREWS (3)

BUD COLLYER (3)

NATHAN LANE (3)

ROSIE O'DONNELL (3)

JAMES SAUTER (3)

EDDIE ALBERT (2)

RICHARD BURTON (2)

GLENN CLOSE (2)

HENRY FONDA (2)

HELEN HAYES (2)

GREGORY HINES (2)

BROCK PEMBERTON (2)

BERNADETTE PETERS (2)

PETER USTINOV (2)

"That American Theatre Wing minute[2012] was my pitch. I said, 'Let's make it a moment where people don't wanna go to the bathroom or quickly grab another plate of food, but make it feel like something legitimate has gone on and then you'll watch it later on the internet.' I love moments in my hosting stuff where you think, 'Wait a second? Did that just happen? Wait. Rewind it.' I wanted to fill the show with moments that you actually needed to pay attention to and make sure you saw what you saw."

—NEIL PATRICK HARRIS, HOST OF THE TONY AWARDS, TONY WINNER, *HEDWIG AND THE ANGRY INCH*

OPPOSITE PAGE: *At the 2012 Tony Awards, host Neil Patrick Harris spoofed the musical* Spider-Man: Turn Off the Dark *during the "minute" on the telecast devoted to explaining the scope of American Theatre Wing activities. "We're hovering about all year long offering financial support and encouragement to theater companies," said Angela Lansbury. "No strings attached," chimed in chairman Ted Chapin. To which Lansbury concluded, "We won't leave you hanging."*

ABOVE: *In 1995, Glenn Close not only hosted the Tony Awards but took home top honors for her performance in* Sunset Boulevard. *Joining her to celebrate was Ralph Fiennes who was named as best actor in a play for his acclaimed* Hamlet.

LEFT: *Richard Burton co-hosted the 1983 Tony Awards with Lena Horne and Jack Lemmon. Lena Horne had recently completed a triumphant Broadway return in* The Lady and Her Music *while Burton was then appearing in a revival of Noel Coward's* Private Lives *opposite his ex-wife, Elizabeth Taylor.*

THE TONY AWARD AND "IT'S A WONDERFUL LIFE"

By Patrick Pacheco

ABOVE: *Rosalind Russell starred in* Wonderful Town, *the 1953 Tony-winning musical which got enmeshed in the proceedings of the House Un-American Activities Committee when Jerome Robbins, who was called in to doctor the show, testified against Jerome Chodorov, one of its writers.*

In the Frank Capra film classic It's a Wonderful Life, *the banker George Bailey, played by James Stewart, is facing ruin. As he contemplates suicide wishing he'd never been born, a heavenly visitor shows how dismal the life of the community would have been without his presence. The Tony Award has impacted the lives of its recipients in various ways, from more money in the bank to a stepping-stone to a pinnacle. But, like George Bailey, what if the Tony had never existed?*

Fiddler on the Roof, 1965

In fact, the Tony Award, established in 1947, was facing extinction in 1965 when Helen Menken resigned as president of the American Theatre Wing. The awards, financed by her stockbroker husband, George N. Richard, had been cancelled until producer Harold Prince convinced Menken to rescind her resignation and resurrect the ceremony. He may have had a more than passing interest in

doing so. The biggest hit of the season was his rapturously received *Fiddler on the Roof,* which had a troubled out-of-town tryout but which turned around its fortunes before reaching New York. The musical's tenacity and brilliance were rewarded with nine Tony Awards, including best actor (Zero Mostel), best featured actress (Maria Karnilova), best musical (producer Harold Prince), best book (Joseph Stein), best score (Jerry Bock and Sheldon Harnick) and

best direction and best choreography (Jerome Robbins). Robbins had famously resolved the pre-Broadway difficulties when after an especially dispiriting audience response to a performance, he confronted the writers and asked them, "What is this show about?" The team mused and finally concurred, "It's about tradition." "Great," responded the director, "now go write a song about it."

The Crucible and Wonderful Town, 1953

The mercurial Jerome Robbins had also been involved in a controversy more than a decade earlier when the Red Scare and the House Un-American Activities Committee (HUAC) had Hollywood shaken. The blacklist, which had put an end to the career of many writers accused of communist sympathies, had not affected Broadway to the same degree. But Senator Joseph McCarthy was whipping the country into "scoundrel time," as Lillian Hellman put it.

Playwright Arthur Miller, who was among the first winners of the Tony for *All My Sons* in 1947, infused his drama *The Crucible*, about the Salem witch trials, with the same feverish paranoia. The parallels to McCarthyism were evident. The critics were largely hostile and the public was indifferent. But its two Tony Awards, including best play, helped the producers eke out a run of just over five months.

In the same year, the run-in with HUAC was even more dramatic with the musical *Wonderful Town*. The show starred Rosalind Russell and had songs by Leonard Bernstein, Adolph Green, and Betty Comden with a book written by Joseph Field and Jerome Chodorov. The choreography was by Donald Saddler but the director George Abbott

was dissatisfied and Jerome Robbins was brought in. Harold Prince, who was the stage manager of the production, recalls that one day, while the show was in rehearsals, Robbins was summoned to Washington, D.C., to testify before HUAC. "Now, I don't know if Robbins named Jerry Chodorov," says Prince. "But I sure could see the ice forming between the two of them the next day."

Ginger Chodorov, niece of the writer, says the New York Times reported that Robbins had indeed named as communists both her uncle Jerome and her father, Edward Chodorov. "The news brought the American Legion to picket in front of a show co-written by a 'commie,'" she says. Frederick Brisson, the husband of Russell and an American Legion member himself, shooed them away before they could damage his wife's show. Chodorov recalls that Robbins returned from D.C. to rehearsals as if nothing had happened, "No explanation. Nothing." While Robbins may have been trying to save his own burgeoning career by naming names, Chodorov recalls that a rumor going around at the time is that the FBI was threatening to expose him as a homosexual if he didn't cooperate with HUAC.

Chodorov wonders whether the Tony Awards given to *The Crucible* as best play, and *Wonderful Town* as best musical, could be construed as Broadway giving a Bronx cheer to HUAC. "It certainly sounds that way, doesn't it?"

Who's Afraid of Virginia Woolf? 1963

Edward Albee's scabrous play about an evening of highballs and marital discord landed on Broadway like a Molotov cocktail. Reviews were mixed, some objecting to the language and

sexual innuendo. Evaluating the play in the Daily News, John Chapman condescendingly called *Who's Afraid of Virginia Woolf?* for "dirty-minded females only." Nonetheless, the play was recommended for the Pulitzer Prize for Drama by a jury of two critics, John Gassner and John Mason Brown, even though both had reservations. However the advisory board—the trustees of Columbia University—were troubled by the raw spirit of the play. W.D. Maxwell, editor of the Chicago Tribune, called *Virginia Woolf*, "a filthy play," leading the board to snub it. Gassner and Brown were outraged.

Wrote Gassner, "I see no insuperable objection to the work on the grounds of immorality, lubricity, or scatology once one reflects that we cannot expect the vital plays of our period...to abide by Victorian standards."

The Tony committee disagreed with the Pulitzer's timid position and bestowed on the drama five awards, including best actor (Arthur Hill), best actress (Uta Hagen), best director (Alan Schneider) and best play. *Virginia Woolf* was the first of six best play nominations given to Albee, and he finally won again nearly forty years later for *The Goat, or Who Is Sylvia?* A Lifetime Achievement Tony followed three years later, in 2005.

Sticks and Bones, 1972

Amid the fury and divisiveness of the Vietnam War, David Rabe, who was a veteran of the conflict, penned a trilogy that consisted of *The Basic Training of Pavlo Hummel, Sticks and Bones,* and *Streamers.* The second of these was a nasty satire about an *Ozzie and Harriet*-like family dealing with a son returning blind from war in an unnamed country and bringing with him the ghost of his Asian girlfriend. The drama improbably

ABOVE: *The return of a blind Vietnam vet explodes the calm of a suburban home in David Rabe's* Sticks and Bones, *which won the 1972 Tony Award as best play over more conventional fare. Rue McClanahan and Drew Snyder were featured in the drama which opened at a time when wounds were still raw over the polarizing conflict.*
OPPOSITE PAGE: *Uta Hagen and Arthur Hill starred in the original 1962 drama,* Who's Afraid of Virginia Woolf?, *Edward Albee's caustic look at an embittered married couple who taunt young guests (Rochelle Oliver and Ben Piazza). Too hot for the Pulitzer, it won the Tony as best play.*

performances, discomforting the audiences that came to see it because it had been given the imprimatur of the Tony Award.

Children of A Lesser God, 1980

Broadway had never been a particularly hospitable place for the deaf, except for a brief engagement of the National Theatre of the Deaf in 1969. This all changed in 1979 when Mark Medoff's *Children of a Lesser God* brought the complexities of human connection to the fore in a story about a deaf young woman and her troubled romance with a hearing teacher. The production, directed by Gordon Davidson, won three Tony Awards, including best play, best actor, John Rubinstein, and best actress, Phyllis Frelich.

The win by Frelich, born of deaf parents and one of nine hearing-impaired children, was a Tony first. In accepting the award, Medoff acknowledged the crucial participation in the writing of the drama by Frelich and her hearing husband, Robert Steinberg, a scenic designer. Meeting Frelich through Steinberg inspired Medoff to write a play for the actress who bemoaned the lack of stage roles for those similarly handicapped. The ground-breaking play met with immediate acclaim and a long run on Broadway, and was later adapted into film which won an Oscar for Marlee Matlin in the role created by Frelich.

Deaf actors have long acknowledged the debt to Frelich for the slow incremental change in their opportunities, reaching something of an apogee in two Deaf West Theatre productions which have reached Broadway: *Big River* (2003) and *Spring Awakening* (2016), both of which were nominated for the best revival Tony.

landed on Broadway thanks to Joseph Papp, who first produced it downtown at his Public Theater. More improbably, it was nominated for four Tony nominations and won two, best actress (Elizabeth Wilson) and best play. In reviewing a 2014 New Group revival of *Sticks and Bones*, Ben Brantley wrote, "It makes you marvel that such a strange, angry, messy, and profoundly disturbing

work won the Tony Award for best play, a prize usually reserved for more tidy upholders of theatrical convention."

In fact, the Tony voters could have gone the conventional route, crowning Neil Simon's *Prisoner of Second Avenue* or Robert Bolt's *Vivat! Vivat, Regina!*, the prestige drama of the season. But, even though it was hemorrhaging money, Papp kept it running for 227

ABOVE: *The Mark Medoff drama,* Children of a Lesser God, *exposed Broadway audiences to complicated personal and professional challenges of the hearing impaired. In 1980, Phyllis Frelich and John Rubinstein (show here with Julianne Gold) both won Tony Awards for their performances and the drama was named best play.*

The latter was especially revelatory in enlarging the vision of the theater community. The revival included not only many deaf actors making their debuts but also the first wheelchair-bound actor, Ali Stroker, ever to appear on a Broadway stage. When an emotional Medoff accepted the Tony in 1980, he said, "The dream meets reality...I use a sign in the play, it means to be joined in a shared relationship.... We are all of us joined."

Fences, 1987

The year 1985 marked a watershed for African-American literature when the Broadway production of *Ma Rainey's Black Bottom* heralded the arrival of an extraordinarily prolific and poetic playwright in August Wilson. Over the next two decades, Wilson would bring the teeming Hill District of his native Pittsburgh kinetically alive in a ten-play cycle. Before his death in 2005, at the age of sixty, the playwright claimed a best play Tony nomination for every one of his plays—then eight—to have reached Broadway. While one more nomination followed posthumously for *Radio Golf,* the diadem in the series remained *Fences,* the explosive 1987 drama in which James Earl Jones created the role of Troy Maxon, the garbage man whose abortive dream of playing professional baseball scars his family, especially his long-suffering wife, played by Mary Alice. The drama and both actors won Tony Awards. A 2010 revival, starring Denzel Washington, again won three Tonys, including best revival, best actor and best actress (Viola Davis) and was later made into an Oscar-nominated movie.

In the footsteps of Lorraine Hansberry's 1960 Tony-nominated *A Raisin in the Sun* and Joseph A. Walker's *River Niger,* which won the Best Play Tony in 1974, Wilson's cycle took the specific struggles of African-American existence over the expanse of a century and made them contemporary and universal. Tony Kushner noted that Wilson "...was a giant figure in American theater....Heroic is not a word one uses often without embarrassment to describe a writer or playwright, but the diligence and ferocity of effort behind the creation of his body of work is really an epic story." Wilson lived long enough to see the Virginia Theatre renamed in

ABOVE: *Stephen Karam's* The Humans, *which won multiple 2016 Tony Awards including best play, predicted the political turmoil that would follow later that year. The drama, produced by Scott Rudin, exposed the financial pressures of a Pennsylvania family which included Reed Birney, Sarah Steele, Jayne Houdyshell, Cassie Beck, and Arian Moayed.*

his honor but not long enough to see an oversight corrected: *Jitney,* the eighth in his Pittsburgh Cycle which had played Off-Broadway in 2000, finally reached Broadway to unanimous acclaim in 2017. Sixty years. Ten plays. Twelve Tony nominations for either best play or best revival. Epic, indeed.

The Humans, 2016

American playwrights have long taken a back seat to their British peers when it comes to the political landscape. After all, it was left to David Hare, the English writer, to dissect the blunders of the Bush Administration in the run-up to the Iraq War in *Stuff Happens,* which was presented at the Public Theater in 2006. While not overtly political, *The*

Humans, by Stephen Karam, foretold the earthquake of the 2016 presidential election through the economic anxieties of a Pennsylvania family.

That it would win the Tony Award as best play was anything but a slam dunk when producer Scott Rudin told Karam and director Joe Mantello—shortly after previews began at Off-Broadway's Laura Pels Theatre—that he was moving the production to Broadway. Karam cautioned, "Don't you want to wait until the reviews come out?" Rudin said he would forge ahead no matter the critical reception. They needn't have worried. The reviews were excellent. But *The Humans,* told in short scenes of emotional dislocation as a family gathered for Thanksgiving dinner, was

hardly a strong commercial prospect. Its subsequent success was the best news for American playwrights in a long time and no doubt had an indirect role in the transfer of Lynn Nottage's *Sweat* to Broadway the following season. Nottage had been a mainstay of Off-Broadway and regional theater, and it was a surprise that her much-acclaimed Pulitzer Prize winner *Ruined* never made it to the Broadway stage. *Sweat,* detailing the lives of economically depressed factory workers in the Rust Belt, acutely explained the tremors that would shake America through the rise of a dangerous populism. From *The Crucible* to *The Humans,* the Tony Award has kept pace, reminding audiences that we are all, indeed, "joined."

Off-Broadway

ABOVE: *Arian Moayed and Omar Metwally starred in Rajiv Joseph's* The Guards at the Taj *in 2015 at the Atlantic Theater Company. The drama—a fable that exposes the brutality in the shadow of the majestic Taj Mahal—won the best play Obie Award that year.*

"The Wing took an important step in bringing the Obies into the fold because there's no question that this Off-Broadway award has brought an extremely important and new dimension to the Wing. Isabelle Stevenson [the late ATW president] spent years trying to figure out a way to honor the achievements of Off-Broadway, and it just didn't happen in her lifetime. For some years now, Off-Broadway has been instrumental in launching the careers of many actors, like Al Pacino, and developing new and important playwrights, like Edward Albee. And Off-Broadway continues to play a crucial and even greater role in the development of New York theater. You can see that in the nominees for the Tonys. It's not infrequent that you'll have Obie winners among them."

—ENID NEMY, AMERICAN
THEATRE WING TRUSTEE

"When we performed *Saint Joan* by Shaw, our first in 2011, we were on the high wire. We're four or five feet away from the audience and we get people with arms folded, avoiding eye contact. But there's something thrilling when by the end they are leaning forward and really, really present. In the final scene, after Joan is burned and declared a saint, she returns and asks, 'Shall I rise from the dead and come back to you a living woman?' The script calls for no response. 'What? Must I burn again? Are none of you ready to receive me?' And one night, a woman from the audience yelled very loudly, 'I am!' She obviously got carried away. "

–ANDRUS NICHOLS, PRODUCING DIRECTOR, BEDLAM, NYC, OBIE AND NATIONAL THEATRE COMPANY GRANTS

"I'm always looking for a way to thread the needle. The production is going to feel esthetically honorable to the period in which the play was written as well as hip and sexy enough to be exciting for a contemporary audience. The American Theatre Wing grant is very meaningful in terms of expanding the productions of the Red Bull Theater. We produce large-cast classical plays in small Off-Broadway theaters and the grant's incredibly meaningful to a theater our size."

–JESSE BERGER, ARTISTIC DIRECTOR, THE RED BULL THEATER, NEW YORK CITY, NATIONAL THEATRE COMPANY GRANT

"I'm the child of Palestinian Christian immigrants. I grew up in Los Angeles and went to graduate school in Texas and more and more I realized I was straddling two cultures. And one of those cultures was the subject of such awful portrayals in the media. Terrorists, grieving widows, deranged despots. And when you portray a person in a certain way over and over again, that becomes a part of your subconscious thinking and that allows some people to think they can literally do anything to you that they want."

–LAMEECE ISSAQ, NOOR THEATRE, NEW YORK CITY, OBIE AWARD

BELOW: *Andrus Nichols starred in the title role of the 2011 Bedlam production of George Bernard Shaw's* Saint Joan, *which drew spontaneous responses from the audiences intimately seated within four or five feet of the actors.*

THE OBIE AWARD
The American Theatre Wing Embraces the "Wild Child"

ABOVE: *At the 2017 Obie Awards at Webster Hall, Lea DeLaria and company, including dancer Winston Dynamite Brown, confirmed the notion that the ceremony would be as sexy and fun as Off-Broadway has always been.*

In May 2015, the Obie Award ceremony, hosted by Lea DeLaria at Webster Hall in downtown Manhattan, was a raw and profane affair—typical of the Off-Broadway and Off-Off-Broadway work that was being celebrated that night. A grant was given to JACK, an experimental fifty-seat theater in Brooklyn and at the podium to receive it was its co-founder and artistic director Alec Duffy.

"I'm so glad that I was able to be here, because until two hours ago I was busy fixing the toilet at JACK," he told the crowd, which laughed with

recognition. That everybody-pitches-in ethos had long guided their own small and innovative theaters.

"For me, that is the quintessence of the operations that we are dealing with at the Obies," recounts Michael Feingold, the longtime chairman of the Obie judges and the drama critic at the Village Voice, the alternative paper that founded the awards. "It's not about a big slick industrial-like 'combine' producing big slick machines that are tested over and over again until they work. It's about people in a room doing fearless things, and you're happy about

it because it is real and meaningful."

So what was the august American Theatre Wing doing in a place where renegade ideals commingled with spilled beer? Doing what the organization has always done, says Heather Hitchens, president of the American Theatre Wing, recalling the event that marked the first time her organization joined forces with the Village Voice to co-present and administer the Obies.

"Our mission is to nurture excellence and move the art form forward," she says. "So to not be

involved in the excellence of Off-Broadway would mean that we were falling short. It was a gap waiting to be filled, the perfect alliance because the Obie is the Off-Broadway Tony Award. It has a phenomenal track record and we wanted to maintain and strengthen that stamp of approval."

"I remember the first year we went to the Obies, I walked through Webster Hall, and so much beer had been spilled, that the floor was sticky. So when the Obies came under the auspices of the American Theatre Wing, I told Heather [Hitchens], 'Whatever you do, keep it sticky!'"

—Natasha Katz, lighting designer

Indeed, the partnership between the venerable Wing and the sassy Obies brings to mind what was once said of the pairing of Fred Astaire and Ginger Rogers: "He gives her class and she gives him sex." The dance was long in coming but the flirtation between the Wing and Off-Broadway had been going on for decades. In 1955, the same year that Village Voice drama critic Jerry Tallmer founded the Obies, the Wing chose to present a special Tony Award to the Off-Broadway productions of *The Way of the World* and *Thieves Carnival* at the Cherry Lane Theatre. A year later, in 1956, Lotte Lenya won a Tony for her performance in the revival of *The Threepenny Opera* at Greenwich Village's Theatre de Lys (now the Lucille Lortel Theatre).

Mindful of that history, the late Isabelle Stevenson, the president of the American Theatre Wing for many years, had been keen on finding a way to honor Off-Broadway. But, says Feingold, "I'm sure she encountered a lot of

ABOVE: *Lotte Lenya, as Jenny, and Scott Merrill, as Macheath, starred in the long-running revival of* The Threepenny Opera *at the Theatre de Lys. The 1955 production, which caused a major critical re-evaluation of the work, also gave a boost to the Off-Broadway movement. Honors included an Obie as best musical, special Tony Awards to the producers, and a Tony for Lenya as best featured actress.*

resistance from what was then a big commercial establishment saying, 'No, we don't want to get involved with these nutty people doing all those outrageous things downtown. It's too confusing.'"

In the meantime, the Wing found a way to offer financial support to Off-Broadway and Off-Off-Broadway through its National Theatre Company

Grants, many of which went to New York City companies. But the opportunity for a formal alliance finally arose when the financial crisis afflicting all print publications threatened the continued existence of the Obie Award. Says Feingold, "The Voice executives and the Wing saw that a union between a commercially

ABOVE: *On the heels of their 20th wedding anniversary, Matthew Broderick and Sarah Jessica Parker celebrated at the 2017 Obie Awards where Broderick was a recipient for* Evening at the Talk House *and* Shining City.

run alternative newspaper and a non-profit organization specifically there to promote and support theater was a very advantageous thing. The Wing's participation in the Tony Awards tends to overshadow the other good things they do—the grants, the scholarships, the education programs—and this was a great way for the Wing to say, 'We represent and support all theater.'"

Hitchens concurs that presenting the Obies not only gave the Wing a strong footprint Off-Broadway but also dovetailed with her vision that the American theater encompasses an entire "ecology" that demands support from her organization. "This ecology ranges from the most commercial to the most avant-garde," she explains. "And the totality needs to be nurtured because they're all interdependent. If you look at Off-Broadway, especially in the most recent years, this is where the work is being developed not only for the commercial theater but also nationally." Feingold's "nutty people" have indeed been busy. The distinguished work flowing through the Off-Broadway pipeline has increased exponentially and many transfers to Broadway have gone home with the Tony Award, including *Rent, Avenue Q, Hamilton, The Humans,* and *Fun Home.* But, as lucrative and prestigious as commercial theater can be, Hitchens delights in the fact that the Obie Award stands on its own in recognizing an adventurous, often sui generis, artistry whether it moves to a commercial venue or not. From the beginning, the Wing was intent on sustaining the vital, bold and explosively youthful exuberance that the Obie has always represented.

"I wanted to maintain the funkiness of it, to embrace the wild child," says Hitchens. "We need that. The theater needs that. And that's what the Obies are all about."

"I've always considered myself a Johnny-come-lately, a second stringer, in a funny kind of way. So to be given a Lifetime Achievement Obie? I was blown away. Because I've been hopping around all my life, dance concerts, ten years with Robert Brustein and Alvin Epstein at Yale, television, Las Vegas, and, of course Broadway because of Geoffrey [late husband, Geoffrey Holder]. The Obie really knocked me out, and it was very moving to have Savion Glover give it to me. To find out that young people recognized what I'd been doing was unbelievable, because I didn't think anybody was looking."

—Carmen de Lavallade, actor, Obie winner

Above Top: *At the 2017 Obie Awards, Katrina Lenk performed the song "Omar Sharif" from the Off-Broadway musical* The Band's Visit, *in which she stars. The musical's director David Cromer was honored with an Obie prior to the show's transfer to Broadway.*

Above Bottom: *Dance legend and actor Carmen de Lavallade was as surprised as she was honored to receive a 2016 Obie Lifetime Achievement Award because, as she put it, "I didn't think that anybody was looking."*

By Design

ABOVE AND OPPOSITE PAGE: *Clint Ramos demonstrates exemplary versatility whether designing for a Broadway production set in Liberia during a brutal civil war* Eclipsed, *opposite page; or lavishly costuming capitalistic esthetes in Britain on a shoestring budget (The Mint Theatre's 2007 production of* Madras House).

The American Theatre Wing's Henry Hewes Design Awards celebrate the artists who fashion the worlds realized on the city's stages. The award, originally known as the Maharam Award, was renamed in 1999 for Henry Hewes, the longtime theater critic who co-founded the honor which seeks out distinction in design whether on Broadway, Off-Broadway or Off-Off-Broadway.

"When I received the Hewes Award, I remember being impressed with the breadth of the work that they recognized. I had thought of the American Theatre Wing as being a bit more mainstream. But I was pleasantly surprised that the committee had seen and also chosen to recognize a work as experimental and out-of-the box like *This Was the End* at the Chocolate Factory in Long Island City. The spectrum of the work that it celebrates is quite wide."

–MIMI LIEN, SET DESIGNER, *NATASHA, PIERRE & THE GREAT COMET OF 1812*, OBIE AND HENRY HEWES AWARDS, *JOHN*

"When I joined *Eclipsed* I was struck by the delicious and very theatrical dissonance between the clothes, traditional African clothes and Western tee shirts, which the women were wearing. To me what was fascinating was that the women had no idea what they were wearing.

There would be a tee-shirt from someone's bar mitzvah or a give-away shirt from a dentist office paired with an African wrapped skirt. In my research I saw a girl, couldn't have been more than twelve, running away from these soldiers wearing this Rugrats tee-shirt. She is actually running while wearing this cartoon image of innocence. If she doesn't escape a soldier, she'll get raped."

–CLINT RAMOS, SET AND COSTUME DESIGNER, OBIE AND HEWES AWARD, TONY WINNER, *ECLIPSED*

"I think it was useful that Dave [Malloy] and I did not have a theater background and had not been taught how things were supposed to be. We were never indoctrinated with that. The great thing about Dave is that he thinks not only about music and text but also about the entire event. At our first design meeting [for *Natasha, Pierre & the Great Comet of 1812*], he told us about this amazing night where he was wandering around Moscow and ended up in this incredible bar infused with music, food, camaraderie, and the joie de vivre of the inhabitants in the room. It was palpable. And he sat down and brown bread and vodka were placed in front of him, and he was squeezed into a booth, rubbing elbows with people he didn't know and there were musicians all around the room. And he said, 'Wouldn't it great to create an environment like that for the show?'"

—MIMI LIEN, SET DESIGNER

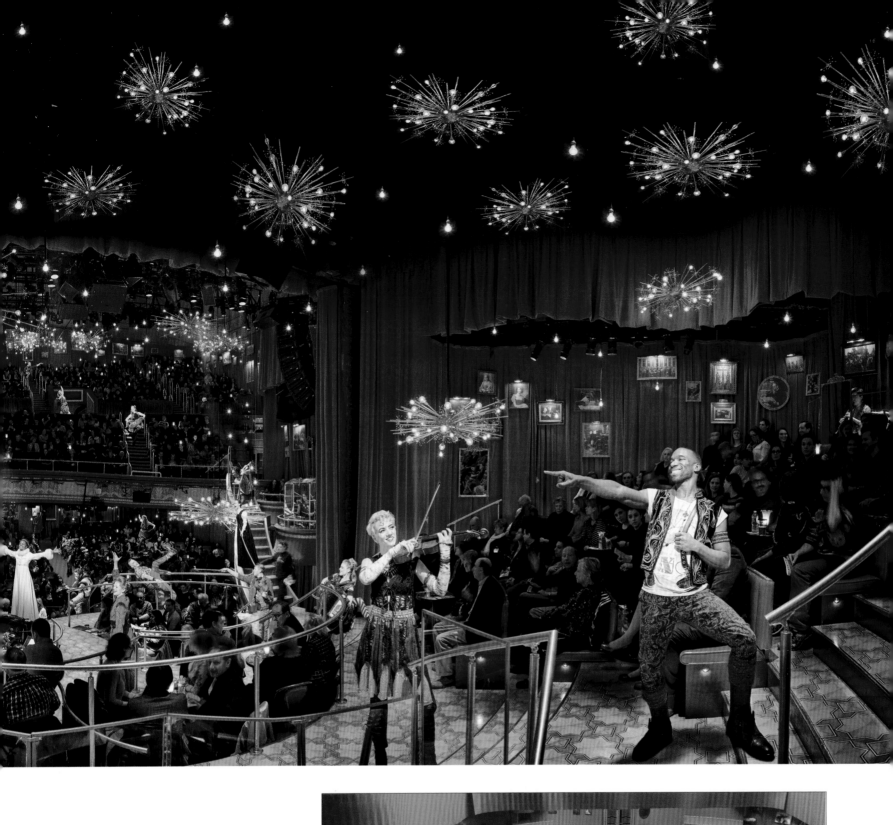

ABOVE AND RIGHT: *Designer Mimi Lien, who was honored with the Wing's Henry Hewes Award in 2016 for the Off-Broadway production of* John, *won the Tony Award the following year for re-creating czarist Russia in* Natasha, Pierre, & the Great Comet of 1812.

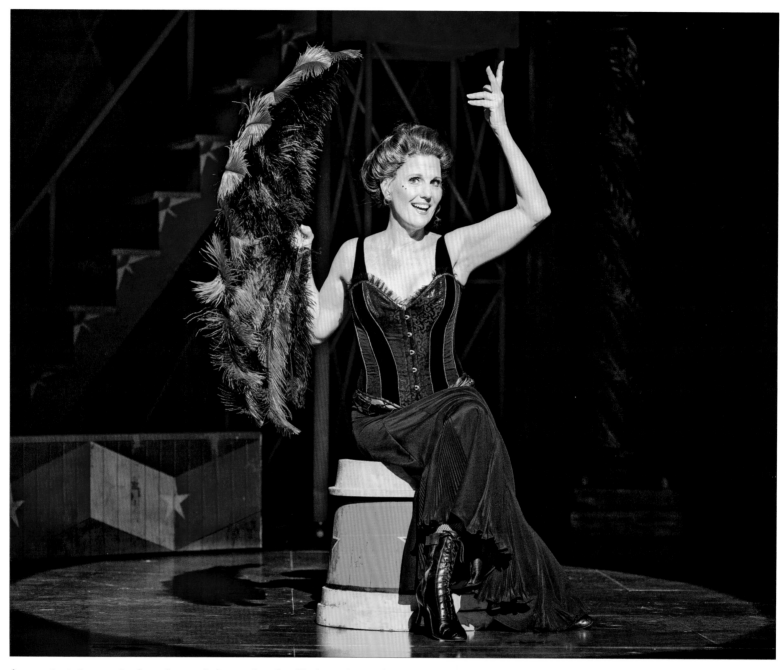

ABOVE: *Lucie Arnaz, as Bertha in the revival of* Pippin, *has played both Broadway and toured throughout the country and sees little difference in the venues. "Broadway is 3,000 miles long," she says.*

"I was on my first national tour [*Seesaw*] and an audience member said to me after the show, 'Oh, you're not on Broadway anymore. You're working here.' And I said, 'Honey, Broadway's 3,000 miles long.' It's still theater, whether you're doing it in St. Louis or Texas or wherever. Broadway just happens to be a location in New York. It doesn't lessen the people who are out there doing quality work around the country. At a meeting, I reminded the board that it's called the *American* Theatre Wing. And that inspired us to take the theater grants across the country and still give them in New York. We were also looking to put the organization on the map so that we were not just about the Tony Awards. It was win-win. It means so much that a little company in Fayetteville, Arkansas, gets

$10,000 from the American Theatre Wing. People would fly in from all over the country to these award luncheons and cross-pollinate ideas. And there would be these speeches from playwrights and artistic directors that we had a chance to put on film for archival use. At one point, someone suggested doing away with the lunches. And I said, 'Are you crazy? This is what we're here for, to be inspired by these small theater companies and starry-eyed young people who work for *bupkes* to get their plays on and find talented new playwrights. The words that come out of their mouths is what keeps us going all year long, remembering what theater is really about.'"

—LUCIE ARNAZ, ACTOR,
FORMER AMERICAN
THEATRE WING TRUSTEE

"In New Mexico, the storytelling tradition goes way back. The Indian pueblos and tribes have lived here for eons. And those roots were a part of our pre-Fusion [Theatre] production to see if we were going to pull off this whole operation. We performed *The Crucifixion,* one of the Wakefield Mystery Cycle Plays, in an old burned-out schoolhouse in Cerrillos, New Mexico, that was roofless. We performed it outdoors over Easter weekend, and people

ABOVE TOP: *Neal Ghant and Garrett Gray starred in the 2016 production of David Mamet's* American Buffalo *about small-time crooks enmeshed with a rare coin collection at the True Colors Theatre in Atlanta, Georgia.*
ABOVE BOTTOM: *Rhiannon Frazier and James Louis Wagner star in a 2016 stage adaptation of D. H. Lawrence's* Lady Chatterley's Lover *at the Fusion Theatre in Albuquerque, New Mexico. The literary lion spent some of his last years in New Mexico, which he called "the greatest experience from the outside world I have ever known."*

came out of nowhere to attend this cool spectacle. That set the tone for the company: a willingness to try new things and to forge new relationships in the community. We just finished a piece directed by Jacqueline Reid, one of our co-founders, a stage adaptation of D. H. Lawrence's *Lady Chatterley's Lover.* To relate it to *The Crucifixion,* it's done as a

221

passion play. It cuts to the crux of who we are and what we do."

–DENNIS GROMELSKI, PRESIDENT, FUSION THEATRE, ALBUQUERQUE, NEW MEXICO, NATIONAL THEATRE COMPANY GRANT

"When we won the national theater grant in 2010, we were not in good shape, teetering on a deficit. It made a huge impact that year. But one of the reasons we're still here is the specificity of our mission—all comedy all the time—and that's part of what the Wing recognizes. I believe in laughter with

abandon and that's what we strive for with each of the shows that we do. And sometimes people think if it's this much fun, it can't be important. I believe there are conversations we can only have after we have been cracked open by laughter. There are truths you can only hear when you say them in a really funny voice."

–JENNIFER CHILDS, ARTISTIC DIRECTOR, 1812 PRODUCTIONS, PHILADELPHIA, NATIONAL THEATRE COMPANY GRANT

"A piece I was a little nervous about, because it was intensely provocative, was called *The Gun Show* by E.M. Lewis. It was the year we won a grant from the American Theatre Wing. It was five stories about Ellen Lewis's personal relationship with guns—she grew up in rural Oregon—and how her perspective changed based on her experiences. We have a very diverse and independent-minded community, a working-class neighborhood, and I think it's important to speak to everybody. We don't just draw liberals. So it was great to have

people sitting side by side that have very different views of guns. And part two of the play—and we can do this because we only have forty-nine seats—is that we asked the audience to make a semi-circle and share their experience with guns. Not how they felt about guns or their opinion about guns, because that's never a good starter. People come to see a play not an 'issue.'"

–ANN FILMER, 16TH STREET THEATER, BERWYN, ILLINOIS, NATIONAL THEATRE COMPANY GRANT

"There's a DNA of the Arena Stage that makes it a first in a lot of areas: the first to open its doors to integrated audiences, the first to have an integrated acting company, the first to tour behind the Iron Curtain, the first to transfer a production [*The Great White Hope*]. It was a company founded by a woman with a pioneering spirit, Zelda Fichandler, and is now led by one, Molly Smith, with an equally rigorous and pioneering spirit. When I mentored with Molly, one of the first things we did was slightly outside of the work of the theater. We put together a march on Washington for gun control. It was just weeks after Sandy Hook. What it showed me was a leader who was fighting for

ABOVE: *James Earl Jones, who studied at the American Theatre Wing's professional training school in the early 1950s, broke through in a big way as boxing champion Jack Johnson in Howard Sackler's* The Great White Hope. *The 1969 Best Play Tony winner was the first production to transfer to Broadway from a regional theater.*

OPPOSITE PAGE: *1812 Productions in Philadelphia prides itself on a being "an equal opportunity offender," skewering both the right and left on the topical issues of the day in their revue,* This is the Week That Is. *Artistic director Jennifer Childs is center, surrounded by Dave Jadico, Alex Bechtel, Don Montrey, Reuben Mitchell, and Aimé Donna Kelly.*

ABOVE: *The tradition of trading food or poultry for theater tickets continues to this day at the aptly named Barter Theatre in Abingdon, Virginia.*

is an important part of our history. We honor the name of the theater when every year we ask people to bring food for the local food bank. We've had groups come out of the hollers of Virginia and Kentucky, so poor they brought honey or produce or a cake. We've been raising about three tons of food a year for the food bank. We started a tour of *Miracle on 34th Street* a couple of years ago and we only took admission in food. We raised almost a ton-and-a-half of food that night. We tour some of the poorest schools in the nation getting to kids who've never experienced theater at all."

—RICHARD ROSE, ARTISTIC DIRECTOR, THE BARTER THEATRE, ABINGDON, VIRGINIA, REGIONAL THEATRE TONY

social justice and unafraid of the backlash consequences. There was no backlash. In fact, there was a lot of support from board members. However, there was fear. There was a Facebook page for the event and we got death threats. I went into Molly's office and I said, 'I'm scared. Are we making ourselves vulnerable by marching?' And she looked at me and said, 'Seema, if we change our route, they will have won. We have our marshals. We

have our permits. We have our volunteers. I understand your fear, but if we give into fear we will have lost.'"

—SEEMA SUEKO, DEPUTY ARTISTIC DIRECTOR, THE ARENA STAGE, WASHINGTON, D.C., REGIONAL TONY AWARD

"For the Barter Theatre to receive the first Regional Theatre Tony Award in 1948 [to founder Bob Porterfield]

"More than anything else I look for a well-written play. Is it viscerally dramatic and moving? If somebody shows me a play about ISIS that is good drama, that surprises me in some way, that is something different from the headlines, then I would be interested in it. I don't know that there are boundaries. Human dignity is my boundary."

—TORANGE YEGHIAZARIAN, ARTISTIC DIRECTOR, GOLDEN THREAD PRODUCTIONS, SAN FRANCISCO, NATIONAL THEATRE COMPANY GRANT

INCUBATING EXCELLENCE
The Jonathan Larson Grant

"Jonathan loved the musical art form so much and he didn't want it to die, so he worked hard to make sure that it evolved, grew, and opened up in people's imaginations what the art form could accomplish. And I think there are a lot of pieces of art now that wouldn't necessarily exist if it weren't for *Rent*. A lot of people cite my brother as the reason why they're doing what they're doing and it's sort of overwhelming for me sometimes. I keep going, 'He was just my punky little brother. He wasn't all that. Trust me.' But it's also very rewarding that he accomplished what he set out to do."

—JULIE LARSON, SISTER OF JONATHAN LARSON, *RENT*

ABOVE: *Jonathan Larson, the creator of* Rent, *tragically died in 1996 at the age of thirty-five. But his legacy lives on in the eponymous grants which have given encouragement to generations of musical artists, including Dave Malloy (*Natasha, Pierre & the Great Comet of 1812*), Steven Lutvak (*A Gentleman's Guide to Love and Murder*) and Benj Pasek and Justin Paul (*Dear Evan Hansen*).*

incredibly experimental. The American Theatre Wing has always been forward-looking in this regard. How do we keep this industry relevant to young people? How do you keep reinventing the form? What is possible?"

—RACHEL SUSSMAN, PRODUCER, AMERICAN THEATRE WING'S THEATRE INTERN NETWORK, DIRECTOR OF PROGRAMMING, NEW YORK MUSICAL FESTIVAL

"When you're unknown, nobody wants you. Once you become Stephen Sondheim or Mike Nichols, everybody wants you. The theater family is practical. If you can't earn a living, you're not gonna be able to stay in it, and it's always sad when you run into a person who just couldn't earn a living and says, 'I had to do something else.' And that's a very common story. So anything that's done to help people launch a career—like the Jonathan Larson Grants or scholarships—is tremendously important."

—TERRENCE MCNALLY, PLAYWRIGHT, MULTIPLE TONY WINNER

"When I was a high school student in Detroit, my favorite shows were *Assassins* and *The Wild Party* [by Andrew Lippa]. They're incredibly dark, but I was fascinated by the sort of subversive world they created and how they humanized characters that society sees as outsiders. I'm attracted to shows like that on both the emotional and intellectual level, and I think the judges for the Larson Grant are great at helping to recognize and develop boundary-pushing work. But they also look for stories that are human and accessible. People are really intersecting more and more with different forms of music, but it's not rarefied. *Hamilton* is

ABOVE: *Shaye Troha, left, and Anna Ishida go mano a mano in* Beowulf: A Thousand Years of Baggage, *presented at the Abron Arts Center in 2009. The show featured music by Dave Malloy, which the New York Times described as "demented" and which won him a Jonathan Larson Grant.*

I got it, I thought, 'Wow, they really are taking weirdos like me. They really are seeking out people who are pushing the form and redefining what it can be. Maybe this is a path I can go down.' And when I got the check, 'Omigod, this is four months rent!'"

–DAVE MALLOY, COMPOSER, *NATASHA, PIERRE & THE GREAT COMET OF 1812*

"We do belong to marginalized and oppressed communities and the Jonathan Larson Grant allows us to call people into our world. Indigenous people have written musicals since the beginning of time. And what they look like might be different from 'the American musical.' But in this way, we've chosen to sort of 'code-switch' to reach people who've maybe never really thought about it or even how it could exist. So it's definitely an act of resistance. It's an act of justice. It's an act of gentleness. And it's an act of using the power of narrative to teach and learn."

–TY DEFOE, JONATHAN LARSON GRANT WINNER WITH TIDTAYA SINUTOKE

"The Tonys just weren't on my radar. I didn't really relate to a lot of the music coming out of Broadway. So I applied for the Larson Grant with my music for *Beowulf,* almost as a joke. I wasn't counting on it at all. I thought, 'There's no way they're taking a weirdo like me. They won't like my music.' But when

"The great thing about the Larson is it can come at a time when no one will return your calls. The Larson family fully understood Jonathan's struggle and they wanted to help other artists. This is the bedrock of what that organization is about and it is so moving. I was on the panel judging the applications. Real talent has an ineffable quality. That's a little like that famous definition by a Supreme Court Justice of pornography: 'I know it when I see it.' So the Larson Grant is saying, 'You're doing good. You're right. You're not crazy.' Which, of course, we all think we are."

—STEVEN LUTVAK, SONGWRITER, JONATHAN LARSON GRANT, *A GENTLEMAN'S GUIDE TO LOVE AND MURDER*

BELOW: *Lisa O'Hare, Bryce Pinkham, and Lauren Worsham cavorted in the murderously funny musical,* A Gentleman's Guide to Love and Murder, *which won four Tony Awards, including best musical, in 2014.*

Pasek and Paul and the Ghost of Jonathan Larson

One of the first songs that Benj Pasek and Justin Paul wrote as undergrads at the University of Michigan School of Music was a list-making song called "Boy with Dreams." Not included on that list? Their own.

"To get laid," jokes Pasek.

"To be a part of the Broadway world," says Paul.

The young men's swiftness in fulfilling the latter is nothing short of miraculous. The songwriting team roared out of college in 2006 with one show, Edges,

under their belt and in short order they became Tony-nominated for A Christmas Story, conquered Off-Broadway with Dogfight, and completed a winning trifecta with the acclaimed Dear Evan Hansen on Broadway. Oh, and just for good measure, they picked up a couple of Oscars in 2017 for writing the lyrics to the song "City of Stars" from the film musical, La La Land.

The booster rocket for their meteoric rise? The Jonathan Larson Grant that they received in 2007, barely out of their teens

and having graduated early in order to qualify for the honor.

"It was the first vote of confidence that anyone in the theater community gave to us: 'We think that you are of value. We think you are worth investing in,'" says Pasek.

"It was someone saying, 'I think you can do this for real,'" adds Paul.

Pasek and Paul encountered Rent when they were both around twelve years old. Pasek discovered it in a small suburb in Pennsylvania where

ABOVE: *Nick Blaemire, Derek Klena, and Josh Segarra, played a cruel game in* Dogfight, *the Off-Broadway musical written by Benj Pasek and Justin Paul, the young songwriting team which received a Jonathan Larson Grant from the American Theatre Wing.*

his gay teacher had a poster of Rent in his classroom; Paul in his school in Westport, Connecticut where his peers glommed onto Rent in the way that today's generation memorizes every lyric to Hamilton. These recollections were part of an interview with the team while their latest project, The Greatest Showman starring Hugh Jackman, was filming and Dear Evan Hansen was one of Broadway's hottest tickets.

What were your early impressions of Rent?

Benj Pasek: The impact was huge. As a confused gay boy, not having a sense that there were other people like me, and then listening to Rent and realizing that there was this whole world of people creating their own families. That really hit me. It became this symbol to me, a touchstone.

Justin Paul: I felt a little bitter towards Rent. [Laughs] Because everybody at school was obsessed with Rent, especially people who knew nothing about theater. All the popular kids would go on sleepovers and hangouts and play the cast album and sing along. And I was just like, "Just because you know the score to Rent doesn't mean you know anything about theater. You know nothing about theater. Do you know Guys and Dolls?" As I grew older, that faded. I realized there was a reason that the show became part of a mainstream culture. It was speaking to its time in a way that a musical had not done since A Chorus Line.

Pasek: I have such respect for the way Jonathan Larson was able to

ABOVE AND BELOW LEFT: *Within months of winning an Oscar for writing the lyrics to "City of Stars" for* La La Land, *Benj Pasek and Justin Paul accepted the Tony Award for their songs for* Dear Evan Hansen. *Asked backstage at the Tonys about the difference in the awards, Paul said, "This is sacred ground to us. Nothing compares to this."*

229

ABOVE: *Adam Pascal and Anthony Rapp created roles in the original 1996 production of* Rent, *the Jonathan Larson musical which has since inspired generations of songwriters. They include Benj Pasek and Justin Paul.*

authentically represent the way his friends spoke and to articulate what his friends and contemporaries were thinking about. If you have the ability to reflect on the times in which you're living, that carries with it an amazing responsibility.

Paul: We loved old musicals and still do. But *Rent* had lyrics that felt very authentic and real and true to life with music that was still very melodic and soaring and modern. Jonathan had an amazing ability to incorporate commercial and pop sounds and still make it theatrical. Whenever we do that, consciously or unconsciously, we're doing it because he did it first.

Pasek: You never forget that. So when we received the Larson Grant, we knew what that meant. It's not just a vote of confidence. You have to live up to that

vote of confidence. If they believed in us, then okay, we need to make good on that.

Paul: A lot of conversations in college surrounded the idea that had Jonathan lived just imagine what else he would've written. There's a big hole there and who knows where he might have taken the art form. So there's gratitude but also responsibility. And it's like everyone who's been touched by *Rent* feels that they must write something that does his legacy justice.

Julie Larson has noted that her brother was not inherently political but became so by virtue of living in the East Village in the 1990s in the midst of an epidemic. How does it feel creating in this time?

Pasek: It crystallizes what your values are and I think that's a gift. I've never

been more sure of what I believe in. What my morals and convictions are because I have something so sharply to contrast them against. So much of it is a reaction to injustice, freedom of speech, women's rights. There are certain principles that I want to champion, what I view as basic human decency.

How is that moral compass reflected in Dear Evan Hansen?

Paul: When we started writing the show we were going to write it from a very cynical point of view: Look at our generation and our world today. Everybody glomming onto being part of something that is not their own. Claiming a tragedy. And we quickly realized that instead we had to figure out what creates such a deep need and desire to be connected that people would fib or put out some mistruth just

ABOVE: *Ben Platt, Will Roland and Mike Faist exuberantly celebrate their nonconformity in* Dear Evan Hansen, *the Tony-winning smash hit with a score by Benj Pasek and Justin Paul who won a Jonthan Larson grant just out of college.*

to be connected to a community. It was exciting to dive into the more humane, emotional component of the story. We weren't making any sort of political statement, but we were saying, "Yes, you can judge, but think about the other side. What makes a person feel so alone and isolated that he would do this?"

Pasek: The theater demands empathy. You have to understand a character if you're going to go on that journey. What makes someone tick? Not just what is broken in you but what is broken in me that I would have the same response. Instead of being cynical about why people are like that, why not examine why we are similar and could easily

be in the same situation? That kind of empathy is what makes the theater world so exciting to work in.

Paul: Our professor in college used to talk about that. "The thing you need to understand, guys, is that when a show works it means that for two-and-a-half hours, 170 people all [worked] completely in perfect harmony, in perfect unanimity." So it's just crazy, it's a real miracle when everyone working on every facet of the show comes together and it works.

Pasek: Everyone making something extraordinary and it's all in one place.

Paul: I really don't think there is anything else like that on the planet

in terms of the intangible of people coming together.

And coming together was what Jonathan Larson was all about?

Paul: I can only imagine there are people who have been profoundly changed by *Rent,* who have walked away far less judgmental or at least with an open mind to people from different walks of life.

Pasek: "Seasons of Love" is still the gateway drug.

THE PAST IS PROLOGUE THE AMERICAN THEATRE WING'S NEXT CENTURY

By Heather A. Hitchens

In 2005, Silk Road Rising, a small but dynamic Chicago theater company, chose to produce Yussef El Guindi's *Ten Acrobats in an Amazing Leap of Faith,* a comedy about an immigrant Muslim family reconciling tradition and progress and dealing with agnosticism, feminism and homosexuality. Hearing of this, a Muslim community leader approached Malik Gillani and Jamil Khoury, the company's artistic directors, and asked that the gay character be excised since there were no gay Muslims.

"We're gay, we're Muslim, we exist," replied the couple. "If we cut this character out, where does it stop?"

The community leader then sent a letter to forty local Muslim organizations calling for a boycott of the theater. Only two of the forty honored the request.

Courage is infectious.

RIGHT: *A Middle Eastern wedding is a part of the "amazing leap of faith" in the Silk Road Rising production of* Ten Acrobats in an Amazing Leap of Faith *which brought out protests from conservative Muslim oganization because of the inclusion of a gay character.*
OPPOSITE PAGE: *Ellen McLaughlin and Stephen Spinella starred in Tony Kushner's* Angels in America *which won Best Play Tony Awards in 1993 and 1994. The two-part drama was later made into a Mike Nichols film and still resonates as both a national prayer and a cautionary tale.*

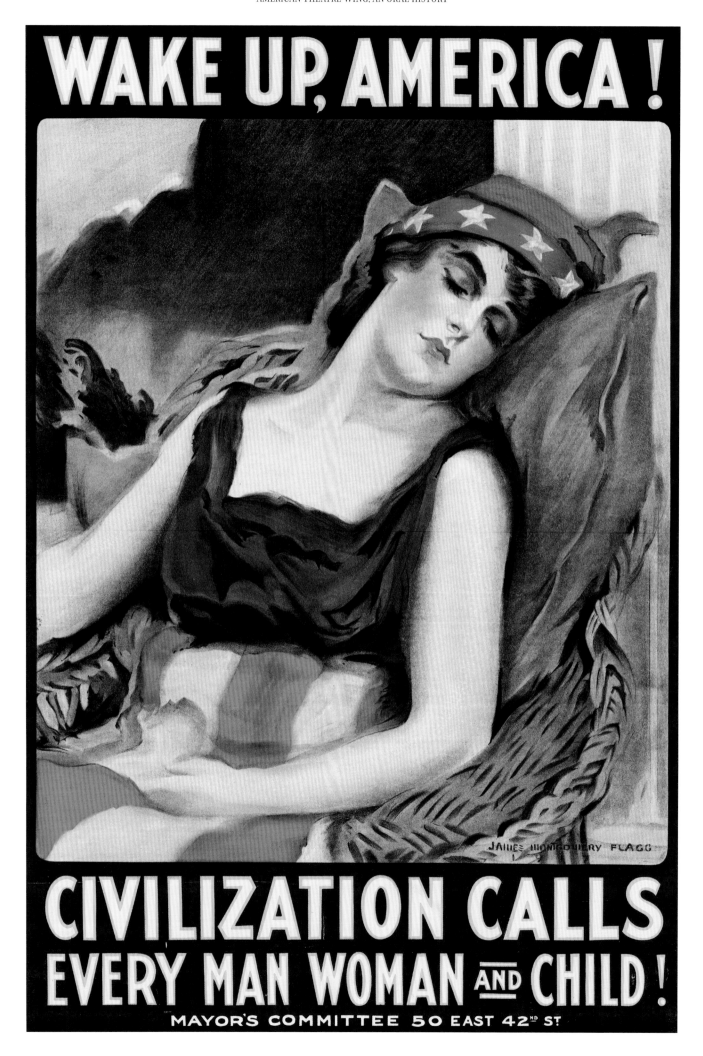

ABOVE: *The handmade quality of the theater from its earliest beginnings was evident in this image from the American Theatre Wing's* Working in the Theatre *documentary on Manual Cinema, a Chicago-based performance collective.*

OPPOSITE PAGE: *Illustrator James Montgomery Flagg, who designed the Wing's early posters, used actress Mary Arthur as his model for Columbia, the symbol of American liberty. The threats to freedom, both domestic and abroad, never end.*

This is but one brave example of the work that the American Theatre Wing supports through our grants. I could describe many, many more. As president and CEO of the organization, it has been my privilege to observe the advocacy and creativity that spring from these grants in what can only be described, to borrow from El Guindi's title, as "acts of faith." Artists "going to work" has been at the core of the American Theatre Wing since its founding upon America's entry into World War I in 1917.

As Harry Belafonte has said, artists are "America's moral compass." Whether it was an opportunity to pursue a career in the theater, or championing artists and fostering development of work that challenges, inspires, and illuminates, the American Theatre Wing has been steadfast in bringing the power of theater to bear on the lives of our citizens.

The form that it will now take depends on the talent, tenacity and wisdom of a generation of American artists facing a country riven with division and a world where the old order is fast disintegrating. We are now in a global war of ideas that pits authoritarianism against democracy, religious fanaticism against open and free dialogue. Playwrights have a crucial role in reminding us of our national purpose, however complex that may be, and the sacrifices that it may entail. Polemics are not called for. Reflecting America in all its diverse, maddening, and contradictory splendor is. Julie Larson, among the many voices in this book, points out that her late brother, Jonathan, was not political. But *Rent,* his landmark and revolutionary musical, was a moving testament to

the circumstances into which fate had thrust him: a struggling artist living in an East Village tenement at a time when drugs and AIDS were having a devastating impact. Jonathan turned that heartbreak into art, and though he never lived to see it, his *cri de coeur* for love, compassion and community has continued to reverberate and inspire succeeding generations.

Two decades later, the problems tearing at the fabric of American society appear even more daunting. But in these "times of dread," playwrights are not only ready to go to work they are psyched and excited about it. What you hear in the "voices" in these pages is anger and outrage, a fitting response to injustice. In an era of so-called "fake news," artists must more than ever do what Lin-Manuel Miranda's *Hamilton* declares with such grace:

"ON EARTH PEACE,
GOOD WILL TOWARD MEN"

THOMAS LYONS

ABOVE: *The American Theatre Wing was part of the World War II Allied Relief Fund, for which this was a donation card. The distinctive logo was also made into a pin which was worn by the Stage Door Canteen hostesses.*

speak truth to power. But there is also an eagerness to build bridges, not walls, to fight apathy and cynicism through the moral imperatives best espoused through art. Despite the polarization—perhaps because of it—what comes up repeatedly is the desire to unite, not to divide; to reach out, not to shun; to find common ground, not to preach to the converted. As a result, a Baptist preacher comes out of the Appalachian hollows to attend and praise a production in Virginia that his church has condemned. Conservative Muslim leaders support a theater run by a married gay couple. Gun lovers share stories with proponents of gun laws in a working-class neighborhood in Illinois. Pro-Israel supporters passionately debate with advocates of Palestinian statehood in a small Off-Broadway theater.

As much as the word "vigilant" comes up, so does the word "entertain," as the first duty of the citizen-playwright. Since that entertainment can take many forms, the American Theatre Wing has been vigilant in promoting work that not only celebrates diversity but also expands the boundaries of what theater can be. We are here to protect and promote the health of the art form itself. Doubt is a corollary to faith. But in the hothouse of creative solutions, it can also lead to the miraculous. The American Theatre Wing is committed to providing the safe environments in which those miracles are most likely to occur.

Early on in the life of this organization, one Wing participant observed that our job was "to provide soul service." It still is. Artists are fervent in the belief that the communal act of theater can be healing—and incredibly necessary. It always will be, until, as Tennessee Williams wrote, "the violets in the mountain have broken the rocks."

"I don't think it's the position of the American Theatre Wing to go out there with placards. That would be the wrong thing to do. But what we do from the get-go—and the grants are a good example of this—is look at what a company is doing and what they are trying to achieve and support the ones who are really sticking their neck out to develop new plays and playwrights. The work doesn't take sides but puts a microscope on what is going on in the country and what we can do to fix it without blame."

–LUCIE ARNAZ, ACTOR
AND FORMER AMERICAN
THEATRE WING TRUSTEE

"The Wing is there with a message—*the arts matter*—and we would be a very poor society without the culture of the theater. When the lights go to half and the curtain starts to go up, I think everybody really wants, hopes, expects to be transformed or uplifted or somehow changed. I know it doesn't happen all the time. It happens fewer times than not. But when it does, it's magical."

–TERRENCE MCNALLY,
PLAYWRIGHT, MULTIPLE
TONY WINNER

It's a gay place even when it's working its hardest

We invite you to be part of that gaiety at The American Theatre Wing

ABOVE: *Helen Menken, president of the American Theatre Wing from 1957 to 1966, was proudest of the organization's professional training center which boasted Guthrie McClintic as head of drama and Jule Styne as dean of musical theater.*

"The Middle East is not monolithic. We're Muslim. But also Christian and Jewish, atheist and gay, veiled and unveiled, white, black, everything. I do feel that we're in a moment where artists are embracing these stories. It's such rich subject matter that it's almost like we don't have enough time to do everything that needs to be done. I feel like that's my pressure, to gather as many resources as possible and support as many artists as possible to get their stories out there."

—LAMEECE ISSAQ, ARTISTIC DIRECTOR, NOOR THEATRE, NEW YORK CITY, OBIE WINNER

"I think that's always the challenge, right? How do you stop preaching to the choir? I've tried to program work that reaches across the aisle, so that people who ordinarily might not come to queer theater are impressed and learn a little more about the queer community. By bringing the outreach program to schools, there are young people whose home life may be a little more conservative. And maybe by humanizing those stories of young trans and queer kids, they can put a face to that."

—ANDREW VOLKOFF, FORMER ARTISTIC DIRECTOR, ABOUT FACE THEATRE, CHICAGO, ILLINOIS

"As artists, we exchange ideas. And if we're playing a character that is despicable, the audience can hate that character. But we can't. We have to understand that character in order to play him or her. So actors are by nature empathetic and open to different points of view. And we want to share that with others. I couldn't wait to take *Kiss of the Spider Woman* on the road. I couldn't wait to take it to Arkansas. I couldn't wait to take it to Georgia. Because I wanted, oh so elegantly, for them to hear a different point of view. And because we'd won the Tony Award, that opened up the opportunities for us to do that."

—CHITA RIVERA, ACTOR, MULTIPLE TONY WINNER

"How do we face the future as artists? I can only give you the answer that feels most organically true to myself, and that is, stay vocal about what you believe in, and that can encompass anything. Introduce new composers and songwriters. Help to get their names out there. Use whatever celebrity you have to bring attention to causes you believe in. Write a piece a music. Write a poem. Help in a soup kitchen. Give love. Participate in society. Fight for justice. Stay *loud!*"

—AUDRA MCDONALD, ACTOR, MULTIPLE TONY WINNER

"American theater doesn't function in a vacuum. Everything we do in this country reverberates in the rest of the world, and that includes theater. Maybe because I'm from the Philippines, I'm much more aware of the effects America has on the world, and that carries with it immense responsibility. It's huge. So huge. Even a play like [Lynn Nottage's] *Sweat,* this play about workers in a small town in Pennsylvania, has immense international repercussions. It shows us an active sense of what America is. The theater is a diverse community of voices that creates this beautiful collective thing."

—CLINT RAMOS, SET AND COSTUME DESIGNER, OBIE AND HENRY HEWES AWARDS, TONY WINNER

"I think the theater—the immediacy of it, the power of it—is a time of communion. It's a time when you're in a very intimate, direct experience with the people. It's a sacred exchange that happens when they've entrusted you with their time and imagination and you have to deliver on that trust."

—DANAI GURIRA, PLAYWRIGHT, *ECLIPSED*

OPPOSITE PAGE: *Chita Rivera won her second Tony Award for Aurora in* The Kiss of the Spider Woman, *a musical whose message is more timely than ever.*

ABOVE: *As much as vigilance is called for in the current national climate, the duty of the arts has always been to first entertain. Few shows in recent history have done that with such irreverence as the musical,* The Book of Mormon, *which won nine Tony Awards in 2011.*

OPPOSITE PAGE: *In 1953, Arthur Miller wrote* The Crucible, *using the Salem witch trials as an allegory for the political opportunism and threats to liberty posed by the House Un-American Activities Committee rooting out so-called communists. "Scoundrel time," as Lillian Hellman put it then, always lies just beneath the surface. E. G. Marshall and Jaqueline Andre were among the original cast.*

"Political unrest has always been pretty good for theater. It's not that people suddenly have something to say. It's that they have something they have *got* to say. That makes for an incredibly exciting time. There's also something to be said for people looking for escapism. Here's the thing that's really important about theater: it should ask questions. You should be a voice for the voiceless and hope for the hopeless. But all of this should be under the umbrella of being entertained. Because there's nothing worse than sitting down in a theater to be lectured. Entertain the audience first and you will find a much more receptive crowd."

JAMES CORDEN, ACTOR, HOST OF THE TONY AWARDS,
TONY WINNER, *ONE MAN, TWO GUVNORS*

"When *Rent* first came out, people were sort of horrified because it wasn't glitzy and pretty. The wrapping is kind of raw. But it feels like an 'action,' the best of what art can do, which is to enlighten and show people something different and better. The themes are loving and universal, about being an us for once, instead of a *them*. It couldn't be more relevant, unfortunately, to what's going on right now."

—JULIE LARSON, SISTER OF LATE
PLAYWRIGHT JONATHAN LARSON

"Because theater is a communal event, there's always the possibility that minds are gently, gently changed or moved forward. Theater is the ultimate civilizing event because you're listening to somebody else for a couple of hours, right?"

–MOLLY SMITH, ARTISTIC DIRECTOR, ARENA STAGE, WASHINGTON, D.C., REGIONAL THEATER TONY WINNER

"One of our core pieces, *This Is the Week That Is,* consists of political humor—Carol Burnett meets *The Daily Show.* We pride ourselves on being equal opportunity offenders, but in many ways it's like talking about what nobody else will talk about right now. It's a real point of pride for us that we could have people from both sides of the [political] aisle sitting in the audience together and we're all laughing collectively about things that are otherwise deep divisions in this country. There's only so much preaching to the choir we can do."

–JENNIFER CHILDS, 1812 THEATRE, PHILADELPHIA, NATIONAL THEATER COMPANY GRANT

LEFT AND ABOVE: *Director Jerry Mitchell, a multiple Tony Award winner, leads a workshop at the Wing's annual Springboard program. His dedication to teach is in the spirit of the Wing's earlier training program at which classes were taught by Lucas Hoving (top), a modern dancer and original member of the José Limón company.*

"In my club act, I joke about the fact that I've drunk a lot in the intervening sixteen years, and I can't remember what happens at the end [of *Cabaret*]. And I go to watch the video at Lincoln Center library, and I say, 'Spoiler alert! It doesn't go so well. So watch out America!' And it's an amazing reaction, people start half-exclaiming. And then I go, 'What, too soon?' And the whole place goes nuts! Right after the election, I had dates in the Midwest, four shows in Louisville, Cleveland, Chicago and Carmel, Indiana. I was kind of dreading it, but actually it was a really reassuring thing to do. That was a great way for me to say what I want to say, make everyone in the audience acknowledge the discomfort, and to expunge something."

–ALAN CUMMING, ACTOR,
TONY WINNER, *CABARET*

"I think that there's a healing effect to theater. I think that it's not an accident that in other parts of the world, people put on theater and expect to be arrested at the end of the moment."

–LIN-MANUEL MIRANDA,
ACTOR AND SONGWRITER,
MULTIPLE TONY WINNER

TOP RIGHT: *"All comedy all the time" is the brief of the 1812 Theatre in Philadelphia. Rachel Camp, Caroline Dooner and Emily Kleimo trot out the red, white, and blue in* The Carols *in 2016. The show recalled the era evoked in the photo at bottom right from the Wing's Stage Door Canteen in San Francisco.*

ABOVE: *Winston Ntshona and John Kani flank playwright Athol Fugard with whom they collaborated on the plays,* Sizwe Banzi Is Dead *and* The Island. *The South African actors were jointly nominated and won the Tony Award for their performances in the anti-Apartheid dramas in 1975.*

"I was just working on a film with John Kani who, with Winston Ntshona, created *Sizwe Banzi Is Dead* and *The Island* [in 1974]. And he performed *Miss Julie* with a white woman in his country [apartheid South Africa], and he was put in solitary confinement for twenty-three days. But he created an outcry that pushed the American government to start putting sanctions on South Africa. You see how artists can exact some impact if they function fearlessly. It's our ability to warm the frozen heart into action. We saw it in the 1930s with Clifford Odets and in the 1950s with Arthur Miller. We must honor that legacy. It's not a time to go quiet. Because the next generation of artists will ask, 'How did you exact change or at least provoke it?'"

–DANAI GURIRA, ACTOR AND PLAYWRIGHT, *ECLIPSED*

"The Wing has really grown from a fairly small organization to one with national reach through the theater grants and, of course, the televised Tony Awards. Now, as theater has become a global enterprise, I think the American Theatre Wing is reaching out to the rest of the world. I was in London and I asked a producer friend, 'David, does a Tony Award meaning anything to you?' And he said, 'Of course it does. It means getting our play over to America or getting an actress of ours over there because she wants to win a Tony Award.' So the Tony holds international recognition outside of Broadway and so do the awards that we give out to theaters across the country. The money that comes with that award is important, but even more, as one recipient told me, was the right to put 'Winner of the American Theatre Wing National Theatre Company Grant' on theater stationery. I'd love to see an American Theatre Wing School in London. There is so much we can learn from each other."

–DASHA EPSTEIN, PRODUCER, AMERICAN THEATER WING TRUSTEE

ABOVE: *The momentum for Jonathan Larson's* Rent *was unstoppable, from the moment of its first preview at the New York Theatre Workshop—just after his tragic death—to its triumphant Tony-winning Broadway transfer.*

"I think the programs of the American Theatre Wing are more important than ever, focusing on the crucial difference that the arts make in the lives of young people. This is the best way that we can fight hatred and terrorism because, if nothing else, we start with all of us putting on a show together. The collaborative nature of people working together is the best diplomacy that we can show others. We're facing a time where democracy is at stake. I've done a lot of shows all over the world, from Asia to Europe. This kind of diplomacy, working with stagehands, makeup artists, designers, and actors, is one of America's best exports. That passion and commitment is catchy."

–Natasha Katz, lighting designer, multiple Tony winner, American Theatre Wing Trustee

"The Woodstock generation responded to the upheaval of the 1960s and '70s with plays like *Sticks and Bones* and musicals like *The Man of La Mancha.* When was the last time we saw a really explosive contemporary political play on Broadway? It took a Brit, David Hare, to come up with *Stuff Happens.* And *Hamilton* is brilliant but it's an historical subject. I'm talking about hitting the current political issues head-on. Tony Kushner's *Angels in America* raised the hope of more like it. But there's been a lull in that style of writing. Maybe the current political turmoil will inspire writers to move away from the family plays, and go toward more overtly political drama. I think the American theater has been great in raising the social consciousness. The Jonathan Larson Grants program is turning out artists who might very well take up the challenge. Can the Wing do more to facilitate it? We can always do more."

–Peter Schneider, producer, American Theatre Wing Trustee

245

"In our strategic and artistic planning, we're asking ourselves, 'How do we become uniters rather than dividers?' We have the capability as a theater to engage with a community and not be bound by religious constraints or political constraints. We're non-partisan. So we have been able to have pretty engaging conversations on controversial subjects that nobody else can have. A Virginia state official said to me, 'You know, I've always thought of Barter as just a theater and tourist attraction. But you're really about community building.' And I said, 'Yeah, that's what it's all about. That's what we're here for.'"

—RICHARD ROSE, PRODUCING ARTISTIC DIRECTOR, BARTER THEATRE, ABINGDON, VIRGINIA

"I feel people are coming from multiple cultures and nations and that intersectionality is something to shed a light on and to recognize that it will constantly be in motion. So how are we, as artists, dealing with

ABOVE: *Founded in 1933 in the midst of the Depression, Virginia's Barter Theatre lived up to its name with an innovative ticket policy. It still honors that tradition once a year. Moreover, the Barter has challenged its Appalachian audience. A frontal nude scene in the play* Liquid Sky *brought out protestors but also supporters.*

OPPOSITE PAGE: *Native-American artist Ty Defoe, a Jonathan Larson Grant winner, performs a hoop dance in the* Glow Variety Show, *which he describes as "a circle of art" that seeks to erase boundaries in order to connect and engage the global community.*

these intersections, dealing with immigration, dealing with gender, how are we echoing what's happening with that? It's invigorating for me to speak and write about it because, like with the bathroom laws [of North Carolina], I know those experiences. And through theater, I can let other people know what that's like, too."

—TY DEFOE, JONATHAN LARSON GRANT WINNER

"To me, audience is like [a unified] pulse. Two hundred people sitting in one room and they all have cameras and phones in their pockets, so that's something to use. If you could give [technology] to someone like William Shakespeare, he would play with it. He wouldn't just ignore it. I think it's very important that when we look at a script, if it looks like a script that was written six hundred years ago that means we're repeating the same mistakes. That means we didn't renew our way of thinking."

—NASSIM SOLEIMANPOUR, PLAYWRIGHT, *WHITE RABBIT RED RABBIT*

"The idea of the artist is by definition freedom. The sky's the limit when you're there to serve the written word. And we have a responsibility toward these artists to give them all the protection, support, and freedom we can."

—WILLIAM IVEY LONG, COSTUME DESIGNER, MULTIPLE TONY WINNER, FORMER CHAIRMAN OF THE AMERICAN THEATRE WING

ABOVE AND OPPOSITE PAGE: *Popular illustrator James Montgomery Flagg, who created a number of posters for the American Theatre Wing, created the iconic "I Want You for the U.S. Army." Two writers who heeded the call decades apart were playwright Joe Masteroff* (Cabaret*) and Stephan Wolfert* (Cry Havoc!*) and both received financial aid through the Wing.*

"Veterans tend to be conservative and we've had a number of conservatives in the room so we had a policy of no bitching about politics. You can only bring it in the room if it's relevant to what we're talking about because we're really looking towards healing the trauma, whatever the trauma happens to be. When I perform *Cry Havoc!*, whether it's in the Mission district of San Francisco or a part of Michigan where there's a billboard of Obama with devil horns on it, the post-show discussion is the same. It isn't political. We talk about reconnecting to our humanity and taking care of each other. The politics of it really doesn't matter."

STEPHAN WOLFERT, DIRECTOR OF VETERAN OUTREACH, BEDLAM, NEW YORK CITY

"There's something about everyone being in the same room and having the same experience that is powerful and increasingly rare. We curate our reality more than ever. We unfollow people we disagree with, and it's easier than ever. Even in the news, we can get a different set of facts from a different network. So I think that the power is in everyone being in a room, putting down their phones, and theater is one of the last bastions of that as well."

–LIN-MANUEL MIRANDA, *IN THE HEIGHTS, HAMILTON*

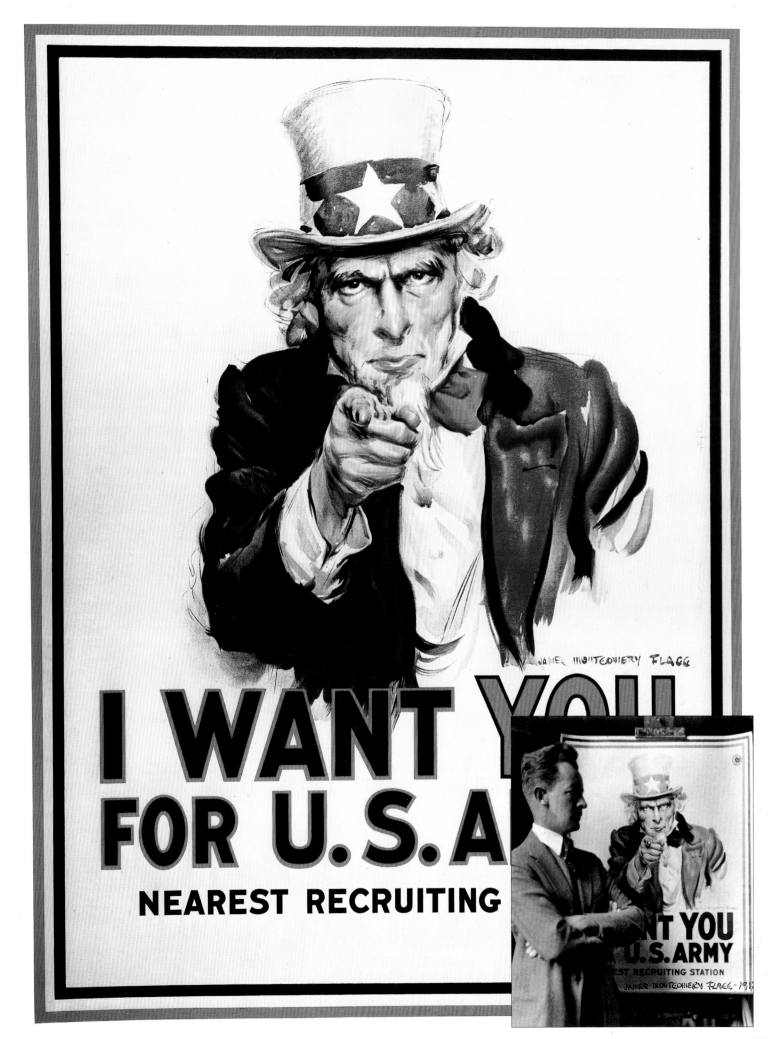

ABOVE: *The Fusion Theatre in New Mexico made an organic connection with its audience when it presented* The Crucifixion, *a passion play, in the adobe ruins of an old church.*

LEFT: *Playwright Andrew Hinderaker dreamt big with his play* Colossal *and the theater expanded to accommodate those dreams.*

"This play [*Colossal*], is the result of my colleagues and the American theaters saying 'yes' when they had every reason to say 'no.' This is a piece that you're told that you shouldn't write. 'You shouldn't write a play that demands this many resources!' Yet throughout its development we have been surrounded by people who have said, 'Yes, keep dreaming that definition of theater bigger.' Theater can be so exciting when it intersects with all the forms of live performances: sports, performance art, comedy, magic, dance, and music. I'm hungry to engage in that kind of art."

—ANDREW HINDERAKER,
PLAYWRIGHT, *COLOSSAL*

"I was excited that Garry Hynes and I won in the same year, the first female directors to win the Tony Award. What was more important about The *Lion King* was that it wasn't, you know, a fluke. It comes from the amount of time I spent being able to try stuff, to be able to be experimental. To be supported in doing that is very critical. You can't know if it's within the box, outside the box, pushing the envelope or not, because there's fear there. And in order to overcome that, you need a place where you can experiment. *The Lion King* didn't come out of nothing."

–JULIE TAYMOR, DIRECTOR, TONY WINNER, *THE LION KING*

"I have to believe that people will stand up as they have been. You want to inspire yourself to fight against corruption? Go watch *Hamilton*. And rise up. Rise up and tell your sister. Rise up! That's where I've always gotten my inspiration to fight for what's right: in the songs of musicals that moved me in a manner that no other art form does. And I think *Hamilton* says it best. 'Look around, look around at how lucky we are to be alive right now.'"

–ROSIE O'DONNELL, ACTOR, ISABELLE STEVENSON HUMANITARIAN TONY HONOR

ABOVE TOP AND BOTTOM: *Before Julie Taymor created the international phenomenon,* The Lion King, *she constantly experimented with innovation with such works as* Juan Darien *at Lincoln Center in 1996. Even after her success, she continued to push the envelope. The 2013 production of* A Midsummer Night's Dream *at the Theatre for a New Audience starred David Harewood and Tina Benko.*

"I think it's the purpose of the theater to present and produce both sides. *The Originalist,* the play that we did on Justice [Antonin] Scalia is, for many people from the liberal perspective, not a play they wanted to see because he is considered the most radical and conservative jurist that we have had on the Supreme Court. And yet we produced the play, and it will also be traveling to other parts of the United States as well. Because it's a play that asks, 'Can we get back to a political center?' I think that's one of the biggest questions that we have to ask in the theater. And yet the theater has the ability to foment conversation, arguments, fierce disagreements. Because, ultimately, we're all citizens, and regardless of where you are on the political spectrum,

this is a moment when civic engagement is at the highest level in my lifetime."

–MOLLY SMITH, ARTISTIC DIRECTOR, ARENA STAGE, WASHINGTON, D.C., REGIONAL THEATRE TONY WINNER

"The Wing's mandate has never changed but the interpretation of what that mandate means can shift. It depends on how the theater is changing and how the personalities involve change it. When you have artists like Natasha Katz, Ken Billington, David Henry Hwang and William Ivey Long representing the American Theatre Wing, it's a different kind of conversation than when you had only society ladies from the Upper East Side. [Trustee] LaTanya Jackson is amazing. The board has been diversified a fair

amount, and the Wing's in a good position to face the future. Because God only knows!"

–TED CHAPIN, AMERICAN THEATRE WING TRUSTEE, PRESIDENT OF RODGERS AND HAMMERSTEIN ORGANIZATION

"We are having our way of life menaced, and if we all talked more to one another, we'd be much better off. One thing I used to quote when doing my welcome speech up on the podium at the Obies at Webster Hall is something [Bertolt] Brecht said in a play called *Puntila* that I once translated: 'If the cows could get together and talk things over, the slaughterhouse wouldn't last long.' The theater is often a key trigger to the public conscience. The British playwright John Arden once said a great thing about this. To paraphrase, the theater cannot convince you of anything, but it can confirm something that you are beginning to feel."

–MICHAEL FEINGOLD, THEATER CRITIC, CHAIRMAN OF THE OBIE AWARDS

LEFT: *Nicholas-Tyler Corbin and Jocelyn Lonquist at the 2017 Obie Awards were happy to join in the subversive counterculture that has always been a part of the honors co-presented by the Village Voice and the American Theatre Wing.*

ORLANDO, 2016

ABOVE LEFT: *Just prior to the 2016 Tony Awards, host James Corden was absorbed in the script, studying how he was going to acknowledge and address the brutality of the day's news .*

ABOVE RIGHT: *James Corden, host of the 2016 Tony Awards, struck a somber note at the beginning of the program by fusing the Broadway community in solidarity with the victims of the terror attack on Pulse, a gay club in Orlando, Florida. "Your tragedy is our tragedy," he said.*

"My overwhelming memory of was about 7:40 PM that night. I was thinking in twenty minutes we're gonna address the biggest mass shooting in American history and then we're gonna do a parody of *Hamilton*. And then we're gonna do a seven-minute song which we have never gotten completely right.

We'd never done it completely through with the full company. I thought, 'If the next ten minutes doesn't work, then everything else will struggle. If this works everything else will be fine.' Ten minutes in, I just knew it was all working. The only other time I had a feeling similar to the one hosting the Tonys was when I was in *One Man, Two Guvnors*. I've never been so aware of having a great time whilst I was doing it. I was also incredibly fortunate to be hosting the show in a year when there was a genuine cultural and theatrical masterpiece in *Hamilton*."

—JAMES CORDEN ON HOSTING THE 2016 TONY AWARDS

"All around the world, people are trying to come to terms with the horrific events that took place in Orlando this morning. On behalf of the whole theater community and every person in this room, our hearts go out to all of those affected by this atrocity. All we can say is, you are not on your own right now. Your tragedy is our tragedy. Theater is a place where every race, creed, sexuality and gender is equal, is embraced and is loved. Hate will never win. Together we have to make sure of that. Tonight's show stands as a symbol and a celebration of that principle."

—JAMES CORDEN, HOST OF THE 2016 TONY AWARDS COMMENTING AT THE BEGINNING OF THE TELECAST ON THE DAY'S TRAGEDY WHEN A GUNMAN OPENED FIRE AT AN ORLANDO GAY CLUB

ABOVE: *The 2016 Tony Awards were a bittersweet night for Lin-Manuel Miranda and the cast of his blockbuster, Hamilton, as they tried to make sense of a senseless act of terrorism on the day of their triumph. The mantra of the evening was "Love is love is love...."*

BELOW AND RIGHT: *Since its inception, the American Theatre Wing has expressed compassion for those enduring the hardships of war, disease and terrorism. In 1917, Elsie Ferguson sewed clothing for refugees and soldiers overseas. At the 1991 Tony Awards, Jeremy Irons unveiled the AIDS ribbon—which would later become ubiquitous—for the very first time; and in 2016, Wing chairman William Ivey Long created the silver ribbon (opposite page, bottom) to signal communion with those killed in the terrorist attack in Orlando Florida.*

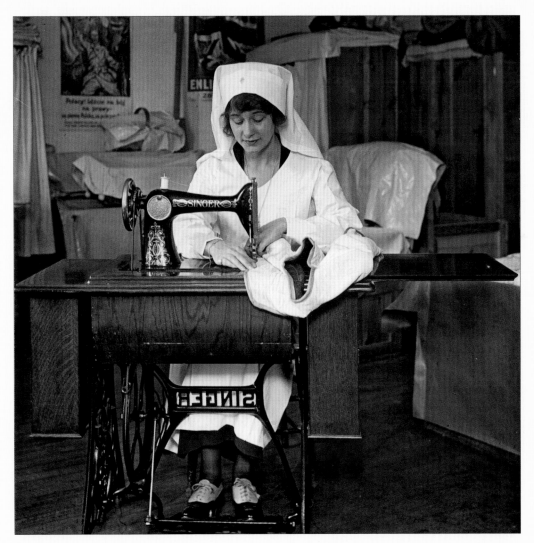

"When senseless acts of tragedy remind us/That nothing here is promised, not one day./ This show is proof that history remembers/We live through times when hate and fear seemed stronger,/We rise and fall and light from dying embers, remembrances that hope and love lasts longer/And love is love is love is love is love is love is love cannot be killed or swept aside."

—LIN-MANUEL MIRANDA,
ACCEPTING THE AWARD FOR BEST
SCORE AT THE 2016 TONY AWARDS

"Tonight, our joy is tinged with sorrow. But we're here to celebrate Broadway, and the beauty that artistry can bring into this world."

—BARBRA STREISAND,
A PRESENTER AT THE
2016 TONY AWARDS

ABOVE AND BELOW: *Stephen Sondheim wrote "Children will listen" and here they listen and laugh at an American Theatre Wing* Working in the Theatre *seminar on puppetry. Later their joy in performing was captured in an American Theatre Wing* Working in the Theatre *documentary on Andrew Lloyd Webber's* School of Rock.

"Chaplin once said it only makes sense to create comedy if it's filled with poetry. The primal foundation of clowning is human suffering. Clowning is about being able to laugh about the things that hurt. The embarrassing moment, feeling humiliation, the loneliness, the despair, all of it. The human condition. Clowning is powerful because it deals with the human condition, transforming pain into laughter. That's it."

—DAVID SHINER, ACTOR, *WORKING IN THE THEATRE: CLOWNING*

"There's no formula. The chain, the connection, going back and going forward, is the thing that is so unique about the theater because it's ephemeral. The knowledge that is passed down and passed forward. That's all there is: the stories. When Roger [Rees] was with the Royal Shakespeare Company, Ian Holm taught him 'not to chase every mouse,' meaning don't go for all the little laughs at the expense of the big laughs. And, during the rehearsals for *Peter and the Starcatcher,* Roger repeated that to Christian Borle. And Christian won his first Tony Award. Then Christian was again nominated, this time for *Something Rotten!* We were given tickets to the Tonys because I was a nominator. But Roger wasn't feeling well. He'd had to drop out of *The Visit* just two-and-a-half weeks previously because he was so ill. He just couldn't do it anymore. So we watched from home. And when Christian won, he got up and he thanked, 'My good friend, Roger Rees, who taught me not to chase every mouse.' Roger, who'd been dozing off and on, wasn't sure he'd heard his name. He was having trouble speaking so he just looked at me. And I said, 'Yeah. Yeah.' His eyes welled up with tears. He was so proud that Christian thought to mention him on that night. And, of course, a few weeks later, Rog was gone."

—RICK ELICE, PLAYWRIGHT AND HUSBAND OF ROGER REES

"The first thing I thought when I walked into my first board meeting was 'What the hell am I doing in this room full of swells?' But they are dedicated to keeping the dream alive, as it were, of what those women started so many years ago. It's now blown up into an entire supportive unit for the arts. *Manna from heaven!* This is the blood source. Everyone's dedicated to making sure that at least on our watch, theater is going to be nurtured, encouraged, cultivated and supported. Because we're living through times where we have to hold the mirror up to ourselves and really examine what our moral compass has become. We're going to have to be innovative about communicating that."

–LaTanya Richardson Jackson, actor and American Theatre Wing trustee

Top Left: *From left, Roger Rees, Christian Borle, Alex Timbers, and Rick Elice take a bow on the opening night of* Peter and the Starcatcher, *which was awarded five of its nine Tony nominations. Among the latter were nods for co-directors Rees and Timbers and writer Elice. Borle won his first Tony for his madcap role.*

Bottom Left: *Gwen Verdon and Mary Rodgers celebrate the 107th birthday of the legendary George Abbott at the 1994 Tony Awards. The director was greeted with a rousing standing ovation from the crowd. Among his many protégés is producer-director Harold Prince who holds the record for Tony Award wins: 21.*

ABOVE AND BELOW LEFT: *Angela Lansbury won her fifth Tony Award for her delightful Madame Arcati in the 2009 revival of* Blithe Spirit. *Audra McDonald broke that record winning a sixth with her Billie Holiday in the 2014 solo drama* Lady Day at Emerson's Bar and Grill. *Lansbury, who was awarded an American Theatre Wing scholarship when she was fourteen, graciously passed the torch.*

"When we first began work on *Ragtime* in 1995, it was apparent that many of the issues encountered were still issues almost one hundred years later. Now, that struggle still goes on but shows like *Ragtime* remind us that we must continue to seek a way forward and speak up against injustice. We must move beyond our differences."

—BRIAN STOKES MITCHELL, TONY WINNER, *WORKING IN THE THEATRE: RAGTIME ON ELLIS ISLAND*

"My mother always said I had in me a quality that she called stubborn. Not stubborn. *Determined.* I was buoyed by the support of people who saw in me something that I myself was not aware of, and that encouraged me to stick with it. The American Theatre Wing serves that purpose in many of the lives of young people who aspire to be actors or work behind the scenes. That's what I saw in the children at the Cicely Tyson School of the Performing

Arts in East Orange, New Jersey who lived in what was termed 'a deprived area.' I looked into their faces and what I saw in them was that need, that desire I'd felt as a child growing up on the East Side. There are so many children who are lost and wondering what to do. They wouldn't be killing each other if they found someone who cared enough to spend time with them and let them know that they are worth something. So, to the American Theatre Wing, your job will never be over!"

—CICELY TYSON, ACTOR, TONY WINNER UPON BEING HONORED AT THE AMERICAN THEATRE WING'S 2016 GALA

ABOVE: *Ellis Island—through which throngs of immigrants passed dreaming of a better life in America—was the site for a 2016 concert version of* Ragtime, *the 1998 musical which paid tribute to those yearning to be free.*
BELOW: *Cicely Tyson, who was honored at the 2016 American Theatre Wing Gala, is overcome with a tribute offered by Tony-winner Cynthia Erivo (kneeling) and (from left) Saycon Sengbloh, Danielle Brooks, Adriane Lenox, and Amber Iman.*

ARS NOVA, JONATHAN LARSON AND TWO COMETS STREAKING ACROSS THE SKY

By Patrick Pacheco

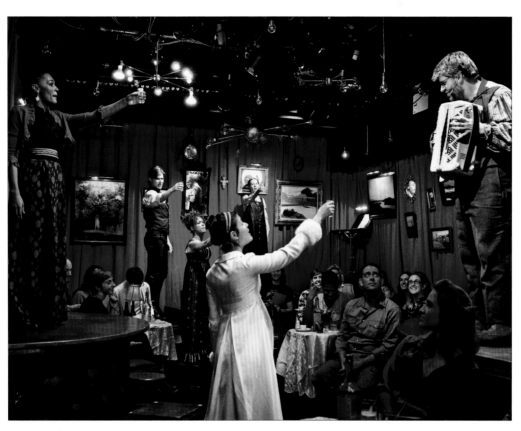

ABOVE: *In the 2012 production of* Natasha, Pierre & the Great Comet of 1812 *at the 87-seat Ars Nova, Amelia Workman, Lucas Steele, Amber Gray, Phillipa Soo, and Brittain Ashford salute Pierre, played by Dave Malloy. Malloy wrote the songs and libretto for the opera which transferred to Broadway and was nominated for twelve Tony Awards in 2017.*

In May 1995, Jonathan Larson was taken by a friend to the Obies at Manhattan Center. Later that night, he called his sister Julie and bubbled over about the raucous theatrical event: "I stood in the back, popped open a beer, took a swig and said to myself, 'Next year, it's mine.'"

As it turned out, Jonathan was right. The following year the Obie was his. But it was his sister Julie Larson who was at the podium accepting it. He had died suddenly of an aortic aneurysm five months earlier on the eve of the first preview of *Rent,* his Off-Broadway musical. Following a quick transfer from the New York Theatre Workshop to Broadway, Larson's show

would also win the Tony Award for Best Musical at the 50th annual Tony Awards just a month after the Obies.

Watching the Tony Awards that year was twenty-one-year-old Jason Eagan. He'd gathered with friends to watch the finale of the telecast backstage after a performance at the San Diego Opera where he was working at the time. "That was the moment I knew I was moving to New York; it was a deep and emotional connection to that world," he says. He got a job managing the design studio for *The Lion King,* the ultimate in Broadway spectacle, and he was thrilled when it won the Tony Award for Best Musical in 1998. But it was a chance

encounter with a group of friends that would divert his attention to the experimental side of theater. "They were on their way to see a workshop of a musical and they said, 'Come along. We'll get you in.'" The play turned out to be *Hedwig and the Angry Inch.*

"It opened up my eyes to what theater could be," says Eagan. And that in turn led him to Ars Nova, the tiny but innovative midtown theater where he started producing in 2003. It had been founded the year before by Jon Steingart and Jenny Wiener, an ambitious dream that like *Rent* was birthed in heartbreak. Gabe Wiener, a recording executive and the brother of Jenny, had just poured the foundation for Ars Nova, music building in midtown, when he suddenly died, at age twenty-six, of a brain aneurysm. Just as the Larson Grants were created to promote the work of young composers, Jenny Wiener was determined to honor her brother's legacy by finishing the building and inviting experimental artists to create freely there.

Three thousand miles away, while Eagan was working at Ars Nova on cutting-edge productions, there was a young San Francisco composer, Dave Malloy, for whom Broadway was scarcely on the radar—with one exception. While in college, he was the pianist in a band called Harrison Fjord whose marimba player was a big fan of *Rent* and Jonathan Larson. "We played 'Without You' and 'Take Me or Leave Me,' from the show," says Malloy. Thus, in 2008, when Malloy decided to follow some friends to New York, he was familiar with the

name as it routinely popped up when he started combing the net for arts grants in order to survive in the city.

"The Jonathan Larson Grant was the big one that came up all the time as the most prized and coveted thing for emergent composers," says Malloy of the award administered by the American Theatre Wing. "And so I applied for it with my work, *Beowulf*, and I won which was such an amazing surprise. It was such an affirmation: 'Yeah I should be doing this, other people are responding to my work, this actually might be a good idea.' And that encouragement— for someone who'd just arrived in New York—was huge. It was an enormous boost for my confidence."

Malloy's Jonathan Larson Grant in 2009 allowed him to work on *Natasha, Pierre & the Great Comet of 1812*, developed as a composer-in-residence at Ars Nova where Jason Eagan was now artistic director. It was also around this time that Ars Nova's endowment from the family of the late Gabe Wiener was winding down, and it was essential that the organization gain funding from outside the organization. Coming to the rescue in 2014 was the American Theatre Wing with a $10,000 National Theatre Company Grant (NTCG). "That really helped us just at the right time," says Eagan. "For a small Off-Broadway company to be recognized by the Wing was hugely significant for us, a signal to the community and other funders that something special was happening here."

More encouragement was to come when the company was given a 2015 Obie Award for Sustained Excellence under the auspices of the American Theatre Wing. That honor, combined with the NTCG grant, gave Ars Nova the comfort to support and develop with a Philadelphia company *The Underground Railroad Game* which

was met with critical acclaim. By this time, T*he Great Comet,* which had premiered at Ars Nova to rave notices, had transferred to commercial runs in pop-up tents, first in the Meatpacking District and then in midtown. Finally four years after its debut, *The Great Comet*—which had indirectly been nurtured by two young men whose lives had streaked across the sky—transferred to the Imperial Theatre on Broadway where it was nominated for twelve Tony Awards and won two.

Says Eagan, "People ask me if the success of *The Great Comet* will lead us to do more 'commercial work' and I laugh because the reason it's so successful is because we choose to do

risky work that we didn't necessarily understand at first or didn't really have a model to follow. I still don't think it's commercial. It's an anomaly that it's made it to Broadway. We're making art for the sake of making art. We're just telling stories."

BELOW: *Jennifer Kidwell and Scott Sheppard created and starred in the acclaimed two-hander,* The Underground Railroad Game, *which laid bare the roots of racism through snarky comedy. The show won an Obie Award as Best New American Theatre Work following its 2016 New York premiere at Ars Nova.*
LAST PAGE: *Denée Benton, as Natasha in* Natasha, Pierre & the Great Comet of 1812, *looks into the future with hope and trepidation capturing the mood of America as it faces uncertain times from within and without.*

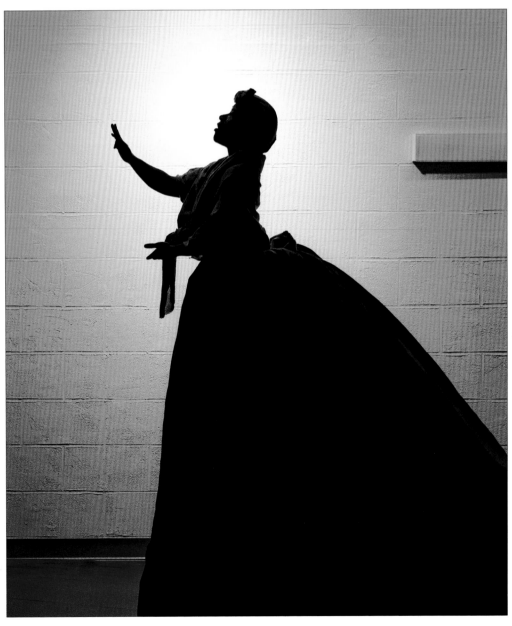

ACKNOWLEDGEMENTS

We are particularly grateful to the following individuals and organizations whose help was instrumental in putting this project together. The extremely dedicated team of Jennifer Markson, Karen Matsu Greenberg, Julie Tesser, Deborah Hofmann, Deborah Dragon, and Michael Friedman. The invaluable staff of the American Theatre Wing, including Rachel Schwartz, Nicole Mitzel Gardner, Ian Weiss, Jessica Ward, Joanna Sheehan Bell, Megan Kolb, Jeremiah Hernandez, Alicia Vnencak, Melissa Cabrero, and Autumn Hamra; the publicity office of Rick Miramontez, Andy Snyder, and Michael Jorgensen; the staff of the Lincoln Center Library of the Performing Arts, Lincoln Center, including Executive Director Jacqueline Z. Davis, Doug Reside, Linda Murray, Tom Lisanti, Louise Martzinek, and Phillip Karg; NY1 "On Stage" and Frank DiLella, Kevin Dugan, and Audrey Gruber; the family of Isabelle Stevenson, including Susan Brown, David Brown, Laura Maslon, and Francine Ringold-Johnson; Erik Forrest Jackson, Bob Callely, Sylvia Weiner, Rosie Bentick, Joan Marcus, Merle Frimark, Chita Rivera, Brandon Cordeiro, Bobby Pearce, Corice Canton Arman, Ann H. Haskell, Harry Haun, Charles Nelson, Ellis Nassour, Philip Rinaldi, Ari Conte, Mimi Lien, David Rockwell, Clint Ramos, Stewart F. Lane, Bonnie Comley, and the wonderful team at BroadwayHD; the team at Siegelvision, etc., Alan Siegel, Frank Liu, Dan Sheehan, Noam Freshman. And with special thanks to the writers of the introductory essays: Angela Lansbury, Rosie O'Donnell, Dale Cendali, Allison Considine, David Henry Hwang, Patti LuPone, and Kenny Leon.

The editor is grateful to for the following resources and theses:

"V Was for Variety: The American Theatre Wing, Broadway and World War II" by Dale Cendali, Yale University, 1981

"The Stage Door Canteen: Nothing Is Too Good for the Boys!" by Kathleen Winter Thomforde, University of Tennessee, Knoxville, 2006

"Creating a Canteen Worth Fight For: Morale Service and the Stage Door Canteen in World War II" by Katherine M. Fluker, Ohio University, Columbus, Ohio, 2011

Footnotes:

Pg. 62, Review of the film of Stage Door Canteen by Bosley Crowther, New York Times, June 25, 1943

Pg. 68-69 Excerpted from "A Proper Job" by Brian Aherne (1969), Houghton Mifflin

Pg. 73, "Remembering Antoinette Perry," by Ellis Nassour, May, 1996, Playbill

Pg. 75, ibid.

Pg. 90, "News from the Jerome Robbins Foundation," Vol. 3, No. 1 (2016), pg. 16

Pg. 96, "Obituary: Robert Anderson, Playwright and Screenwriter," London Independent, March 28, 2009

Pg. 159, Lin-Manuel Miranda to Daniel Nasaw in the U.S. edition of The Guardian, June 30, 2008

Pg. 165, Lyrics to "Broadway: It's Not Just For Gays Anymore," lyrics by David Javerbaum, music by Adam Schlesinger, opening number, Tony Awards, 2011

Pg. 243, Lin-Manuel Miranda to Tom Brokaw, NBC's Dateline, January 25, 2017

Pg. 248, Lin-Manuel Miranda, ibid.

The Tony Awards are co-presented with The Broadway League.

AUTHOR'S BIOGRAPHIES:

Chapter 1
History & Origins: *Answering the Call*

Dale Cendali is a partner in Kirkland & Ellis LLP's New York office and a nationally recognized leader in the field of intellectual property litigation. She has successfully litigated numerous high-profile cases and argued before the U.S. Supreme Court. In 2009, Managing Intellectual Property Magazine named her trial victory for J.K. Rowling as the "Copyright Trial of the Year." She has been repeatedly ranked as a "top tier" lawyer by Chambers Global and Chambers USA and was named one of the 100 Most Influential Lawyers in America by the National Law Journal. She is a summa cum laude, Phi Beta Kappa graduate of Yale College, where she was president of the Yale Dramatic Association. Dale also is a graduate of the Harvard Law School, where she is now an adjunct professor on Copyright and Trademark Litigation. Her essay in this book was derived from her Yale senior thesis, "V Was for Variety," which can be read in full on the ATW website: americantheatrewing. org/docs/v-was-for-variety/

Chapter 2
Education: *Opening Doors*

Allison Considine is a staff writer for *American Theatre* magazine. She has also written about theater for *Broadway Style Guide* and *Brooklyn* magazine. She was a critic fellow as part of the 2017 National Critics Institute at the Eugene O'Neill Theater Center. Allison is a member of the National Youth Theatre of Great Britain. Her favorite onstage credits include performing at London's Hackney Empire, and starring in a production of *Gypsy* alongside Austin Pendleton. She received a B.A. in Acting and Literature & Cultural Studies at Pace University. She's a proud alumna of the American Theatre Wing's SpringboardNYC and Theatre Intern Network programs.

Chapter 3
Community: *When Your Story Becomes Our Story*

David Henry Hwang's stage works includes the plays *M. Butterfly, Chinglish, Yellow Face, Kung Fu, Golden Child, The Dance and the Railroad,* and *FOB,* as well as the Broadway musicals *Elton John & Tim Rice's Aida* (co-author), *Flower Drum Song* (2002 revival) and *Disney's Tarzan.* Hwang is a Tony Award winner and three-time nominee, a three-time OBIE Award winner, and a two-time Finalist for the Pulitzer Prize. He is also America's most-produced living opera librettist, whose works have been honored with two Grammy Awards, and a Writer/Consulting Producer for the Golden Globe-winning television series *The Affair.* Hwang serves on the Board of the Lark Play Development Center, as Head of Playwriting at Columbia University School of the Arts, and as Chairman of the American Theatre Wing. His recent productions include a revival of *M. Butterfly,* starring Clive Owen and Jin Ha and directed by Julie Taymor, which was recently seen on Broadway as well as *Soft Power* at Los Angeles's Ahmanson Theatre.

Chapter 4
Excellence: *A Place in the Sun*

Kenny Leon is a Tony Award-winning Broadway and film director. His Broadway credits include the 2018 revival of *Children of a Lesser God,* the Tupac musical *Holler If You Hear Me, A Raisin in the Sun* starring Denzel Washington (Tony Award for Best Direction of a Play and Best Revival of a Play), *The Mountaintop* starring Samuel L. Jackson and Angela Bassett, *Stick Fly* produced by Alicia Keys, August Wilson's *Fences* (which garnered ten Tony nominations and won three Tony Awards, including Best Revival of a Play), *Gem of the Ocean* and *Radio Golf,* as well as *A Raisin in the Sun* starring Sean "P. Diddy" Combs. Leon's recent television work includes "Hairspray Live!", and "The Wiz Live!" on NBC. Awards include the 2016 "Mr. Abbott" Award, and the 2010 Julia Hansen Award for Excellence in Directing by the Drama League of New York.

Chapter 5
The Past is Prologue: *The American Theatre Wing's Next Century*

Heather A. Hitchens is a nationally recognized arts leader with more than 25 years of performing arts administration, policy, and program development experience. Hitchens began her tenure as President and CEO of the American Theatre Wing (ATW) in July of 2011. As ATW's chief executive officer, she is charged with maintaining its brand of excellence in the Tony Awards as well as overseeing and shaping its extensive grant making, professional development, education, media, and awards programs. Prior to ATW, Hitchens served a four-year term as Governor Eliot Spitzer's appointee as Executive Director of the New York State Council on the Arts, the largest state arts agency in the country. Hitchens also completed a successful ten-year stint as President of the renowned national arts service organization Meet The Composer, and prior to that served as Executive Director of the Delaware Symphony Orchestra and worked for the American Music Theatre Festival in Philadelphia. A percussionist since the age of six and a lifelong lover of the performing arts, Hitchens holds a M.S. in Arts Administration from Drexel University, Philadelphia, PA and a B.M. in Percussion/ Music Business from DePauw, Greencastle, IN.

THE PROGRAMS OF THE AMERICAN THEATRE WING

The Tony Awards

Since the 1900s, Broadway has represented the highest level of commercial theater in the English-speaking world and since 1947, the Tony Awards have celebrated the best of Broadway. Widely recognized as the American theater's most prestigious honor, the Tony recognizes excellence in twenty-four award categories, including performance, direction, choreography, writing, producing and several other fields of stagecraft. Broadcast live on CBS beginning in 1978, the Tonys help illuminate and validate American theater by reaching national and global audiences. The awards reflect the legacy of their namesake, Antoinette "Tony" Perry, an actress and director who tirelessly led the American Theatre Wing during World War II. For more than seventy years, the Tony Awards have not only been considered the pinnacle of Broadway achievement but also instrumental in advancing the arts and culture of the nation.

The Tony Awards are co-presented with The Broadway League.

The Obie Awards

The Obie Awards honor the highest caliber of Off-Broadway and Off-Off Broadway theater, recognizing brave work, championing new material, and advancing careers in theater. The award was founded more than sixty years ago by the Village Voice which put Off and Off-Off Broadway on the map by recognizing the artistic power of downtown theater. In 2015, the American Theater Wing joined the Village Voice to co-present The Obies with the mission to celebrate the diverse artists who bring important, progressive work to every New York City stage. The Obie Awards honor the boundary-pushing theater to be found in the city's intimate performing spaces, supporting and validating Off-Broadway as an important league of its own. Obie award categories were made purposefully informal to create limitless possibilities for recognizing individuals, companies and productions worthy of distinction. The loose nature of the Obies foster an award ceremony that is as spirited as the people who pioneered the downtown theater movement more than six decades ago.

The Hewes Design Awards

The Hewes Design Awards celebrate excellence in theatrical design, recognizing achievement in sets, costumes, lighting, sound and other notable effects which enable audiences to suspend disbelief and enter the magical world of the theater. Henry Hewes, the award's co-founder and namesake, was a distinguished drama critic who was among the first of his peers to give equal emphasis to Broadway and Off-Broadway productions, particularly those which were among the most innovative. Because of his passion for theatrical design, Hewes was named Chairman of the new Maharam Design Award Committee which evolved into the American Theater Wing Design Awards. The award was renamed by the American Theatre Wing to honor Hewes' perceptive writing on design and his life-long commitment to the American theater.

Working in the Theatre

Working in the Theatre is the American Theatre Wing's Emmy nominated documentary series which entertains audiences by revealing the theater's inner-workings, profiling industry luminaries, and taking a closer look at the unique stories which surround important work. *Working in the Theatre* excites and informs audiences about theater by documenting conversations, narratives, techniques, and theatrical history, thus sharing and preserving knowledge of the industry. Spanning four decades of programming and featuring extraordinary achievements across the nation, *Working in the Theatre* is the most comprehensive theater series to date.

The Jonathan Larson Grants

The Jonathan Larson Grants are awarded to young musical talent—composers, lyricists, librettists—with the potential to create work that shapes contemporary culture. The recipients are given free reign to use the grant's resources in whatever way they see fit. The hope is that the grant will allow them to fulfill their artistic visions and provide the support necessary to make a lifelong commitment to musical theater. The award is named for Jonathan Larson, a young librettist and composer, who relished the bohemian life of downtown New York in the late eighties and early nineties. After nearly a decade of development, Larson's rock musical *Rent,* a gritty urban update of Puccini's *La Bohème,* premiered to enormous critical and popular success. The show reflected Larson's personal struggle as an East Village artist getting by with the support of his contemporaries. Tragically, Larson passed away suddenly the night before previews of the show began. The brave and inspirational subject matter of *Rent,* however, gave the show a life of its own and established Larson as the voice of a new generation. The musical went on to win the 1996 Pulitzer Prize and four Tony Awards and the show remains a celebrated cultural touchstone. Thanks to the resources of the Jonathan Larson Performing Arts Foundation and the generosity of the Larson Family, the program will be sustained in a permanent home at the American Theatre Wing.

National Theatre Company Grants

The National Theatre Company Grants are the Wing's annual investment in innovative theater companies making local impacts across the nation by connecting their respective communities to excellence in the performing arts. The grant recognizes the respective missions of regional organizations to develop outstanding new work and to foster education and community engagement. The grants help these progressive theater organizations build infrastructure, enhance

resources, and create new initiatives. Those invited to apply include organizations between five and fifteen years old that have articulated a distinct mission, cultivated an audience, and nurtured a community of creatives in ways that strengthen the quality, diversity and dynamism of American theater.

The Andrew Lloyd Webber Initiative

The Andrew Lloyd Webber initiative provides students at all levels with enhanced theater education with the intent of initiating a relationship with theater while still in childhood or as teenagers. By fostering a lifelong engagement with theater through educational avenues, the awards provide diverse young people across the nation with access to seasoned industry professionals. The initiative provides classroom grants to create or enhance theater programs in our nation's under-resourced schools. For those students who are determined to pursue a career in the theater, the Initiative offers scholarships for afterschool and summer training programs as well as tuition support in higher education. The initiative expands The Wing's legacy commitment to education and diversity as it seeks to provide students from diverse backgrounds and locales the opportunity to play a role in the American theater.

SpringboardNYC

SpringboardNYC brings college-age actors into the epicenter of American theater—New York City—in an intensive program that connects young talent to the knowledge, tools and connections necessary to become part of New York's vital theater culture. The in-depth curriculum includes workshops, seminars, and master classes taught by some of Broadway's most accomplished artists as well as access to important work on Broadway and off. Springboard introduces students to industry players, creating major opportunities and professional advantages. The program forges connections between fellow actors at start of their career, building a peer community for those new to New York and the professional theater. The students are thus able to create their own

theater network through the friendships they make. The program also serves as the participants' first contact with The Wing, initiating a lifetime connection to the organization and its extensive support.

Theatre Intern Network

Theatre Intern Network provides young theater professionals with advanced education, networking opportunities, and tools for career advancement within a supportive creative community. New York City is full of theater professionals, each with their own vision for creating or supporting important work. Theatre Intern Network (TIN) connects students, interns and young professionals to senior players, theater companies, and prestigious organizations in New York. The Wing's network provides exclusive events, seminars, panels, and networking opportunities, fostering a community with regular gatherings for building relationships with peers and professionals.

Songwriting Challenge

In partnership with The National Endowment for the Arts, Songwriting Challenge is a competition for high school songwriters to compete on the national level. Students across the nation compose music for the chance to bring their musical theater song to New York City, learn from musical theater professionals, and compete with five regional finalists for the national title. The National Endowment for the Arts' Musical Theater Songwriting Challenge for High School Students (the "Songwriting Challenge") began in 2016 as an opportunity for students in three cities to showcase their songwriting talents as they competed regionally for the opportunity to participate in a final competition in New York City.

Swing Seats

In partnership with Show-Score, Swing Seats is a ticketing platform that allows theater regulars to give their extra tickets to theater students, interns and artists, expanding their theater going experiences.

The moment a theatergoer realizes that they have an extra ticket is often the day of the show. If someone they know doesn't claim the ticket, their options are limited. Swing Seats offers an effortless platform for theatergoers to donate their ticket to a young person hungry for live theater.

CREDITS

Page viii: Illustration by James Montgomery Flagg; x-xi: Photo courtesy of Angela Lansbury; xiii: Shevett Studios; 14-15: Photo by White Studio ©Billy Rose Theatre Division, The New York Public Library for the Performing Arts; 15: inset Illustration by James Montgomery Flagg; 16: Paul Thompson/National Archives; 17: Billy Rose Theatre Division, The New York Public Library for the Performing Arts; 19: AP Photo; 20: George Karger/Contributor/Getty Images; 22: National Archives; 23T: Billy Rose Theatre Division, The New York Public Library for the Performing Arts; 24: Paul Thompson/Museum of the City of New York, 38.379.23; 25: Billy Rose Theatre Division, The New York Public Library for the Performing Arts; 26: Underwood & Underwood/National Archives; 27,29, 30: Paul Thompson/National Archives; 31T, 32: Billy Rose Theatre Division, The New York Public Library for the Performing Arts; 33: Rare Books Division, The New York Public Library; 35T: Billy Rose Theatre Division, The New York Public Library for the Performing Arts; 36: Horace Abrahams/Stringer/Getty Images; 37, 38, 39, 40: Billy Rose Theatre Division, The New York Public Library for the Performing Arts; 41: Bettmann/Contributor/Getty Images; 42L: Tom Fitzsimmons; 42R: Billy Rose Theatre Division, The New York Public Library for the Performing Arts; 43: Archive Photos/Stringer/Getty Images; 44: AP Photo; 45: Culver Pictures; 46: Billy Rose Theatre Division, The New York Public Library for the Performing Arts; 47: Photofest; 48: Billy Rose Theatre Division, The New York Public Library for the Performing Arts; 49T: American Theatre Wing; 49B: Weegee(Arthur Fellig)/International Center of Photography/Contributor/Getty Images; 50: Illustration by Irma Selz; 52: Carl Van Vechten (1880-1964)/Museum of the City of New York. X2010.10.226 ©Van Vechten Trust; 53: Carl Van Vechten papers, Yale Collection of American Literature, Beinecke Rare Book and Manuscript Library. Photo by by Carl Van Vechten and ©Van Vechten Trust; 54: Carl Van Vechten (1880-1964)/Museum of the City of New York. X2010.10.116 ©Van Vechten Trust; 55T: Library of Congress Prints and Photographs Division; 55B: Carl Van Vechten (1880-1964)/Museum of the City of New York. X2010.10.117 ©Van Vechten Trust; 56: AP Photo; 57: Billy Rose Theatre Division, The New York Public Library for the Performing Arts; 58L: Illustration by Sotomayor; 58TR: Illustration by Clifford K. Berryman; 58CR: American Theatre Wing, Eddie Cantor; 58BR: Bob Eagle 59: Illustration by Arthur Ferrier; 60TL: Illustration by Fred Ray; 60BL: Time Life Pictures/Contributor/Getty Images; 60TR: Billy Rose Theatre Division, The New York Public Library for the Performing Arts; 60BR: Acme Photo; 62: Cosmo-Sileo; 64TL,B: Stage Door Canteen Film; 64TR: Illustration by Irma Selz; 65T: Stage Door Canteen Film; 65B: Photofest; 66: Signal Corps. U.S. Army; 67T: CBS Photo Archive/Contributor/ Getty Images; 67BL: Billy Rose Theatre Division, The New York Public Library for the Performing Arts; 67BR: AP Photo; 68: Billy Rose Theatre Division, The New York Public Library for the Performing Arts; 69: Eileen Darby/Contributor/Getty Images; 70: Bettmann/Contributor/Getty Images; 71: Bain Collection/Library of Congress Prints and Photographs Division; 72: White Studio (New York, N.Y.)/Museum of the City of New York. 48.210.1413 ©The New York Public Library; 74: Peter Killian; 76: Photo by Vandamm Studio ©Billy Rose Theatre Division, The New York Public Library for the Performing Arts; 77: Edward Steichen/Vanity Fair © Conde Nast; 80, 81: Shevett Studios; 82: Photo by Martha Swope ©Billy Rose Theatre Division, The New York Public Library for the Performing Arts; 84, 85: Greg Weiner; 87: Shevett Studios; 88, 89: AP Photo; 90: Jerome Robbins Dance Division, The New York Public Library for the Performing Arts; 91: Photo courtesy of the Benedetto Family Archives; 92: Sara Krulwich/Contributor/ Getty Images; 93: Records of the National Woman's Party/Library of Congress Prints and Photographs Division; 94: Photo by Friedman-Abeles ©Billy Rose Theatre Division, The New York Public Library for the Performing Arts, 95: Photo courtesy of Joe Masteroff Family; 96: Photo by Friedman-Abeles ©Billy Rose Theatre Division, The New York Public Library for the Performing Arts; 97T: MGM/Photofest; 97B: Photo by Friedman-Abeles ©Billy Rose Theatre Division, The New York Public Library for the Performing Arts; 98: Joan Marcus; 99, 100, 101L: Greg Weiner; 101R: Ben Barron; 102: Greg Weiner; 103: Photo Caption: Ocean (Tiffany Tatreau) and members of the Saint Cassian choir (Emily Rohm, Jackson Evans) face an uncertain future in Chicago Shakespeare Theater's U.S. Premiere production of Ride the Cyclone, directed and choreographed by Rachel Rockwell, in the theater Upstairs at Chicago Shakespeare, September 29–November 15, 2015. Photo by Liz Lauren; 104T: Shevett Studios; 104B: Tristan Fuge; 105L: Olivia Luna; 105R: Photo credit: Stephanie Berger; 106, 107, 108: Shevett Studios; 109: Two River Theater, T. Charles Erickson; 110: AP Photo/Richard Drew; 111T: Ric Watkins/Covington High School; 111B: Photo Courtesy of Quinn Chisenhall; 112L: Photo courtesy of Dina Perez; 112R: Photo courtesy of Kaisheem Fowler Brant; 113L: Photo courtesy of Carrli Cooper; 113C: Photo courtesy of Grace Pruitt; 113R: Photo courtesy of Macus Gladney; 114: ATW/Working in the Theatre; 115T: Photo by C.J. Zumwalt; 115B, 116, 117: ATW/Working in the Theatre; 118: Joan Marcus, 119, 120, 121, 122, 123, 125, 126, 127: ATW/Working in the Theatre; 128: Joan Marcus; 130: Eiko Ishioka Estate; 131L: Photo by Joseph Sowmick; 131R: Greg Weiner; 132-133: Joan Marcus; 134-135: © The Al Hirschfeld Foundation. www.AlHirschfeldFoundation.org; 136: Photo by Carl Van Vechten and ©Van Vechten Trust/Library of Congress Prints and Photographs Division; 137: Photo by Martha Swope ©Billy Rose Theatre Division, The New York Public Library for the Performing Arts; 138TL: Bettmann/Contributor/Getty Images; 138BL: